In memory of the brilliant Alan Couldridge,
whose inspired understanding of fashion education
was pivotal to the story of the School
he so loved

WENDY, JANEY, JOANNE & MADGE

Inspirational Professors of Fashion
at the Royal College of Art
1948–2014

Henrietta Goodden

Unicorn Press

First published in Great Britain in 2020 by Unicorn Press
60 Bracondale
Norwich
NR1 2BE

tradfordhugh@gmail.com
www.unicornpublishing.org

A CIP record of this book can be obtained from the British Library

ISBN 978 1 916495 77 7

Designed by Nick Newton Design
Printed in Belgium by Graphius

Cover portraits, top to bottom: Wendy – Jonathan Prew;
Janey – John French; Joanne – unknown photographer;
Madge – unknown photographer.

Front cover background: Royal College of Art Archive, unknown photographer.

Back cover: RCA Fashion studio, 1963. Upper left, Alan Couldridge; right, Janey Ironside.
Royal College of Art Archive, unknown photographer.

Endpapers: reverse-colour image taken from dot and cross paper used for marking out
garment patterns.

Contents

Foreword Sir Christopher Frayling

One of my first roles at the Royal College of Art, in autumn 1974 – as a fresh-faced one-day-a-week tutor in what was then called, unhelpfully, General Studies – was to teach the Fashion students on Wednesday mornings in a moody mausoleum of a house with an imposing Doric porch on the corner of Cromwell Road. My commission was to stimulate the young postgraduate designers to think on the wing about wider issues in culture and society – beyond their specialism – and to supervise their written dissertations; it was also to try and build bridges between the Fashion School and the rest of the College.

This wasn't as easy as it looked. The psychological distance between Kensington Gore and Cromwell Road was a lot greater than the actual distance. When my Professor, Christopher Cornford, briefed me, he said that the Fashion School didn't just feel physically isolated, they still resented the fact that when the College became a university institution in 1967, able to grant its own degrees, at first the School had been excluded. They had tended to blame the Rector Robin Darwin. In fact, the decision had also been the result of strong pressure from the University Grants Commission and the new Department of Education and Science, who could just about bring themselves to welcome the College into the university sector, after swallowing hard, but could not bring themselves to authorise degrees in Fashion. So, diplomas it had remained. Janey Ironside, Cornford said, had resigned partly as a result ("the other part?" / "Don't ask, Christopher."), and the inevitable newspaper headline had been "Fashion Students One Degree Under", a reference to a then-celebrated TV advertising campaign for yeast pills. In the event, the decision was reversed within less than a year – but the damage had been done. Fashion still felt it had been treated like the tradesman's entrance into a university.

Almost as soon as I entered that Doric porch, I discovered that the School – under Professor Joanne Brogden, known by students and even some of the staff as 'Miss Brogden' – was run with remarkable efficiency as a very busy fashion house, by far the tightest ship in the College as well as the most 'industrial' (up there with car design). But Joanne herself, with her trademark Vidal Sassoon fringe and inseparable Guards cigarettes, was surprisingly prickly about it. Earnest and prickly. The students were there, Joanne reminded me in no uncertain terms, to study and practise fashion design – to become young professionals. Nothing else mattered. In the Madge Garland era, they had also been taught the outline history of costume by James Laver – and had been encouraged to read Jane Austen (for decorum) – but that sort of material (though not, of course, the Jane Austen) was now covered by

undergraduate courses. Clearly, something more appetising would now be required, integrating with studio work rather than compensating for it. She wished me luck, but in a stern voice.

Over the ensuing months, my course called 'Signs of the Times' settled down. We began with 'Reading Fashion and Clothing', once we'd established that Roland Barthes didn't write *Oliver!*, and branched outwards from there. The students were bright, committed and amazingly knowledgeable about what was in the ether. The teaching staff – Alan and Valerie Couldridge, Annie Tyrell and in time Joanne Brogden, who became a close friend – turned out to be supportive once the ice had been broken and once they had reassured themselves that I wasn't trying to turn the young designers into eggheads from another planet. The technical staff – Phyllis and Rose – gave me some cheerful lessons in diplomacy . . .

I finished that first year by asking each of the students to give a ten-minute presentation in the Kensington Gore Lecture Theatre about the thing they were most passionate about, outside their daily work. One student chose to present three statuesque male models dressed from head to foot in zipped-up black rubberwear, accompanied by throbbing synthesiser music. Her presentation was called *Fetish*. There was just a single question from the floor: 'Is it hot in there?' This was followed by a visual essay on 'The Royal Family and anti-fashion', and, after some more predictable James Dean, Fred Astaire, Audrey Hepburn (twice) and Betty Boop, an evocation of the thesis that life was decomposing before our very eyes – with some very curious slides and readings from Oscar Wilde. Maybe I should have been more precise about the brief . . .

In the end, the course – I like to think – proved valuable for all of us. It certainly did for me. It gave me an understanding of Fashion's distinctive contribution as a design discipline (and I mean discipline), an admiration for the way the School was run, and a determination to stop the fine artists up the road from being so patronising and sexist about it. Colin McDowell has written, with characteristic generosity, that when I became Rector in 1996 'it soon became clear that [I] would become very pro-fashion . . .'. My teaching in the mid-1970s definitely contributed to this.

The story of Fashion Design at the RCA is not the story of a stable and secure learning environment. How could it be? As Lord Esher (Robin Darwin's successor in 1971) once quipped to me: 'If all the staff in Fashion had been given lifetime tenure, the students would still be wearing cycling bloomers!' That said, it is notable that Madge Garland, Janey Ironside and Joanne Brogden all resigned, citing 'disagreements' with the powers-that-be. Sometimes, the analogy with the volatile fashion business has maybe been a bit *too* close . . .

This remarkable book by Henrietta Goodden, who taught in Fashion for many years and whose father was Darwin's second-in-command, is about, for the first time in detail, four strong personalities – eccentric, stylish, talented, driven. Together, they defined Fashion at the College from the Second World War right through to the twenty-first century. The book takes the subject as seriously as it deserves – and is fun to read as well. It has unlocked many memories . . .

Introduction

I'm not sure when I first understood the word 'fashion'. My mother Lesley came from a family of keen dressmakers and I still have the book of meticulous drawings from a pattern-cutting course she took in London in 1946, with the comment 'very good, 90%' signed by a Monsieur or Madame J. Trois-Fontaines. I suspect that if she hadn't then met my father she might have ventured into the world of fashion.

There was little opportunity for statements of style in the depths of East Anglia, but my mother loved sewing and was constantly creating beautiful dresses for herself – often adapting *Vogue* patterns – or unconventional clothes for us, who so desperately wanted to look just like other children. I do remember she made a rose-pink taffeta skating skirt for my sophisticated London friend Sasha, complete with embroidered name, and I never understood why I, dressed in artistic bottle-green velvet for parties, couldn't have had the same.

When I started at secondary school in Essex I had no idea what it meant to have the latest look. Other girls giggled at my huge beret, sensible Clarks lace-ups, droopy hair (Helen Shapiro was top of the pop charts) and unusual name. Suddenly, in my third year, everything changed. I began to go to the art room, where Molly Brown the art-mistress, terrifying until she knew you, would stride around smoking and shouting, in orange lipstick, gold stilettos and a white overall under which was an olive-green wool suit by couturier John Cavanagh. The Beatles had arrived on the scene and soon I was the school expert on the Fab Four, faking a left-bank look with customised duffel-coat and black stockings, oversized school V-neck and wannabe-Françoise Hardy hair (the droopiness now acceptable) straightened on the ironing-board. My father brought home a copy of *Elle* every week from London, and I began to see what fashion really meant. With help I began to make my own clothes – first of all a dark-striped wool tunic and skirt, then a pink gingham earwig-collared dress. The most exciting thing of all was going to annual fashion shows at the Royal College of Art, where the awe-inspiring Janey Ironside and her sparky students were changing everyone's idea of how to dress.

Admiring of wonderful fashion drawings in *Honey* and *Vogue* by Bobby Hillson, Moira Macgregor, May Routh and Barbara Hulanicki, I joined the foundation course at the art school in Colchester. On my weekly day of fashion drawing there were cool graphics tutors from London, looking like fashion photos themselves, who criticised and sometimes encouraged. I got into Kingston School of Art to study for my Dip AD and loved every minute of it once through the first year, during which I would

hitch-hike home from Gant's Hill tube station in my Biba boa and minidress. Though I didn't think of applying for the RCA fashion school when I finished my course (no-one from Kingston ever did until years later) I became a College groupie, sharing a flat with a friend who was studying textiles. The College had always seemed such a special place to me, and my father, one of Robin Darwin's first team of professors, would sometimes treat me to lunch in the legendary Senior Common Room. Much, much later, when I was happily teaching at Kingston and never dreaming an RCA career was remotely possible, Alan Couldridge phoned and asked if I could replace Sheilagh Brown as tutor for womenswear. It was one of the most thrilling days of my life.

Having written a fair amount about the College and various subjects in its design history, I had never considered researching the School of Fashion, even after nineteen years of teaching there. When Sir Christopher Frayling suggested this, I wondered why on earth I hadn't thought of it first. The worldwide influence of the four charismatic and powerful women who were in charge of the Royal College of Art's School of Fashion from 1948 to 2014 changed the face of British and international style. Through their rigorous determination to produce nothing but the best, and the top-level design stars who emerged as a result, they have been largely responsible for the story of British and international fashion in the second half of the twentieth century and the start of the twenty-first. In this admirable quartet, each individual professor after Madge Garland complemented the work of her predecessor. Janey Ironside, the sparkling innovator, put a modern spin on the stable foundations laid by Garland, a brave and rigorous pioneer in an age of considerable resistance. Joanne Brogden consolidated what both the others had done, her resolute commitment to her department shepherding the school successfully into a competitive commercial world. Like Garland and Ironside, she perfectly understood and supplied what the College had set out to achieve – the education of creative designers ready for high-level industry – and when Professor Wendy Dagworthy took over in the final decade of the 20th century, her objective was to take the School into a new era while paying great personal respect to the legacies of the first three female professors of Fashion.

Maybe I was too close to the subject to think about recording it – but I would like to thank Sir Christopher, the College and its remarkable professors of fashion since 1948, for providing such an inspiring and enthralling subject.

Henrietta Goodden
October 2019

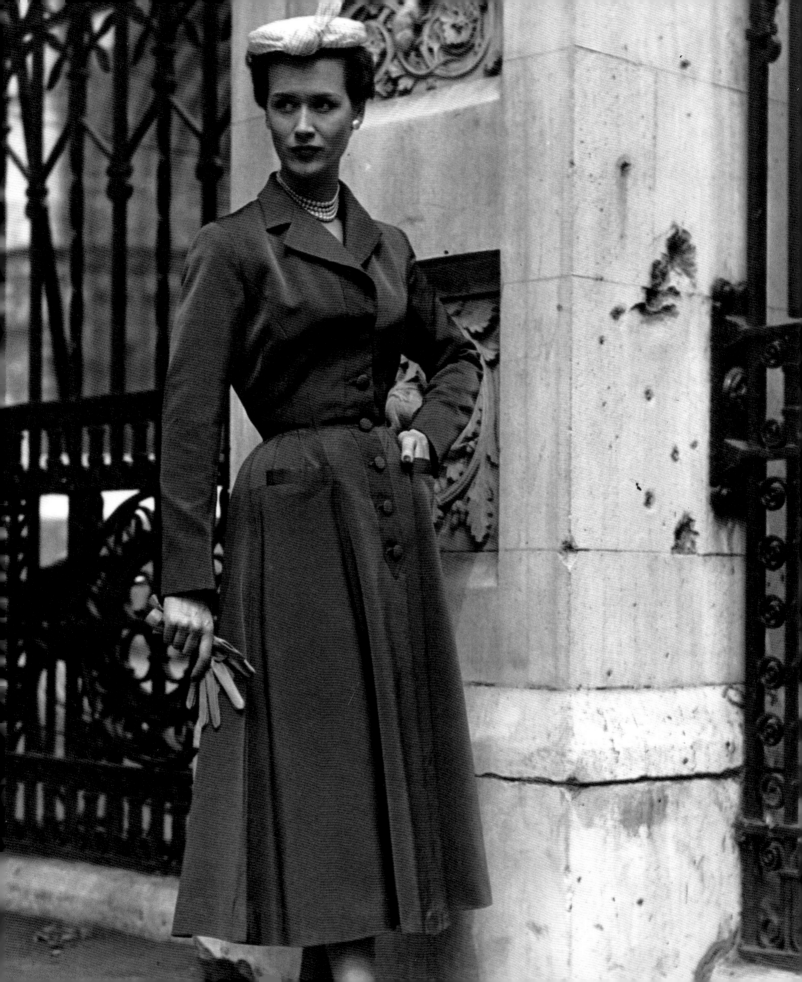

Chapter 1

A New Look at Fashion

'You cannot divorce trade and creative art'.[1]

In 1946 the French *Ministère de l'Economie Nationale*'s expedient announcement gave optimism and new aspiration to the French fashion business, which had only recently emerged from the wartime occupation of Paris and the disturbing period of oppression this had brought to the people of the City of Light. With the normal life of the nation put uncomfortably on hold for five years, the mothballing of Paris's revered *haute couture* houses had taken the last remnants of pride and acclaim from an already suffering city. For immensely proud the French fashion industry was, and the minister's words, explaining how couture would now be under the wing of the *Office Professionel des Industries et de la Création*, serve to underline the enormous prestige placed by France on the production of fine clothing and the economic importance of fashion as a high-profile and necessary national commodity.

Class-obsessed Britain thought differently. 'Trade' had downmarket connotations, and above a certain social level the idea that the word could be used in the context of upmarket fashion was barely believable – let alone the mention of couture clothing alongside that of industry. But couture, naturally, was not available to everyone. Press reports from the Paris shows generated inspiration for manufacturers and smaller suppliers, and between the first and second world wars, more affordable fashion garments (often copied from Parisian or Viennese designs) were supplied by private dressmakers or 'madam shops', which either bought stock from suppliers or produced their own lines.[2] On a different level, the British ready-to-wear business was growing steadily. The influx of Russian Jews escaping the Czarist empire before the First World War had resulted in the emergence of many skilled tailors and furriers who, once established, put all their investment into new machinery in order to introduce better and faster manufacturing methods. These family businesses were supplemented by the mass arrival in the mid-1930s of German and Austrian refugees, many of them professional tradespeople fleeing the persecution of the Nazis and their brutal 'Adefa' campaign, which victimised Jewish shopkeepers and allowed only Aryan products to be sold to the public.[3] The number of small British garment businesses and subcontractors therefore multiplied hugely in the 1930s, boosted by a new female work-force and also by improvements in machinery, creating faster production, and in new technology such as the introduction of modern garment-grading techniques from the United States.

Fitted coat-dress attributed to Joanne Brogden, c.1951

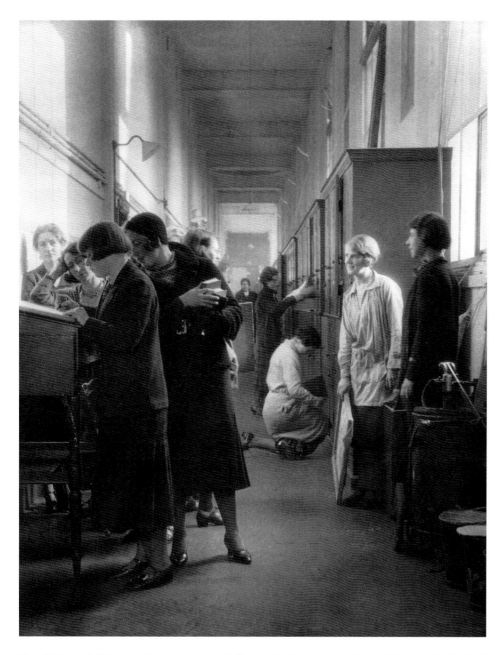

RCA students signing the Book of Attendance,
1932

The British clothing industry grew and thrived in the great cities of the north, fuelled by the cotton factories and the woollen mills, and in the East End of London. Here, small family or culturally-linked units increased threefold between 1930 and 1939. In the winter of 1940–41, the devastating bombing of the East End and the City of London so decimated these parts that the wholesale drapery business and its closely-related trade publications were obliterated, slowly re-evolving as a central 'garment district' in Soho, south of Oxford Street, and the area to its north[4] which was conveniently near to the big department stores and the West End branches of the burgeoning 'multiples' offering ready-made clothing to the masses. Often bringing a desirable 'continental' expertise to the industry, these businesses adapted and integrated well and began to introduce specialist areas of manufacture, though

it is characteristic of the phlegmatic British attitude that the production of women's coats, skirts and blouses was still considered a 'clothing' rather than a 'fashion' business. In the eyes of many, trade and fashion still did not mix. While established menswear companies such as Burberry, Aquascutum, Burton and Hepworth sold through their own shops, womenswear was generally supplied by the manufacturer to a wholesaler whose travelling salesman would then approach store buyers by appointment, a hierarchical marketing system which is the subject of the writer Eric Newby's evocative and hilarious memoir *Something Wholesale – My Life and Times in the Rag Trade*.[5]

The 1931 imposition of import duties on cloth and clothing had forced British textile manufacturers (in cautious Bradford with its winter woollen industry, very traditional; and go-ahead Manchester, specializing in cottons and lighter weights) to invest in advanced new machinery, mainly from the US, and therefore to expand production. It also encouraged these fabric producers, previously in competition with European mills, to create important new lighter-weight fabrics for fashion wear, thus increasing opportunities for simpler manufacturing and multiple production runs. The advent of easy-care synthetic fibres was a godsend for busy working women and fast-changing trends in fashion meant that collections were produced seasonally, making essential the presence of a designer whose finger was on the pulse. Paris design (available for manufacturers to buy, with strict limitations, in the form of sketches and patterns from the latest shows) was still paramount in an era when the French couture was at its most imaginative, but it became more and more evident that an in-house designer, and not the filtered-down ideas of the boss or his wife, was of great importance to any business that wanted to be considered a 'fashion' label. It was Madge Garland, fashion adviser to the Government, who wrote early in the 1940s 'The more mass-production there is – the more often a model is copied – the more important is the original design and the more significant the role of the designer'.[6]

In 1938 the Dress Committee of the Council for Art and Industry (later to become the Council of Industrial Design) produced a report on *Design and the Designer in the Dress Trade* which in the event was finally published in 1945, when austerity and rationing were at their peak. Britain's art and design training schools, many of which had originally been set up by the Government in the 19th century as a result of the Industrial Revolution, had been educating students who would become design apprentices mainly in the ceramic, metalwork and textile industries. After the war a swathe of new technical colleges, offering courses preparing students for industry, swallowed up many of these creative courses and the art schools which managed to survive these changes began as a result to concentrate on fine art and handcrafts, becoming remote from industrial reality. 'Dress', in a somewhat amateur or 'artistic' form, was taught as an adjunct to some of the textile courses and several reputable schools began to train clothing designers and cutters, notably the Central School of Arts and Crafts and the Leicester College of Arts and Crafts. However, the leaders of these courses barely understood fashion and, assuming that their students would eventually work nowhere as unsavoury as 'the Trade', taught little about the

importance of technical knowledge. Conversely, London's industry-related Barrett Street Technical School, originally opened to extend the education of secondary-school girls and later to become the London College of Fashion, was turning out graduates who were excellent technicians but who had no formal knowledge of garment design.

A talent for fashion

Fashion (as opposed to 'dress') as a further-education design subject had not really existed until a scholarship girl from the Midlands arrived in 1928 to study fine art at the Royal College of Art. Muriel Pemberton's background was highly artistic. Her father Thomas Henry Pemberton, an aspiring painter who realised that a career in fine art would not be sufficiently lucrative, had turned his skills to photography and set up a successful portrait studio in which he combined commercial business with creative talent. His wife Alice was a soprano singer, and with their rare enthusiasm for art and culture, their frequent parties and musical evenings became well-known in the somewhat conservative industrial society in which they moved.

Four daughters were born, all very close in age, followed by a single son. From an early age the children were constantly encouraged to paint, draw, learn the piano and sing, and to organise costumes and sets for family theatricals. The house was always full of creative projects-in-progress. Alice was a gifted needlewoman and knitter, and the girls were dressed in stylish outfits often finished with beautifully-trimmed little hats. Craft, particularly embroidery, was important, and Thomas as well as Alice was able, unusually for a man at that time, to join in: 'father would embroider violets round the hemline of each girl's dress'.[7] If times were hard, the parents, ever resourceful, would even dye fabrics so that they could continue to make clothes for the children.

Growing up in an environment wholly encouraging to budding artists and designers, particularly in the subject of clothing, it was no surprise that Muriel decided at the age of 14 that she wanted to be an artist. She applied and secured a scholarship at Burslem Art School (which, with its close links to the potteries, continued to train designers for industry, its original *raison d'etre*) and was reluctantly released from her high-school. One of the youngest-ever students, in her three years of study she developed her already remarkable drawing skills and applied for a place in the painting school of the Royal College of Art, which at that time had four schools: painting, sculpture, architecture and design. She was successful and eventually took up her place, aged 20, with a bursary for tuition, art materials and living expenses.

Muriel, with her interest in the human form, enjoyed every aspect of the syllabus, particularly the life classes, however segregated and decorous. But like her father, she began to realise how difficult it would be to make a living from drawing and painting. At the end of her first year she felt so concerned about this that she went to see Professor Tristram, head of the School of Design, and asked him if she could transfer her degree to the study of fashion, although there was no provision in the College for a diploma in this subject. Tristram, forward-thinking and interested in

this serious young lady's proposals, agreed with the proviso that she write her own curriculum which, if approved, would allow her to continue her college study within the School of Design.

The determined and resourceful Muriel worked out a timetable which, as well as basic study, somehow managed to include one day a week observing and sketching couture techniques at Revell and Rossiter, the Court dressmaker. She also arranged dressmaking classes two days a week at the Katinka School of Cutting in Knightsbridge: for these, she traded drawing classes in order to pay for her study. She spent as much time as she could in the Victoria and Albert Museum library, where she researched all kinds of clothing, sketched, filled endless notebooks and was often able to talk to the in-house costume historian, James Laver (later to lecture at the College). As a result of all this study, Muriel was well able to write and illustrate her eventual thesis which would be based on the knowledge she had absorbed during these profitable visits.

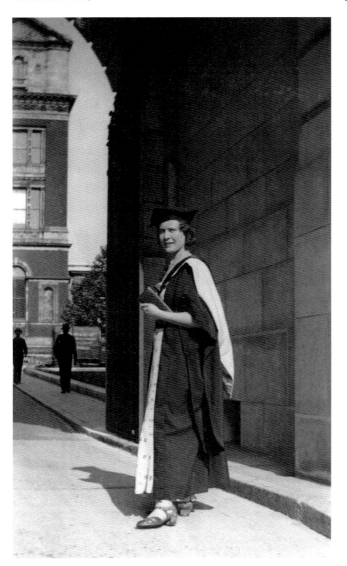

Muriel Pemberton's graduation day at the RCA, Exhibition Road, 1931

With this impressive timetable also including toile-making, technical fabric research, life drawing and fashion drawing, Tristram could hardly refuse Muriel's request. After three years, Muriel presented her own collection and graduated triumphantly in 1931 with the RCA's first diploma in Fashion. She found work almost immediately at a London furrier where, sketching the mannequins, she must also have learned specialist knowledge in construction methods; some of her drawings appeared in a subsequent copy of *Vogue*. In 1932 she applied for a post as part-time fashion drawing tutor at St Martin's School of Art in Charing Cross Road, and successful in this, began by insisting the students draw from live fashion models. These classes became so popular that she asked the Head of School for permission to bring in staff to teach pattern-cutting and toile-making. Her job eventually became a full-time post, and thus she developed a curriculum which became the first real fashion design course in Britain. Heading this up for many years, her charismatic leadership attracted both talented students and much media attention. Unique and directional, Muriel Pemberton's course did retain its fine-art bias towards real drawing, and the fashion school at St Martin's long retained her credo (sadly often missing in today's colleges) that students should have a mature understanding of the drawn image as well as of the creative design.

Meanwhile, the Dress Committee's investigation into the meaning of fashion design, the need for designers and the willingness of the trade to employ them, resulted in the recommendation that the RCA (where, after Muriel's self-directed efforts and probably inspired by them, a fashion school with industrial links had already been approved in the Hambleden Committee's 1936 report *Advanced Art Education in London*) should be the place where their design

education should be completed. Muriel Pemberton was delighted – even if not immediately, her efforts to upgrade the College's advanced fashion provision had been noticed, and throughout her teaching life she would repeatedly advise her staff and students at St Martin's that she 'expected everyone to go there'.[8]

An influential report

Immediately after the Second World War, in a necessary effort to boost Britain's beleaguered manufacturing trades, the newly-renamed Council for Industrial Design (CoID) had produced a paper on 'The Designer and his Training', a collaboration between two colleagues who had met in the wartime Directorate of Camouflage: Christopher Ironside, in charge of the Training Committee, and Robin Darwin, Training Officer acting as secretary. As a result of this, it was urgently decided to undertake a comprehensive report in order to investigate the issues discussed in the document, in combined operation with the Ministry of Education, heads of art and technical colleges, and experts from industry and related fields. Both the Hambleden report and the CoID's recommendations had already highlighted the RCA as the only school potentially capable of producing fully-fledged fashion designers, and the weighty report 'The Training of the Industrial Designer' (researched and produced by the overstretched Darwin, teaching temporarily at Eton and simultaneously negotiating a new post as Professor of Fine Art and Director at Newcastle's School of Art) emphasised that post-graduate training in fashion design was essential in order to rectify a post-war decline of the industry in Britain.

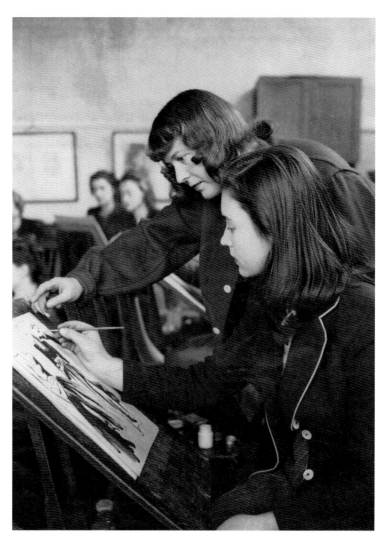

Muriel Pemberton instructs a fashion illustration class, St Martin's 1932

The CoID's paper, finally finished and circulated in April 1946, was seminal and far-sighted. The word 'fashion', in highbrow Britain, had up till then often elicited a reaction that could only be described as dismissive: to many, it carried the negative connotation of a subject seen as shallow, superficial and exclusively feminine. Perhaps this was the fault of the word itself, and the image it had come to describe. Although its original definition is broad (everybody, after all, has to wear clothes; and the word itself originally describes the act of forming or shaping) in many circles it simply conjured up images of female frippery along with a tendency towards a limited feminine intellect. After the Second World War this misogynistic misconception was very much the case in establishment and higher education circles (made up mostly of men). In rare cases where an appreciation of the subject was shown, it was generally accepted that the British shouldn't be meddling with it: 'It's up to God to supply people with a better sense of clothes than the French possess – otherwise, Paris will still remain the centre . . .'[9]

Robin Darwin, RCA Senior Common Room, early 1950s

The report's main target was to point out the acute need for facilities to train designers in all disciplines including 'the Fashion industries in which a small number of leading designers affect the level of design throughout the country'. Although 'it may be argued … that taste and a Fashion sense cannot be taught, that designers in this field will be born and never made' it was worth considering the provision of 'facilities to help the born designer along his pre-destined way'. Darwin's conclusion was that it would be essential to instigate a 'major school' (no mention, as yet, of the RCA) or centre where all aspects of design could be taught at an advanced level, crucially supported by close collaboration with industry. Debated at length by government ministers and members of the CoID and finally approved by a panel of educational experts, many of whom also had strong ties with the British

manufacturing industries, Darwin's paper was later to act as catalyst for his eventually successful application for the role of Principal of the RCA. It was to become the basis for his operational philosophy throughout his quarter-century in charge of this unique institution, and its words would filter down to become a manifesto for the re-organisation of British art-school education.[10]

The New Look

The RCA did have a department named 'Dress Design', headed by Mrs Gibson since 1936, but its output bore little relationship to fashion. The end of the war created a new urgency for the understanding of design, and it is fitting that the RCA's School of Fashion should have been conceived, with Robin Darwin's appointment as Principal in 1947, in the same year that Christian Dior launched his New Look (a style so distant from British post-war rules of austerity that the director of the Board of Trade, Sir Stafford Cripps, gave British journalists strict instructions not on any account to write about its extravagance). In the words of the School's first Professor, 'When Robin Darwin became principal of the Royal College of Art in 1947, he gave it a New Look which altered it almost as dramatically as his contemporary, Christian Dior, changed women's clothes in the same year'.[11] During the war the British couture business had expanded unexpectedly, owing to the absence of French fashion and the return of English couturiers formerly based in Paris such as Captain Molyneux and Charles Creed. In 1942 the Incorporated Society of London Fashion Designers (IncSoc) was initiated, its founder members being Hardy Amies (seconded from his war work in the Special Operations Executive), Norman Hartnell, Edward Molyneux, Digby Morton, Bianca Mosca, Peter Russell, Victor Stiebel (of Jacqmar, and a senior figure in the Directorate of Camouflage) and Worth London. To some, IncSoc appeared to be an elitist organisation – '… everyone seemed to have a title' observed grand fashion journalist Prudence Glynn, herself Lady Windlesham. These houses were joined a little later by John Cavanagh, Charles Creed, Bernat Klein, Michael, and Ronald Paterson. One of IncSoc's main purposes was for its designers to create high-fashion garments in line with austerity regulations, taking into consideration all the restrictions caused by wartime rationing of fabric and haberdashery. In addition to producing their own couture and ready-to-wear collections the designers worked on the government's Utility Clothing Scheme – fashion items suitable for mass-production, also in strict accordance with the limitations of rationing restrictions.

IncSoc was followed in 1947 by the less elitist, commercial but still upmarket London Model House Group, initiated by Frederick Starke, which included such companies as Brenner Sports, Dorville, Koupy Models, FS,W&O Marcus, Rima, Silhouette de Luxe, Simon Massey and Spectator Sports.[12] From June 1947 the group produced a timetable of synchronised seasonal shows, and a maintenance code of standards for top-end manufacture and export. Other associations were formed to support the coat industry and the dressmaking trade. Although British ready-to-wear manufacturers did not yet have the cachet of their go-ahead American counterparts whose production was unaffected by world events, several of the large

established companies such as Ellis and Goldstein (with labels Dereta, Eastex and Laura Lee), Windsmoor and Steinberg (Alexon) were enthusiastic, with the relief of returning to normal production after years of supplying military uniforms, to consider their merchandise in a new light. The popular retail move towards 'shops within shops' meant that ranges such as theirs, along with those of the more traditional British companies Burberry and Jaeger, were easily available to the consumer. Berkertex, an early habitué of this approach, had invited Norman Hartnell to produce a collection in 1942, making a previously unreachable couture name accessible to the general public, and this encouraged a broader appreciation of the importance of design.

In spite of the Board of Trade's taboo on the New Look, the 1948 British collections showed a post-war return to femininity in the form of fitted bodices with narrow shoulders and tiny waists, and an emphasis on the hips whether created by full skirts (risqué – too much fabric) or by clever draping. Dior's revolutionary designs had reinstated Paris as the world's centre in fashion, at both couture and ready-to-wear levels. The hope in Britain was that the increased need for fabric would stimulate the textile industry, still struggling after the war, but it was a sluggish process – the manufacturers were slow to realize that newly updated methods of production and trading were essential in order to export both fabrics and fashion to Europe and America. Little by little, assisted by the investments of the Marshall Plan,[13] by the realisation that British quality was what the world wanted, and in no small way by the efforts of IncSoc with its ready-to-wear as well as its couture collections, the fashion and textile industries emerged from their torpor, recovered momentum and gradually managed to rebuild their war-impaired reputations.

What fashion needed now, in order to compete with the world, was an endless supply of creative ideas, and where better to find these than in a central London college with a training course specially conceived by the Ministry of Education for the purpose of encouraging only the best in art and design; supported by industry, a school whose well-qualified alumni would influence international fashion, and which would quickly become the post-graduate destination of choice for students the world over.

Chapter 2

Resilience and Determination

The harsh, icy weather in the severest British winter for decades did not prevent February 1947 from being a particularly auspicious month for the future of British design education. Early in the year the government had called an important gathering of senior figures from the Ministry of Education and the Council of Industrial Design so that they could begin discussing the CoID's substantial document 'The Training of the Industrial Designer'. The first meeting began with the significant announcement that the Royal College of Art would reopen the following academic year with a new principal and governing body, its main emphasis being the education of designers for industry alongside equally important courses for the practical study of the fine arts. Time was short, and interviews were hurriedly arranged for the post of principal. An eventual shortlist of eleven was considered, with one additional candidate, Professor Robin Darwin, being seen after arriving late in the application process. In the event, unorthodox though his interview had been, the board decided that Darwin's fervent vision of the College's future and his professional understanding of the issue (along with strong recommendations from senior personnel in the CoID and the Ministry of Education) made him the only candidate worthy of consideration, and after undertaking scrupulous enquiries, the panel, albeit a little nervous of its decision, offered him the post of Principal of the Royal College of Art.[1]

Darwin makes changes

Darwin had to work fast. The outgoing principal of the College, Percy Jowett, offered to stay until Christmas to ease the transition, thus helping Darwin wrap up his short-lived tenure at Newcastle. Darwin's first priority for the RCA was to assemble an advisory council, under which a new committee was set up for each design subject. In order to find out the requirements for training designers, each committee included at least one industrialist, a number of professional designers and a representative from the Ministry of Education, and was chaired by a member of the Council. Darwin then considered the existing teaching provision and, in a style soon to be notorious, made himself extremely unpopular by terminating the contracts of all academic staff (including amongst them the unlucky Mrs Gibson) in order that he could re-employ those who deserved it, and assist those he felt unsuitable in finding other jobs. He was horrified to find the College had no staff pension arrangements and set out to create a beneficial contract system which would eventually become a long-standing national model for art and design school staff.

Paris couture dress fitting, probably at Robert Piguet with assistant designer Christian Dior, c.1937

His next task, more pleasurable, was to recruit a team of new professors. Darwin's professional and social network was considerable, and it is interesting that he called on a group of fairly recent acquaintances, colleagues from his wartime experiences, to head up a number of the College's new schools. While in his position of secretary to the Camouflage Directorate he had met, in addition to painters and sculptors, a lively band of qualified architects and designers who were working on army, admiralty, air force and civil camouflage. He found their output fascinating and was particularly interested in the way the architects within the group developed concepts, using technical theory to back up creative ideas – in his view, a model for training students in design for any industry.[2] So amongst the new professors were

Robin Darwin and his professors, early 1950s, with the Brazilian Ambassador, Dr Assis Chateaubriand (second right). L–r seated: Madge Garland, R.D.Russell, R.W.Baker, Robert Goodden, Darwin, Richard Guyatt (far right). Standing: Rodrigo Moynihan, Frank Dobson

several architects (some of them to be put in charge of entirely unrelated design subjects) as well as a graphic designer, a textile designer, a journalist and three eminent fine artists. Each professor was totally responsible for employing the necessary team of tutors and technicians, and each was expected to continue private practice while teaching, thus creating a uniquely professional 'design office' environment in which the students could study.

The journalist was Madge Garland. The only female, the oldest of the new professors and a well-connected choice, she had been introduced to Darwin by his Camouflage colleague Victor Stiebel, and by Allan Walton, a close friend of hers who unexpectedly died the summer before he could take up his RCA post as Professor of Textiles. Madge had been fashion editor of British *Vogue* in the mid-1920s and again from 1932–1940, and had built up a social and professional *milieu* selected from the cream of high cultural and artistic life in London and Paris. While couture was her main passion, during Madge's time at *Vogue* she had become aware of the urgent need for change in the British ready-to-wear industry. In the early 1940s she took up a position as merchandise manager for a large London department store, and also became instrumental in the setting up of the Incorporated Society of London Fashion Designers. She became a dedicated campaigner for British textiles, acting as a consultant to several top textile manufacturers while also giving lectures on the industry and, in an early involvement with mass media, making radio and TV appearances. This high-profile exposure, along with reliable recommendations and, of course, Madge's chic and formidably elegant style, indicated clearly to Robin Darwin that here was the ideal candidate to head up what was, to him, the most curious conundrum in his grand project – the new school of fashion at the Royal College of Art. Alien as the subject was to him, he was much later to proclaim proudly (and perhaps not entirely truthfully) that the idea of the School was 'this child of my own little mind after looking at trade figures in 1945 at the CoID'.[3]

A challenging childhood

Madge McHarg was born in Melbourne, Australia, in 1896. Both her parents were children of Scottish immigrants, amongst the vast numbers of Britons who had migrated in the 1850s with the discovery of gold in the new state of Victoria. Madge's father, Andrew McHarg, worked in the garment business, rising from his early employment as a clerk to join his brother James as a partner in the successful business Brooks, McGlashan, McHarg, wholesalers of imported trimmings, fabrics and manufactured garments. In 1892 Andrew married Henrietta (Hettie) Aitken, daughter of a prosperous brewer and in 1898 the family, at that point comprising the parents, Madge's older brother Gerald and young Madge herself, moved to London to represent the company in Britain.

Hettie and Andrew were respectable and conventional, and the houses they lived in (beginning in North London and slowly progressing nearer to the fashionable West End, the pinnacle of Hettie's aspirations) were furnished in an expensive, bourgeois way and, in Madge's later view, completely devoid of any sign of personal taste.

However, Hettie did understand fashion, and she made it her business to accompany her husband on his frequent trips to Paris. She was always beautifully dressed and loved dancing, although most of the time she expected others to wait on her in order that she need not physically exert herself. As a child, Madge herself was dressed by a 'visiting dressmaker' in clothes that, while not the height of fashion, were made to fit if not to flatter. There was one childhood garment which in her view stood out from the others: the description of her 'exquisite pinafore [worn over a day dress] of white muslin edged with Valenciennes lace and insertions through which blue ribbons were threaded and bubbled up into bows on my shoulders'[4] is written with the same passion as that with which she would later appraise the collections of her favourite Paris couturiers.

Hettie was basically kind if rather remote, wrapped up in her appearance and rarely available to her children. The arrival of a baby brother and then a sister all but extinguished her interest in her older daughter. Madge later wrote a poignant, heartbreaking account of her love for her nursemaid May, who became more than a surrogate mother. 'She was my nurse-maid, young and affectionate ... She enveloped me in a warm cocoon of security...no harm could come to me if May was there ... she was my entire world'.[5] Then, suddenly, this world was shattered – May left the household to get married. Madge's notes recall that '... at 5 years old I was already conscious of the great gulf between my helpless condition and the limitless power of grown-ups.' Feeling abandoned and distraught, her description of her father was 'tyrannical'. He expected his growing daughter to live meekly in a home bare of culture – nothing to read, no interesting pictures to look at, few friends her own age, the parents frequently away. Madge, unsurprisingly, was often ill, but she loved her first school because she was encouraged to be inquisitive, to find answers to her many questions. However, when her parents decided to send her to Cheltenham Ladies' College she refused to go (on the grounds, true to future style, that she would run away rather than wear the unflattering uniform), unwittingly

Madge McHarg, c.1912

Fancy dress on the Pacific, 'made hat out of cardboard', c.1914

deleting her chances of being groomed there for Oxford or Cambridge. The chance return of a friend's wayward daughter, tamed and polished from a finishing school in Paris, provided inspiration for a solution to the problem, and Madge was escorted by her resigned and relieved parents into the happiest years in her life so far.

At Mademoiselle Laquerelle's International School the girls were vigilantly looked after but liberally educated. In addition to everyday lessons they saw major dramatic productions at the best theatres and the glamorous Opéra, and made regular visits to museums and historic buildings in and around Paris and as far afield as the Loire valley. Amongst a cosmopolitan group of girls Madge found her first real friends there. She learned to speak French fluently, and appreciated the chance to enter and understand a new world of culture and freedom of thought. When she returned to London at the age of eighteen, she found life even more stultifying than before. The only diversion from everyday boredom was the arrival of Ewart Garland, the son of close family friends in Melbourne, who was training to be an officer in the Royal Flying Corps. Madge and Ewart, similar in age, became close friends and she enjoyed his company as a handsome escort to the theatre, to dances and other London social events.

Madge was grudgingly allowed to enrol on a course in English Literature at Bedford College, a respected women's college situated in Regent's Park, and was determined that this would give her the chance of applying for an undergraduate place at Newnham College, Cambridge or St Hilda's in Oxford. But at this point her father dealt her the most crushing blow of all. He decided that, instead of fulfilling her lifetime dream and going to university, Madge was to accompany him, in spite of the danger of a wartime crossing, on an extended business trip to Melbourne. Madge, devastated and furious, had no choice: her mother was unprepared to go, and Madge was to be her substitute. Although on this trip she met the person who became her first real love, a young American socialite called Olguita Queeny who would reappear in her life from time to time, she never forgave the family for diverting her future plans. Once back in England after the war, she rebelled completely against her parents and her bourgeois background. Desperately looking for work, she left the house early each morning and methodically and persistently turned up at every office in Fleet Street until she found a lowly job at Rolls House Publishing in Chancery Lane, whose director William Wood was overseeing the publication of the new British edition of *Vogue*. It may have helped Madge that she had met the publisher Condé Nast himself through her glamorous American connections, and she dropped this fact into her interview; anyway, even a dogsbody situation was a foot on the ladder, and Madge was determined to climb.

Vogue and scandal

As soon as Andrew McHarg was aware that his daughter was working (and worse, working in the iniquitous environs of Fleet Street) he ordered her to stay at home. Madge refused, and in the summer of 1920, her financial support cut off, she found herself renting a shabby attic flat in a down-at-heel area, travelling to Chancery Lane

every day on the underground. She enrolled in night classes in typing at an institute in Balham, which offered cheaper training than schools in the West End. One of her advantages, though she had no money, was her appearance: her natural style was enhanced by a willowy model-girl figure, and the ready-to-wear clothing that she had acquired in America en route from Australia was still smart and new enough to impress. From office-girl she graduated to a receptionist's job, working all hours almost every day and often overnight too. Tirelessly driven, for reasons of ambition as much as of money, she worked her way up the *Vogue* ladder, becoming a secretary and eventually being elevated to the position of assistant to the editor. The English version of the magazine had up till then simply added photos of titled ladies and society events to the American issue's fashion pages, but under the well-connected Elspeth Champcommunal's direction, the magazine's glossy pages were now filled with images of what was going on in London's high-bohemian arts circle (with particular emphasis on the Bloomsbury group) and in avant-garde Paris, with a group of artists and designers led by the fashion designer Paul Poiret and his entourage. Champcommunal eventually left *Vogue* to set up her own couture business, and Madge, now working for editor Ruth Anderson, was enjoying the new social levels she had reached. Working overtime, eating very little and going out dancing once her long day was over, she became ill with jaundice. Her parents' dismissive attitude was 'we told you so' and, in an uncharacteristic moment of vulnerability, Madge telegraphed her faithful friend Ewart Garland and demanded that he marry her immediately.

Whether Ewart was overjoyed or not, his gallant and long-suffering spirit told him to obey Madge. The marriage was entirely on her terms – no grand ceremony for the disappointed parents (though they did approve of the groom), a pacifist minister, not even a change of name for Madge. It was only much later, when Gertrude Stein suggested to Madge that the name 'McHarg' held little magic in a world of arts and letters, that she took her by then estranged husband's name and became Madge Garland.

Poor Ewart. The union lasted two years. By then, Madge's affections had taken a different direction. She had fallen in love and moved in with Dorothy 'Dody' Todd, the Eton-cropped and strictly-tailored new editor of *Vogue*, whose personal mission was to enhance what Champcommunal had started and to represent fashion in a new and different way – as high culture, accompanied by images and words contributed by the arts élite of London (people like society photographer Cecil Beaton, writers Aldous Huxley, Edith Sitwell and Virginia Woolf, modish designers Edward McKnight Kauffer and Marion Dorn). Madge, by then appointed fashion editor, complemented this by passionately supporting *Vogue*'s original Parisian background, and the magazine's news of the French avant-garde, featuring such stars as Picasso, Matisse, Jean Cocteau, Gertrude Stein and Le Corbusier, went some way to satisfying the new British appetite for European culture and design.

Madge McHarg and Ewart Garland, c.1919

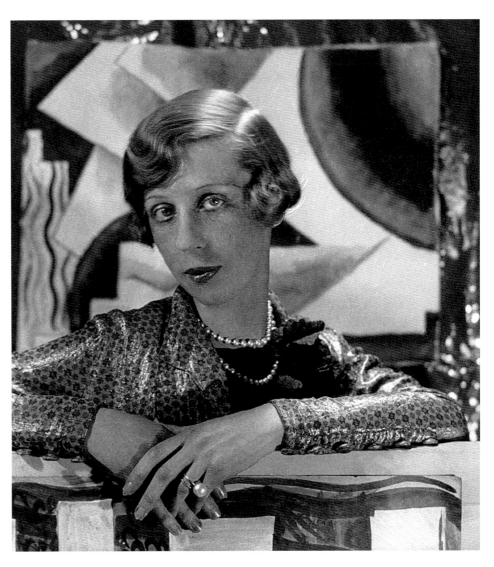

Madge Garland, portrait by Cecil Beaton, c.1926

Dody was a complicated character, and though she may not have been easy to live with she admired Madge's dedication to her work, her natural appreciation of modern style and contemporary art, and her individual point of view. They worked perfectly as a team, elevating the magazine's reputation and making it a cross-cultural monthly bible of elegance, style and aspiration. Madge, with her model's silhouette and her individual taste, became an influential example for her magazine's readers and a stylish companion for her racy male friends, who included Cecil Beaton and the designer Allan Walton, whose later influence on Madge's career would be so far-reaching. They played as hard as they worked, dining out and dancing all night; all this partying, in true 'roaring twenties' style, could have taken its toll, but Madge's self-imposed discipline meant that her work never suffered. It was the same strictly-controlled attitude that trained her to study and absorb in detail the couture collections she attended (where photography and sketching were forbidden), meaning that six weeks later when publication was allowed, she was able to give readers a fresh and clear idea of that season's styles.

In 1926 Dody was fired from *Vogue*, disgraced by 'financial irregularities' and, perhaps more, by stories of her unorthodox private life. She and Madge had never admitted publicly to being a couple (although, unlike male homosexuality, lesbianism was not illegal) but Madge was unfairly and ignominiously sacked soon afterwards. The dismissals shook Bloomsbury and caused much scandalous gossip in the mostly male world of journalism and publishing. Alison Settle, groomed to represent *Vogue* 'as its readership would expect' (which of course Madge's stylish and *soignée* appearance had been doing for several years) was made editor. It took Madge, now living with a broken woman, four years to clear the enormous debts that Dody had racked up, mostly to fuel her dependence on alcohol and very often in Madge's name. Heartbroken and betrayed, Madge moved away from what had been the most important relationship in her life – so special that, much later, she was to insist that her memory of it held absolutely no regrets. Madge's own notes give away little about the 'friend' with whom she shared her life, and the devastating end of the partnership.

After a sojourn in the south of France, barely finding work and living a penniless bohemian life, Madge returned to London where in 1929 she was eventually approached for a new job as women's editor of *Britannia and Eve*, the clumsy title for an ailing amalgamation of two very conventional British journals. She described it as 'a women's magazine devoted to fiction of a very dubious sort'. Over several years she managed to transform the publication into something with noticeable style. At the same time she became a freelance journalist

ABOVE Dody Todd, mid 1920s

LEFT Madge Garland, south of France, late 1920s

RIGHT Sailor-girl Madge, *Côte d'Azur*, late 1920s

for New York's slick garment-trade newspaper *Women's Wear Daily*. As a result of her flair, and no doubt because of her considerable connections, she was asked to contribute to the high-society columns of *The Bystander*, Fleet Street's upmarket gossip weekly. In 1932 she was headhunted by Condé Nast himself (on her own financial terms) to return to *Vogue* as fashion editor under Alison Settle. It was a different world: couture still reigned, but many houses also had a sideline, selling exclusive toiles and patterns to the growing ready-to-wear business. Fashion photography had largely taken over from drawn illustration, and Madge insisted *Vogue* had its own studio, with Cecil Beaton more often than not behind the cameras and his entourage of beautiful society girls frequently acting as models. She also headed up the London Fashion Group, formed to promote British couture by way of shows and press coverage. Madge's job at *Vogue* lasted until early in 1940 when she was again forced out for doubtful and probably personal reasons (one questionable excuse given was the magazine's 'excessively sprightly nature') by a new editor shipped in from America, the 'reliable' Betty Penrose,[6] who appeared to disapprove of everything Madge stood for. Madge, disappointed but defiant, cited the fall of Paris, the resulting closure of many of the French couture houses and the consequent lack of fashion news as the reason for leaving the magazine. It was ironical that Penrose was almost immediately ordered back to the US for the duration of the war, and assistant editor Audrey Withers was put in charge: she knew and approved of Madge, but was promoted too late to save Madge's situation.

Introduction to retail

In a climate of war and austerity, London's department stores were being forced to rethink their retail strategies to accommodate new patterns of buying and selling, and Madge was approached by the director of Bourne & Hollingsworth with the offer of a position as fashion merchandise manager. The store's staff was 'in great disarray'[7] as all the women's clothing buyers, mostly men, had been called up for military service. Reluctant at first, not having worked before in retail, Madge eventually agreed with Mr Bourne to accept a three-month trial period, and ended up staying for several years. Once she had settled in (helped along by the provision of her own elegant office, an efficient secretary and a more-than-generous annual bonus) she began to enjoy seeing clothing from a new point of view, getting to know the suppliers and their methods. She made seminal changes to the running of the department, working hard on the welfare and treatment of staff, and she installed a new sizing system based on the American model, with standard measurements to be used by all her suppliers. The wartime rationing of clothing was a challenge which she appreciated, promoting waste-free manufacturing in a restricted range of government-approved fabrics. The Incorporated Society of London Fashion Designers arrived as an offshoot of the London Fashion Group in 1942, and as well as working with it on the Utility Clothing Scheme, Madge took a critical interest in how the designers managed to produce their own collections in line with austerity regulations. In contrast to these British restrictions, the designers could have much more licence with their export ranges, where less limited yardage

At home in Shoreham, mid-1940s

and more lavish silhouettes allowed them the freedom to which they had been accustomed before war broke out.

Although Madge enjoyed her job at Bourne & Hollingsworth, her wartime experience was harrowing. She lost everything in 1944 when her beloved Shoreham cottage was badly blitzed by V1 bombs, the terrifying silent 'doodlebugs' heading for London. She was once again homeless, often unwell, and had to search for lodgings through various acquaintances, frequently finding herself moving from flat to empty, abandoned flat in the devastating debris that was central London. Stoical as ever, throughout the war she somehow managed to take only two days off from work. The store's business was badly affected by the relentless bombing, and when a worried Madge was asked by Miki Sekers, Hungarian owner of the West Cumberland Silk Mills, to act as his consultant, she gladly accepted his offer of work on a freelance basis. This was followed by additional contracts with further high-profile textile companies including ICI, whose pioneering work in synthetic fibres appealed to her practical, modern point of view.

During the war Madge had regularly read of developments in the American fashion trade, imagining it as 'a fairy land totally unlike a wartime England'.[8] In addition to

learning about the delights of easy-care fabric and the interest in clothing for sport and leisure, she was particularly struck by the idea of 'clothes for the young, actually designed by the young'. In 1945, on Madge's suggestion, the Board of Trade agreed to send her to the US in order to research ready-to-wear manufacturing and marketing. Bourne & Hollingsworth were happy to release her for three months and Mr Bourne generously agreed to pay all her expenses. Her wardrobe updated with the help of extra clothing coupons and in a beautiful black bespoke suit by Digby Morton, she made her escape from poor, grim, ruined London. She travelled across America via major industrial cities, visiting clothing and textile manufacturers from New York to Los Angeles, where the free-and-easy attitude to casual clothing fascinated her. Excited by her findings, Madge found her return to London very hard: the factories' reinstatement to the manufacture of civilian clothing was slow, there were extreme shortages of food and fuel, causing night blackouts to continue and not helped by the relentlessly freezing winter of 1947; people were ill with depression and malnutrition. But Madge, unwell herself, was tireless in her fight for home-produced textiles and properly designed clothing for the masses. The American trip was followed by a visit to France, even more deprived and destitute than London, where she visited Lyon to see the development of artificial silk (highly acclaimed, unexpectedly, by the somewhat snooty couture industry) and of course Paris where, irrepressible, the couturiers and milliners were once again making magical collections almost out of thin air.

The need for design

Around this time, the Council of Industrial Design was holding meetings concerning the marketing of textiles and fashion. The enormous popular success of the 1946 'Britain Can Make It' exhibition at the Victoria and Albert Museum had opened the public's impoverished eyes to the options of good design in everyday life, and the Council was keen to encourage the trades to open regional design centres for the purpose of promoting their products. A Cotton Centre already existed in modern-thinking Manchester, but even though IncSoc had held a successful fashion show in Leeds in 1946, the wool trade, true to form, was slow to follow, its leaders complacently stating that 'practically every manufacturer of worsted and woollen cloth' was already employing 'two or three and in some cases more' designers.[9] The International Wool Secretariat in London was already promoting the use of raw wool, and it was keen to get the respectable but staid British woollen mills interested in fashion shows and other relevant, up-to-date display and marketing ideas.

In May 1947, a Wool Design Centre in Yorkshire was still under discussion, and the idea of a Fashion Centre had been suggested, to be opened in London with a launch event at Selfridges. The CoID Second Annual Report (1946–47) mentions the setting up of working parties for 'Boots and Shoes', 'Dress and Fashion Accessories', and 'Clothing' – 'informal discussions have taken place about the possibility of a composite centre for all industries dealing with, or affected by, Fashion'. Madge Garland must have been delighted with her appointment to set up this prototype

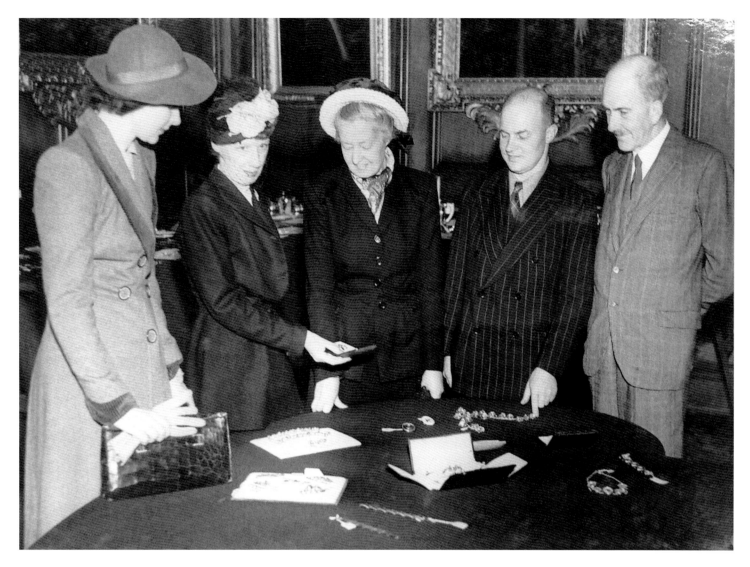

design centre for clothing and accessories. The opening date was set for November 1947 and to kick off, Madge was dispatched to her beloved Paris to buy samples of shoes, gloves, and underwear in order that British manufacturers could get a feel for Dior's New Look, and be able to improve their product by copying, with official permission, the meticulous French manufacturing methods.

However, the promising start went nowhere. The CoID's Third Annual Report (1947–48) makes no more mention of the Fashion Centre. It seems the main reason for rejecting the idea was that, bizarrely, both fashion and automobiles (also under discussion) were industries considered too fast-moving to warrant specialised promotional centres.[10] Reading between the lines this excuse is surely a cover-up for the disdainful British attitude to its fashion industry, and Madge, disappointed again, must surely have been sharply critical of the decision not to continue with the idea.

On finally leaving Bourne and Hollingsworth Madge, well-paid as a freelance consultant for a high-profile group of British textile companies, continued to travel

Selection committee for jewellery, *Britain Can Make It*, 1946. Second left, Madge Garland

Madge Garland, portrait by Paul Tanqueray, 1948

to the US to promote her clients' products and to bring back modern American ideas. Always confident in her appearance and her beliefs, she continued to make many broadcasts for the BBC. She also enjoyed giving regular lectures to the British textile and fashion trades, keeping them in touch with technical and design news. Relatively content with the path her career was taking, she must have been surprised when she received an invitation from Robin Darwin to consider taking on a unique position – the world's first chair of fashion, at the newly-revived Royal College of Art, whose mission statement for design students was that throughout their training they would be supported and sponsored by the industries they would enter on graduating. If at first Madge was uncertain about taking the job, the idea of the College's aspirations – to support creative art and design with the backing of technology and trade – would certainly have met with her wholehearted approval.

Chapter 3

Fashion's First Professor

The puzzling world of fashion was an environment unfamiliar to Robin Darwin, in spite of his natural appreciation of elegant design and his approving admiration of a well-dressed woman. Even with his contacts at the CoID he had encountered few people who were related to the business. Typical of his class and generation, if he had considered the subject at all it would have been as nothing more than a frivolity, a mysterious feminine enigma best not interfered with. During his short tenure at Newcastle School of Art he had involved himself little with the Textiles and Dress departments, leaving the existing staff in place to continue teaching their crafts in a style which was probably rooted more in an 'artistic' tradition of aesthetic dress than in modern design.

Darwin had, however, come across one or two professional fashion designers through his wartime work, notably the South African couturier Victor Stiebel who, like a number of fashion designers, had previously trained to be an architect – a profession much respected by Darwin and therefore a comforting factor to him in this unknown world. During the Second World War Stiebel had closed his very successful couture house but, while he was in a senior military post at the Eastern Command Camouflage School, he was also allowed as a member of IncSoc to continue designing, notably for the Utility clothing scheme. He later became involved in the design of uniforms for the female forces. It was while Darwin was secretary for the Directorate of Camouflage that they had met. Stiebel had known and often dressed Madge Garland since the 1930s when they were both immersed in the fashion, arts and entertainment circle so adored by *Vogue* and its readers. She had acted as an advisor for the Utility scheme, and when in 1947 Darwin consulted him as to whom he thought suitable for new post of Professor of Fashion, Stiebel's immediate response was that Madge would be ideal.

Another of Madge's well-connected friends was the painter and designer Allan Walton. She had first visited his Chelsea studio in the 1920s while arranging a photo-shoot for *Vogue* and had been captivated by his eclectic and exquisite style, his ability to assemble groups of disparate objects with a particular eye for colour and arrangement. Early in the 1930s, realising that appropriately-designed textiles were not widely available for his clients' clean white modernist interiors, Walton set up his own printed-textile company, using (as well as his own designs) the talents of artists Cedric Morris and Frank Dobson, and Bloomsbury painters including Vanessa Bell and Duncan Grant. Walton's unique interior schemes demonstrated his intuitive flair for mixing old and new, traditional and unexpected pieces to magically suit his

Dress by student Anne Watts, 1952

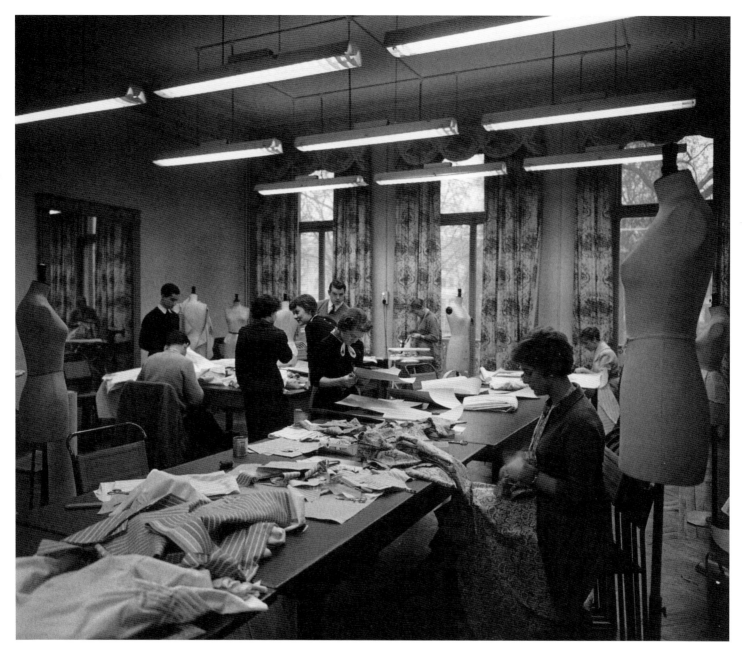

Fashion studio, Ennismore Gardens, early 1950s

clients' tastes. With his friend Marcel Boulestin, who had set up his own London studio using the latest textiles and wallpapers from Europe, Walton was a co-founder in the mid-1920s of Boulestin's eponymous and fashionable restaurant. It may be that Robin Darwin met him there, or more likely that they were introduced during Walton's tenure as director of Glasgow School of Art from 1943–45; recognising his talent, Darwin invited him in 1947 to head up the School of Textiles at the RCA and, once Walton had accepted, also asked him for suggestions for a professor of fashion. Like Stiebel, Walton was convinced that this would be the perfect job for Madge Garland. Tragically, he was never able to take up his post or to witness the opening of Madge's new School: in the summer of 1948, before the

College even opened its doors to its first students, the recurring ill-health that had beset him for several years caused his untimely and widely-regretted death.

The third person consulted by Darwin, and someone who could recognise Madge's skills from a professional point of view, was Audrey Withers, who had worked on *Vogue* throughout the 1930s and became assistant editor before replacing Betty Penrose as editor. Darwin knew Withers from her membership of the CoID and, with his limited knowledge of fashion, had a great respect for her opinion. While Madge was fashion editor, Withers as a young sub-editor had been able to observe Madge's meticulous style, her awareness of the equal importance of art and industry, and her unfailing dedication to her work. No doubt she was wholehearted in her recommendation of Madge as head of such an important new school.

Setting up the School

Madge's recent eye-opening visits to the US, where designers were creating a fresh new style for fashion, and her annoyance at much of the British industry's slow and curmudgeonly acceptance (some would call it complete unawareness) of design, must have made the proposition seem so exciting. To be professor of a royally-approved school for training home-grown fashion designers, backed by industry and using the best practitioners as tutors – what could be a more prestigious appointment, and a better boost for British business? With certain conditions Madge accepted Darwin's offer, to the universal approval and interest of the couture and ready-to-wear businesses, the manufacturing trade and the national press.

Before even starting to think about a curriculum, Madge made it her duty first to return to New York in order to visit Parsons School of Design, and to observe some of its teaching methods as a guide to setting up a British school. The main attraction there was the school's close links with the fashion trade, ensuring financial support as well as jobs for graduates, and one of the stipulations she set out to Darwin and the RCA Council was that her tutors should come from the British fashion business. This at first drew disapproving reactions from the Ministry of Education and some senior Council members, so Madge then set up the School's own committee of high-powered fashion-industry figures who would allow their own staff (few of whom had any kind of teaching experience) to act as part-time tutors. 'It was all very practical. I had absolutely no interference. Robin Darwin let me do what I wanted. I got the trade to serve on the committee and to give bursaries and do competitions and to take students for a period in the vacations to work in their businesses. I tried so hard to marry art and industry...'[1]

Once she was appointed professor, Madge took on the project of masterminding the restoration of the 'near-derelict house' in Ennismore Gardens, off Exhibition Road and not far from the V&A and the rest of the College, which was to become the home of the Fashion School. With her passion for interior design, this was a pleasure as well as a challenge for her: she enjoyed transforming the grand, elegantly proportioned rooms into working studios, albeit with her own touches such as full-length printed chintz curtains, with a motif of giant bouquets by Allan

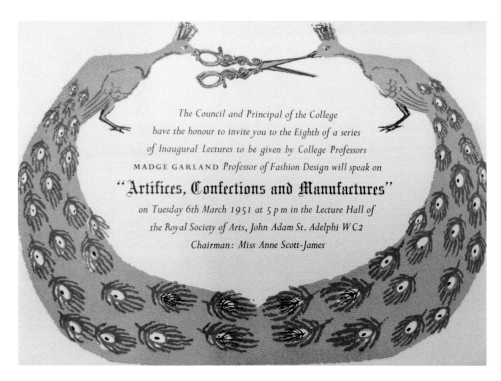

The Council and Principal of the College
have the honour to invite you to the Eighth of a series
of Inaugural Lectures to be given by College Professors
MADGE GARLAND *Professor of Fashion Design will speak on*
"Artifices, Confections and Manufactures"
on Tuesday 6th March 1951 at 5 p m in the Lecture Hall of
the Royal Society of Arts, John Adam St. Adelphi W C 2
Chairman : Miss Anne Scott-James

Invitation to Madge Garland's inaugural
lecture, 1951

Walton, for the fine windows of the big first-floor workroom. Madge's next priority was to think about staffing her school. Through Robin Darwin, she had met Janey Ironside whose husband, Christopher, had worked with Robin Darwin on 'The Designer and his Training'. Janey had her own private dressmaking business and had made 'one or two small things' for Madge, who approved of her style and offered her a job as assistant. Janey's account of her interview at Ennismore Gardens describes the formidable atmosphere. Madge was a terrifying presence, 'sitting at her desk immaculate in a tight-bodiced, full-skirted cotton dress from Horrockses – the most successful firm making mass-produced dresses at that time – wearing a large straw hat, dark glasses and short white gloves'.[2] The office itself was no less imposing. It was a huge space decorated in 'shrimp-pink and pale grey, with a yellow carpet',[3] floor-length pink velvet curtains at the enormous windows, original cornices and a grand fireplace with dramatically-lit alcoves decorated by RCA painting student Peter Rice, who would marry textile student Pat Albeck and himself become a distinguished theatre designer. Selected pieces from Madge's considerable art collection were hung on the walls (she had sat for Marie Laurencin in Paris in the 1920s, and a prettily-coloured Laurencin was amongst the pictures decorating the room), and the furniture consisted of carefully-chosen antique pieces with Madge's desk placed diagonally in front of one of the windows. She could often be found sitting here working with fabrics produced by her freelance clients, fulfilling Robin Darwin's stipulation that all his professors should teach by example and continue their own practice during college hours. Janey Ironside was impressed 'how sensually she adored colour and texture. She did all but eat her little samples'.[4]

The panel which Madge had insisted on setting up in order to involve 'the trade' in the running of the school consisted of 'two wholesalers, two couturiers, a

Students and tutors at Victor Stiebel's *salon*, 1953

representative of the fashion press'[5] as well as Robin Darwin and herself. In order to find appropriate teaching staff, several companies (starting with those of the panel members) were approached and asked if they could 'loan' specialist members of their staff teams for perhaps a half-day per week. So Digby Morton offered his head tailor Roger Brines; Berkertex supplied the services of Miss Irene Elfer who would explain the mysteries of mass-production; Wolsey's head designer came on board to instruct on jerseywear; and Dorville's senior cutter was released to teach pattern-cutting. This exchange of skills surely worked both ways: the students were eager to learn, absorbing all the information they could get about the ways of the fashion world, and it was refreshing for the professionals to be amongst them, listening to their ideas and being stimulated by the vibrant, exciting atmosphere of the School. To act as anchors, the two permanent members of staff in addition to Janey were the 'unflappable' Miss Morfey who was in charge of machinery and equipment as well as running the all-important stockroom; and, also invaluable, Madge's secretary, Miss Wright, whose job it was to organise the lives of both Professor and students in this complicated unit. A prestigious, occasional Official Visitor to the department was also appointed, in the person of Harry Yoxall, managing editor of British *Vogue*.

The first students

With staff in place, the next job, most important of all, was the recruitment of the students. The requirements were laid out in the prospectus: 'Students enter the College at 17 to 25 years of age, and the course takes 3 years. At the end of the course, in order to qualify for her [sic] Diploma, each student is expected to spend at least 6 months holding down a job in some branch of the fashion industry. Students do not live in, the fees at present are £45 a year, and [those] who do not live at home must have an adequate living allowance from their families'. It is surprising, when many of Madge's favourite couturiers and designer friends were men, that she appears to have expected applicants to be almost exclusively female. This is a comment on the 'feeder' schools and on industry, where almost all students and practitioners of the manufacture of dress at that time were young women.

Enquiries flooded in from individual students at home, or from abroad via embassies and the British Council. There were applicants from art schools and queries from industry about short courses. The target figure for the first year was ten, and the successful applicants made up a group consisting mainly of female students with a small number of males. It was not essential that they had already completed a fashion course elsewhere – Helen Jones (later Hamlyn), for example, applied and got a place directly from her general art-and-design foundation course – but they had to show more than a strong aptitude. In Madge's words 'The average first-term student has not the faintest idea of fashion. Probably she [sic] has not even seen one first-class dress in all her life. The first job is to get her eye in'.[6] In a further interview she stated 'Fashion designing is not merely a question of glamorous frocks . . . a love of dress is not enough. What this school looks for is interest in the mechanics of dress, clearness and swiftness of perception, memory, a mind capable of analysis, together with punctuality, application and hard common sense'. She laid particular emphasis on quick reaction, on being able to speedily translate ideas into working garment designs. A 'real love of beauty' will enhance all this, and a good student must 'distinguish between what they love themselves and what is fashion, something one cannot expect from any girl [sic], but which a good student must learn and apply'.[7]

In Madge's inaugural lecture as professor, she goes some way to explaining why fashion is important. Trying to understand and therefore eliminate the British prejudice towards fashion, she explains how the French have always looked on the Paris Collections with much the same attitude as they view an exhibition of fine art, applied art or technology – with respect and an educated interest. The Collections 'are considered as much a subject of intelligent and critical conversation as are any other exhibitions or shows of the moment'.[8] One of Madge's earliest students, who had spent time in France in her teenage years, was fascinated by the Continental importance of *haute couture* and by the high regard for a fashionable appearance, both for women and for men. She pointed out how in France 'if you were intelligent you were pretty, if unintelligent you were plain'[9] comparing this to the bluestocking culture of Britain where clever girls, far from being glamorous or attractive, would never dream of succumbing to the frivolity of fashion. Observing that all the other

schools in the RCA 'have behind them a body of literature, an accepted standard of criticism, a tradition which has accumulated over the years and which acts as a guide to Professors, teachers and students'[10] Madge was determined that the fashion students should be given an education that would provide them with the same status as students in other departments. She organised that they had weekly meetings with her to discuss fashion, art and culture. She also insisted that they wrote essays and discussed their work with their peers on other courses. To nurture that 'real love of beauty' insisted upon by the Professor, the fashion students attended drawing classes with the fine art students at the V&A, taught by tutors such as John Minton who was 'so involved in everything and loved the Fashion School'.[11] It is not clear whether the painting students willingly attended the fashion tea-parties to which Madge invited them on Friday afternoons, but perhaps the opportunity of meeting the most attractive and best turned-out girls and boys in College was part of the draw.

The School of Fashion's first curriculum covered all aspects of creating clothing and accessories, with lectures by 'experts in the numerous branches of fashion': designers, historians, journalists and beauty experts. There were frequent visits to workrooms and factories as well as to the Paris and London collections, so that the student could 'absorb the whole atmosphere of fashion'; lectures were given in textiles and 'contemporary design' and in business studies. Couturière Bianca Mosca and wholesale designer Olive O'Neill visited to discuss their differing fashion worlds; journalists such as Alison Settle, by now fashion editor at *The Observer*, held talks with question-and-answer sessions. The distinguished historian James Laver gave fortnightly lectures on costume in the V&A galleries; Valerie Hobson might come in to talk on designing for the theatre; and first-hand reports on the collections were given by Anne Scott-James, editor of *Harper's Bazaar*. In order to 'give the students that rare, indefinable but essential quality – sophistication'[12] it was necessary that they constantly saw what was going on at the theatre and in current exhibitions, and after these visits Madge would hold a 'conference' with them. The aim was 'to draw out creative abilities and teach them how to observe. They report on what they have seen, what trends they have noticed, which fashion shows, or fashion photographs, or window displays they have thought good or bad.'[13]

From time to time Madge would invite selected groups of students to her stylish and cultured dinner-parties (to the more timid amongst them, an awe-inspiring experience) so that they would get an idea of how to behave in London and international society. In Janey Ironside's words '. . . a glimpse into the great world of couture shows, first nights, private views and intellectual soirées' was what Madge wanted for the students, even if they only scratched the surface of this glamorous world. To sum it up, they were taking a degree not only in fashion but in the worldliness and *savoir-faire* essential, in Madge's exacting view, to the education of a designer.

Another of Madge's methods of teaching was by the example of her own soignée appearance. She was always immaculate and in Helen Hamlyn's description of her in

the early 1950s, with her couture suit, chic little hat, high heels and rolled umbrella from a special Paris supplier, she could look 'terrifying – like someone from a bygone age'. Photographs, often by Cecil Beaton, of Madge in the late 1940s show how her elegant figure lent itself so well to the graceful New Look silhouettes by her favourite Paris couturiers Balmain, Balenciaga and Schiaparelli (whose clothes, with her model dimensions, she would buy in sample sales) and the English houses of Michael, Digby Morton and of course Victor Stiebel. In the early days of the Fashion School, when fabrics were still rationed and the British style often quite restrained, Madge would appear in 'flowery hat and gloves and pearl choker, looking like the *Vogue* fashion editor she had been'.[14] To a certain extent, her clothes were her armour as she admitted later: '... hard work, increased financial security and a passionate interest in the world ... helped me present a reasonably confident appearance – a thin veneer with many cracks, many papered over by pretty clothes, but one which was adequate for all but my most percipient of friends'. As *Vogue* described the new professor in June 1949: 'She wears clothes with an easy authority and – less expected – infects them with a gaiety which is uncontrived, indefinable, but very much in character'. She was frighteningly chic, and although she was 'not over-strict' about what the students wore inside the College, would insist that the formality of a hat and white gloves were *de rigueur* for the girls at any public occasion.[15] Madge went to the alarming extent of meticulously inspecting their appearances before they set out, commenting on dress, hair and even make-up – an unlucky student could be sent home to change her outfit, a 'wrong' lipstick colour had to be corrected. The dress code was easier for the boys, for whom it was obligatory to wear a suit and tie (much as their fathers would wear to work) but tricky and often excruciating for the female students. When Bobby Hillson, then at St Martin's, was drawing at the V&A one day with a group of fellow students, 'this frightful looking woman' gestured a gloved hand in their direction and disparagingly pronounced 'they must be from St Martin's'. Bobby, friendly with RCA fashion students, heard from them how difficult and 'snobbish' Madge was about their appearance. Robert Buhler's severe 1952 portrait of Madge in pillbox hat and pearls was said later by Joanne Brogden to 'pin her down precisely'.

In College and off-duty, the students' individuality would emerge through the way they dressed themselves. To begin with, each year's group was quite small, and the majority of students were girls. They made all their own clothes and Helen Hamlyn describes her contemporaries as 'pretty outrageous'. Exiled at Ennismore Gardens most of the week, the social events in the College's junior common room in Queen's Gate brought out the true spirit of the fashion students, and a new outfit was made for every party. Pat Albeck, studying textiles at the time, remembered that 'in 1951 absolutely every fashion student [girls,

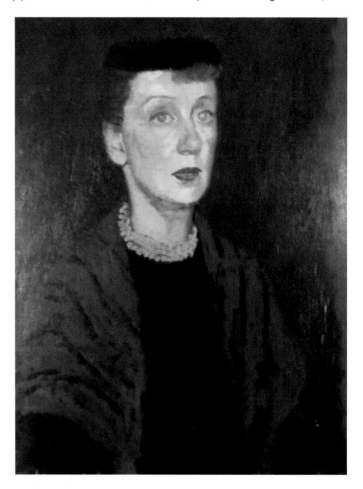

Robert Buhler's portrait of Madge Garland, 1952

anyway] wore a circular skirt in bright primary coloured felt, with plain black sweater over 'uplift' bra, red, green, royal blue, not yellow'.[16] Gerald McCann, one of only two boys in his year, felt that Madge grandly intended it 'like a finishing school', peopled with rich girls whose parents could afford to send them there. However, Janey Ironside has contrasting memories, from perhaps a slightly later time, that most of the students 'came from ... working-class backgrounds, and ... lived meagrely on Government grants', making it all the more difficult for them to stick to Madge's desired dress-code.

The 'white gloves' uniform had to be worn for outings from the college, and was particularly important for the seasonal visits to Paris which Madge arranged so that a selected small group of students could witness at first hand the *haute couture* collections. It must have been alarmingly difficult for the students to appear elegantly from the squalid youth-hostel where they were staying, while Janey (albeit in an attic room) and Madge were comfortably situated at the Hotel Crillon. They would all meet to attend those of the shows where they were allowed in. With Madge it was easy as she knew certain couturiers, but without her the *vendeuses* would do their best to belittle or ignore the College group. However, the shows they did see were a revelation, masterclasses in garment structure, finish and presentation, and every piece in the most luxurious fabric – an inspiration to both staff and students. The students grew to take these visits so seriously that they independently organised a course of 'Linguaphone' French lessons, held in the studios after the working day was over. The London press shows, both couture and

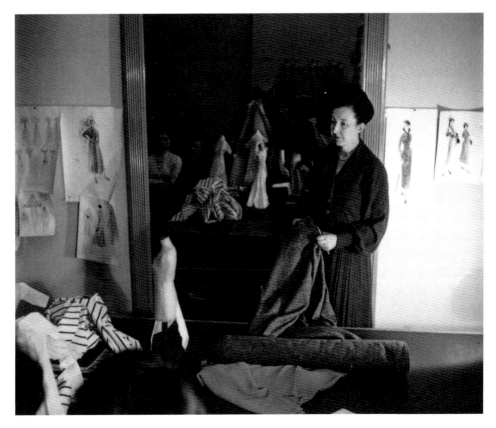

Garment construction class, 1949–50

top-end ready-to-wear, were less terrifying but still ultra-glamorous; as in today's front-row culture, the guests dressed up for the occasion with the top journals' fashion editors a lesson in themselves, each attempting to outdo the others in the most up-to-date style and elegance. After the shows the students were required to submit a written report to the Professor.

The school timetable was strictly organised. In order that the students could learn how to translate ideas into practical commercial possibilities, several methods of teaching were used. The visiting staff, depending on their skills, would teach them one-to-one (today an almost-obsolete way of working which, however, does its best to continue at the RCA) or in small groups, by demonstration. Tailoring was an important skill in achieving the formal, often almost sculptural shapes of the early 1950s, and Roger Brines' Monday-morning classes were invaluable in teaching the students about structure and fit. Softer shapes were developed via toile-making, sometimes from standard basic pattern-blocks but often beginning with the draping, pinning and cutting of a piece of fabric on the dress-stand, and this was taught on Monday afternoons by Marjorie Field-Rhodes. She also lectured on fashion theory, and on the arguably indefinable subject of 'taste'. Drawing and design projects would be set as homework, with the starting point a particular image or a fabric sample. On Tuesdays and Thursdays, when part-time tutors were not there, the students would work independently on whatever they were making, asking Janey or Miss Morfey, who helped with dressmaking techniques, for advice when necessary. On these days there were also life drawing classes and optional embroidery classes, and there might be an outing, arranged by Madge, to a show or an exhibition. Wednesdays alternated between James Laver's costume lectures, and classes in millinery and other fashion accessories. On Fridays, Berkertex's Miss Elfer

LEFT Millinery studio, 1952

RIGHT Moulding a hat with steam, 1952

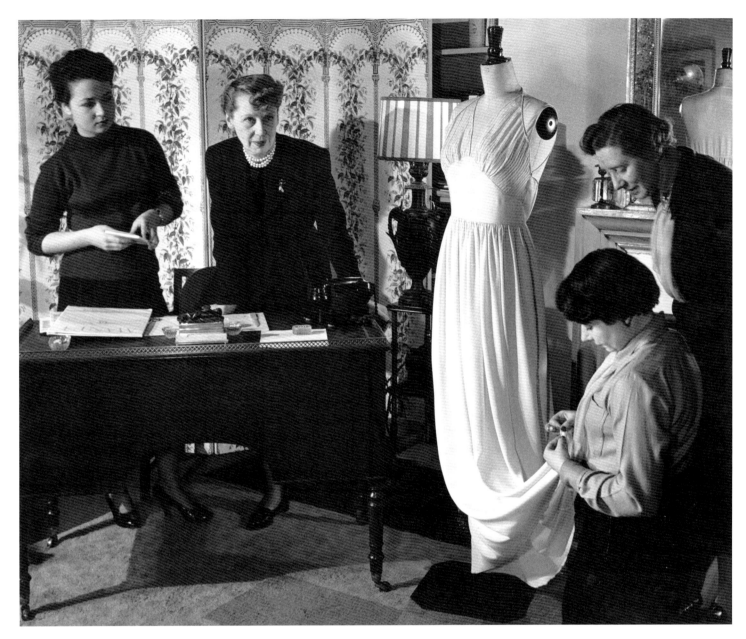

Dress fitting in Madge Garland's office, early 1950s

instructed the class in more commercial 'design within a price limit', starting in the first week with a drawing which would then progress week by week, from the creating of a pattern to a fully-finished garment. The students were also required to attend on Saturday mornings when Dorville's head cutter would be released to work with them on a design selected by the professor, from a brief which would teach them as many techniques as possible: for example, a dress with 'slightly full skirt, not gored or pleated, set-in sleeves, collar, pockets, cuffs'.

Although Madge's staff all came from the trade and she eagerly accepted generous gifts to the school of fabric from various textile manufacturers, she did not allow industrial projects and (seemingly very unfairly) discouraged students from doing commercial work, even though the main and obvious reason was the need to

supplement their government grants. Bernard Nevill, a fashion student in 1952/3, was asked to leave the School because he took on a contract as costume designer for the film 'Genevieve'. Students were allowed to enter competitions, often with money prizes, and *Vogue* set up a scholarship which offered 6 months employment at £6 per week for a student graduating in 1951. Exhibitions of work were encouraged, and the close links with the V&A meant that the students were sometimes asked for clothes to be included in special displays at the museum. Helen Hamlyn remembers a 'faded pink linen faggotted top and gored skirt' she made for an exhibition, and her tears at Madge's disparaging criticism when she turned it inside out: '…you haven't neatened the seams'. Nothing escaped the Professor's censorious eye, the painstaking concern with quality and finish which she forced upon her students – and from the discipline of which, later, they would benefit as they progressed upwards in the fashion world.

Once a year the more senior students would be sent on a work placement, usually in the summer between second and third year of study. This could be any length from several weeks up to three months (if it was considered the student could be away from College for that length of time). *The Sunday Times*, reporting on the end-of-year show in July 1950, records that during the holidays, students are 'encouraged to take jobs in workrooms to get practical experience' and companies such as Dorville and Jaeger were keen to have student input. Helen Hamlyn recalls that Madge sent her on a six-month placement to the Alexon company which was run by the three Steinberg brothers from a dilapidated workshop in what were then the depressing slums of London's East End. Helen, employed as a junior designer, asked if she could make her own toiles. When she asked why she was not allowed to do this she was severely told that it was someone else's job. Discouraged, she telephoned Madge Garland to say how unhappy she was with the arrangement but Madge, strict as ever and unsympathetic, insisted that she stayed. Helen managed four-and-a-half months (during which, even if reluctantly, she must have learned much about the workings of the system) before she was finally able to leave.

The Dress Show

The first end-of-year 'Dress Show' was held in what had been the enormous drawing room at Ennismore Gardens. The models walked to and from a large gilt mirror at the back of the room, between rows of guests who were mainly Madge's fashion acquaintances and friends, with the addition of Robin Darwin, members of Council and any staff who were interested. The first show was a great success and the College's Annual Report for 1948–49 records 'great publicity' from the press and numerous enquiries from prospective students. The following year, the School put on an extra showing by popular demand, beginning a trend which would later see the RCA show being the most talked-about summer event on the London fashion calendar. Janey Ironside's memoirs record that at this 1950 show she read the commentary for each outfit. She and her small daughter Virginia were dressed in 'blue and white Sekers' nylon dresses designed and made by a student'. Towards the finale, Virginia 'was propelled through the door and walked across to me very shyly

Madge Garland, early 1950s, in a suit closely resembling the Victor Stiebel design on page 39

…then together, to the expected clapping and isn't-she-adorable-ing, we walked up the room and down again…I cannot imagine how we managed it without dying of embarrassment.' As a result of this show there was an increase in job offers for the first cohort of students who would graduate the following year. The models, who also showed in couture and ready-to-wear shows, were delighted to wear such fresh, exciting, new designs and were first in the queue when the garments were finally sold at the end of the year, to create funds for the next year's show.

The following years saw the reputation of the School growing and consolidating. With the ready-to-wear trade now on its feet again, industry was taking a keen interest, and a new committee of 'merchandising experts and manufacturers' was set up in order to discuss the curriculum from the point of view of prospective employers. As a result of this, a post for a full-time pattern-cutting tutor was created, a much-needed advantage for the students. Other changes, too, were taking place. Janey Ironside, perhaps feeling that the students were now in capable professional hands, relinquished her job in 1951 after two years as Madge's assistant. It is unclear whether Madge replaced her; a substitute with Janey's inspirational yet pragmatic approach would have been hard to find, and her intuitive modern outlook, a foil to Madge's refined *couture* point of view, must have been enormously missed by the staff and students.

The School, even without Janey's presence, now had a smoothly-operating staff team, regular contact with industry, and an unlimited supply of sponsors and supporters. Respected companies such as Horrockses, Kayser Bondor (underwear and nightwear) and the French star milliner Renée Pavy, offered work placements, and many businesses were disappointed when all the graduating students were already spoken for with employment offers. There was a call for a wider recruitment drive to achieve higher numbers and more diversity amongst the applicants. The Official Visitors were also invited with an eye on differing specialisms – Harry Yoxall was replaced by Digby Morton, with his longstanding expertise in the world of *haute couture*, and when he stepped down in 1952 his place was taken by Frederick Starke, chairman of the London Model House Group and more in tune with mass production. At this point in the 1950s, couture remained important in its own right, and also acted as inspiration for the burgeoning ready-to-wear business. The RCA was doing its best to provide the industry with a fresh supply of young British designers who, while aware of what was going on in Paris and Florence, had a new and individual point of view. As the decade advanced towards the 60s, London fashion, its design fuelled to a great extent by the College, would be what everyone wanted.

The first half of the 50s saw the School working regularly with high-profile fashion and textile companies. Jaeger was a pioneer in setting up a five-year scholarship where the winning student would travel 'preferably to New York', to work in Jaeger's office there. The yearly course fees had risen to £62, and Bianca Mosca offered an annual award for a second-year student, the first one being won by 'Miss Joan Brogden'. The second of these bursaries was won in 1953 by Olga Calnan, who was sent to work unpaid for a year in the workshops of Christian Dior in Paris. This

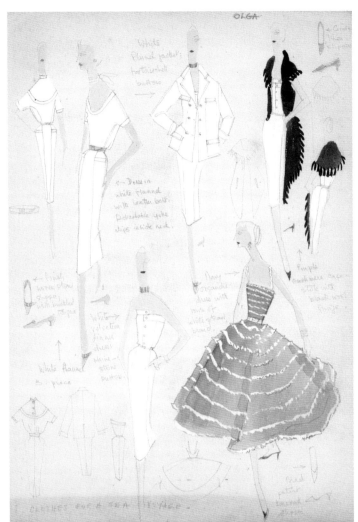

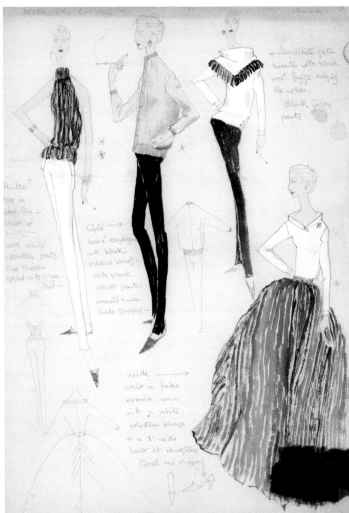

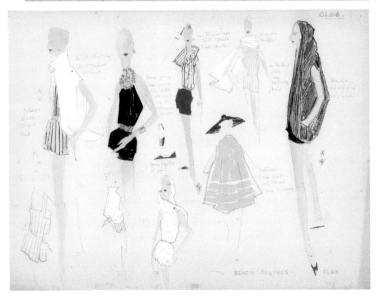

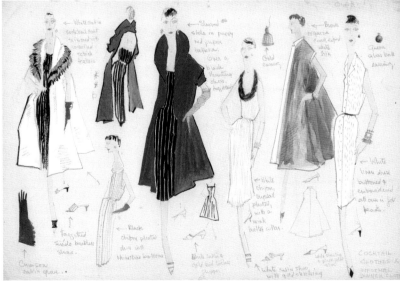

Eileen Blenheim's graduation display, 1951

experience taught her not only about how the recherché world of couture worked, but also about the importance of food and cooking to Gallic culture: lodging in the attic of a house filled with Dior seamstresses, it was impossible not to be aware of their inbred knowledge of French cuisine. Back at the College, the students worked closely with textile manufacturers Courtaulds, ICI and Sekers who supplied the latest developments in their new synthetic or natural fabrics. In 1953, a shoe design course was introduced, with lecturers and facilities supplied by Dolcis, the most fashion-aware of the high-street footwear retailers. The same year, student Gerald McCann furthered international connections by selling designs to giant American stores B. Altman and I.Magnin. McCann, in a prelude to the creation of his own successful label, secured a job at Marks & Spencer and Joan Brogden at Susan Small. Other graduate employers were Jaeger, Dorville's knitwear division, Kayser Bondor and Rhona Roy, who produced an own-label collection as well as supplying the multiple stores. Manufacturers, keen to secure young designers, had begun to approach the school several months before the Dress Show, and this helped in the training and placing of students in appropriate jobs. The 1953 Show was itself televised by the BBC, beginning a link with mass media which was to flourish dramatically as the School developed.

In the next few years, international relations began to take hold, particularly in Europe (or 'the Continent' as it was labelled in the 50s). The terrifying Paris visits of the school's early years had become respectable, the College's reputation securing cooperation and sometimes even encouragement from Paris's haughty *Chambre*

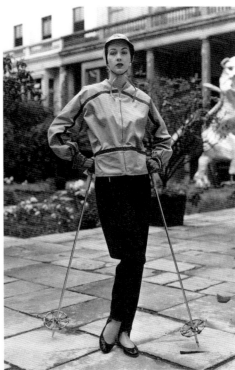
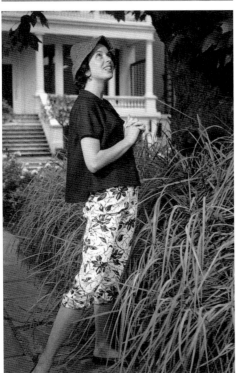
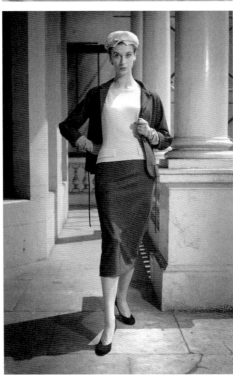
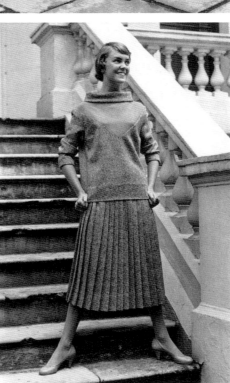

Post-war formality to mid-50s casual: student designs (l–r, top to bottom) by Kenneth Burgess 1951, Helen Jones 1952, Sonia Townsend 1953, Sheila Bevan 1953, Barbara Gambie 1955, Juliet Grimes 1956

Syndicale de la Haute Couture. Jaeger's scholarship had grown into a ten-day visit to Italy for four students, taking in the cultural delights of Siena and, the students' highlight, the Italian collections in Florence. From 1954 the Bianca Mosca scholarship became part of the Royal Society of Arts Bursary Awards, an annual competition open to all British design students. Winners were required to use the awards for international travel in the interests of furthering their studies, and to present a report afterwards. First-year RCA student Hilary Huckstepp won the first Fashion award, thus beginning a tradition of successful RCA entries. In later years and after almost too many RCA triumphs, the Bursary was more democratically confined to undergraduate students only.

A surprising marriage

In April 1952 Madge accomplished something that surprised even the *avant garde* world of art and design. At the age of 55, she married her homosexual friend Sir Leigh Ashton, director of the Victoria and Albert Museum. Ashton had worked there since 1922, beginning as an Assistant Keeper and working his way up in several departments until, after wartime service in the Ministry of Information and in the British Embassy in Ankara, he returned as Director in 1945. He had an amiable personality, and was easily-approachable with an empathy for younger members of staff. He had the qualities of 'a connoisseur and an impresario' and a particular flair for design and presentation.

Instrumental in housing the groundbreaking and hugely popular 'Britain Can Make It' exhibition in 1946, which was masterminded by the CoID and funded by the Board of Trade, in the museum's galleries (emptied of their exhibits for the duration of the war), he became known afterwards for his revolutionary reorganisation of the V&A's historical displays. Instead of grouping exhibits chronologically by type, as had been the accepted habit in the majority of museums, he created displays in which furnishings and artefacts from a particular period were shown together in imaginative display – accused by some as 'too tasteful' – and the museum's attendance figures multiplied.

Madge had known Ashton since the 1920s. They had frequently acted as companions to one another at the numerous prestigious social occasions to which they were both invited, and when she became professor the College's alliance with the V&A meant that their worlds grew even closer. Their astonished friends, and of course the press, outwardly found the idea ridiculous, but many of them must have understood that there was at least one strong underlying reason. In Madge's position she may have decided for various personal reasons that it was impossible to live with a female lover, and for Ashton a chic and successful wife could act as a screen for his considerably active private liaisons. In the 1950s (and up until 1967) homosexual acts between men were illegal, and vicious prosecutions were regularly made; a marriage, albeit of convenience, would be the perfect, respectable decoy.

Madge herself may well have had ulterior motives. As Director of the V&A, Ashton had received his knighthood in 1948 and it is easy to surmise that the idea of a title

would have had huge appeal to Madge, with her grand ways and her interest in elevated society. There was one big problem. Ashton had long been a committed drinker, and shortly before the marriage Madge had tried to call it off as a result of yet another of his dramatic public collapses. However, the wedding went ahead at Caxton Hall, Madge (admitting not quite truthfully to the Press that she was 'in her forties') wearing a short jacket of grey Indian lamb and a chic little hat covered in flowers. Her slingback shoes had daring cutaway wedge heels, in the view of one of the fashion journalists 'shaped like the stern of a yacht'. Whatever the reasons for the marriage, within two years Madge (at heart affectionate for Ashton, but fearful of a repeat of the devastating Dody experience) had thrown him out of her house in Priory Walk. They were once again living separate lives, his to take the form of a lengthy downward decline after his resignation from the museum in 1955. They were officially divorced in 1962, but Lady Ashton (remaining Madge Garland for professional purposes) retained her title for the rest of her long life. In an odd reprise of the aftermath of her first marriage, a former husband's name was once again used to her advantage.

Job completed

The middle years of the 1950s saw changes happening in the School of Fashion. The post-war climate of austerity was gradually decreasing, the rationing of food finally ended in 1954, and a new national optimism was appearing. Madge's young graduates were beginning to change the perception of British fashion, introducing a bold modern look to both *couture* and mass-produced clothing, and it seems that she may have felt that her job was done, that, along with the rest of Robin Darwin's charismatic group of professors, she had set up a new system of educating designers and that it was time for her to move on. She had always enjoyed researching and writing, and a note dated 28 November 1955 records that she was 'working very hard – 2 consultancies as well as RCA, and a book to write'.[17] She was delighted to have been commissioned by Weidenfeld & Nicolson for a volume to be titled *The Changing Face of Beauty*, and was looking forward to starting work on it.

There are differing versions of Madge's reason for leaving the College. Janey Ironside's memoir, published in 1973, simply states that Darwin told her '… we disagreed. She threatened to resign and I accepted her resignation'. At that time, Janey and Christopher often saw Darwin socially, and it seems that Darwin was hatching plans to see much more of Janey, both in professional life and privately too. Whether there was a quarrel or not (and disagreements were certainly not rare in Darwin's relationships with his staff, particularly the less malleable ones) Madge decided to go, but a warmly worded letter from Darwin, albeit after the event, shows his appreciation for everything she did and how proud he was of her achievements. Madge herself stated 'I wish to make clear that the decision to leave the Fashion School was for personal reasons and entirely my own wish. The Principal and Council offered me a renewal of my appointment, which I refused'.[18] Much later, on the death of Darwin in 1974, Madge (in India at the time) sent a four-page letter of condolence to his widow, Ginette, in which she went to great lengths to set the record straight.

She relates that on hearing the sad news, she desperately wanted 'to correct the statement made by Janey Ironside in her book'. She continues that 'Robin wrote me a long & affectionate letter about this, deploring her inaccurate version of my leaving the College … I left the College on the best possible terms with Robin with whom I always remained affectionately involved – & I truly left because of advancing age and declining health. Robin had asked me to sign a contract for a further five years & when I pointed out that this would take me far beyond the usual retiring age, he replied that as far as he was concerned I could stay on as long as I liked. It was a difficult decision to make & it was with great regret that I left the College & I look back on my years there with Robin as the happiest & most rewarding of my long working life. I felt that Robin would like the record put right, so I wrote this to *The Times* & do hope it was published for I think (and so did Robin) that Janey's book does a great dis-service to us both'.[19]

The reign of the College's *grand dame* was almost over. In the summer term of 1956 she put on her final dress show as Professor of Fashion, in the College's Senior Common Room at 21 Cromwell Road. Televised once more by the BBC, it was a grander affair than usual (the College's first 'full-scale fashion parade' according to

LEFT Dress Show invitation, 1954

RIGHT Dress Show invitation, 1955

the press) in the presence of guest of honour HM Queen Elizabeth the Queen Mother, to whom the models all dropped a curtsy as they passed. The press reported that the graduating students showed daywear of a lighthearted nature: playsuits, hooded jackets and striped pullovers with matching stockings, contrasting with more serious empire-line 'town and dance dresses'. In Robin Darwin's address to the royal guest, he paid tribute to the work Madge had done to build up the first post-graduate course in fashion over the eight years of the school's existence. The classes had now grown to a limit of thirty places, and it was the Fashion School's proud boast that every student with an RCA diploma found a job in industry. In the opinion of at least one journalist, the show demonstrated that the professor, while running a rigorous curriculum, encouraged (or 'allowed') freedom of experiment, so that 'the result is the emergence, in varying degrees of proficiency, of twenty personalities, instead of twenty reflections of Mrs Garland's personal, powerful and professional taste'.

It was time for the first professor of fashion to move on. Her notebooks reveal that she was an avid reader, obsessively catching up on what she had missed in earlier life. She loved travel and was now able to visit the South Pacific, India and many other exotic destinations. Notes made on a trip to South Africa and Madagascar, possibly on a commission to investigate manufacture of cotton, give joyful and vivid descriptions of places she visited:

> 'Queen's palace overlooks whole town ... several pavilions ... huge hall – brilliant Douanier Rousseau or Gauguin walls of gorgeous plant forms on flaming ground. Friezes of figures recall Ethiopian paintings? ... orange walls & huge dark brown & cream flower forms – below a blue dado urns, doves, shrubs ... floor of black wood inlaid *palisandre* [rosewood] (light yellow) stars in corners ...'

> 'Men's costume of knee-length shirt (striped) full from yoke ... lamba over. Fringed rakish straw hats. Women dull – lambas in white.'

Madge's passion for travel was balanced by her flair for making a beautiful home wherever she chose to live. Each of her series of homes (after the war, always at quite salubrious London addresses including Park Street, Mayfair; Clarendon Road, in a house designed by her architectural idol Halsey Ricardo, and Melbury Road, both close to Holland Park) displayed her easy ability to create a comfortable, welcoming environment without compromising a scrap of her innate elegance. She wrote regular articles on fashion, architecture and travel for *Vogue*, *The Spectator*, *Apollo* and *Country Life* throughout the sixties, and during the following years also authored several books. In 1962 she produced *Fashion – a picture guide to its Creators and Creations* which was a 'handbook' to the business, written with Madge's sharp wit, tongue-in-cheek and easily readable style. It was observantly narrated at the critical time when fashion was changing so radically with the arrival of 'swinging London' and the introduction of boutique shopping. Although Madge may not have been hugely sympathetic with this shift in style, she wrote with an informed understanding of the sociology of fashion. Her next book was *The Indecisive Decade – the world of fashion and entertainment in the Thirties*. This was a dream subject for

Dress show models backstage. Left: dress by Olga Calnan, print by Pat Albeck, *c.*1955

Madge, who had been involved with so many protagonists of British and European culture in the early decades of the century, particularly after the First World War. The acknowledgements and index are a roll-call of glamorous and often aristocratic figures from the highest echelons of British art and design, society and entertainment, whom she had met during her years at *Vogue*. Madge's intuition and passion helped her to champion designers who later became household names. The book is an erudite, first-hand commentary of the reaction against the controlled minimalism of the Modernists in the 1920s (who themselves were much less puritan in spirit than their 'convent-like rooms of the late 20s' would suggest). Her account is painstaking and accurate, while written with an entertaining lightness of touch.

The Changing Face of Beauty was followed in 1970 by *The Changing Form of Fashion* and in 1973 by a book on her other passion, gardening. *The Small Garden in the City* questions ideas of what a garden is and what it means to most people. It concentrates on the options available in a restricted area enclosed within four walls, and also analyses the reasons for differing fashions in gardens – much the same as those in clothing. 1975 saw the publication of *A History of Fashion*, an opulent publication for which Madge provided the second half, 'Fashion's Past 100 Years', lavishly illustrated with contemporary paintings, drawings and photos. Much of the text is borrowed from *The Changing Form of Fashion*. In the same year Madge also provided the introduction to the catalogue for a Scottish Arts Council exhibition, *Fashion 1930–39*, which explored the relationship between fashion, art, and the decorative arts.

Madge's uncompromising determination had assisted her in forming a school whose targets of excellence and individuality she had thoroughly met; a school which, building on the foundations she had laid, would continue growing to world-wide acclaim. Her life was long and much later, in her eighties, she said that she had been less interested in fashion than in having a financially-rewarding career, but her obvious passion for her subject paved the path for a new generation of British-trained designers. The quote from France's 17th-century lady of letters, Madame de Sevigné, which Madge used to conclude her professorial lecture in 1951, is a simple explanation of her dedication:

'*Dieu, comme j'aime la mode*'.

Chapter 4

Janey's Journey

Janey, oil portrait by Christopher Ironside, late 1940s

On whatever terms Madge Garland's contract as Professor had ended, Janey Ironside's succession appears to have been a smooth and seamless transition artfully arranged by Robin Darwin. He wrote later that, though the 'brilliant and electric' Janey had national recognition as a children's wear designer her private business appeared to be faltering, and that 'when Madge resigned I immediately brought Janey back as Professor in the face of a strong anti-campaign from Madge'.[1] Whether or not the last statement is true, Janey was installed as soon as feasibly possible and perhaps a bit more quickly than decency should have allowed.

Janey's own record of the story differs slightly. Busy with her collection, she was 'incredulous'[2] when Darwin asked if she would be prepared to take over, and not at all confident that she had sufficient expertise. Since 1951, after her two years at the College as Madge's assistant, she had built up a respectable business and had also been more able to spend time with her daughter Virginia, now approaching her teens. Janey's husband Christopher, who had worked so closely with Darwin in Camouflage and then at the CoID, had reservations about the offer but understood its prestige and knew better than to oppose the suggestion. So in 1956 Janey Ironside began her unforgettable reign, leading the fashion school towards the intoxicating decade in which the RCA and its students would become world-famous for their unique brand of British creativity.

An Indian upbringing

Like Madge Garland's, Janey's early background was a colonial one, but there were few other similarities. She was born in India at the end of 1917, the first child of Violet and James Acheson. Her earliest home, as daughter of the governor of the Agra gaol, was in a residence on the site of the prison, and most of the family servants (including several personally allocated to the tiny Janey) were ex-convicts. Acheson was knighted for the distinguished service he gave to his subsequent post as Deputy Foreign Secretary in New Delhi, and Violet, a powerful leader as well as a domestic and loving mother, became Chief Commissioner of the All-India Girl Guides. Remarkably for that time, many of her female relatives on her father's side were successful professionals (doctors, a headmistress, a mathematician and a

Portrait of Janey Ironside, 1948

successful sculptress amongst them) and her feminist interests also led to her position as Chairman of the Srinagar Women's Voluntary Service. She was awarded the Kaisar-i-Hind Gold Medal for her outstanding record of public service.

Until the age of twelve, Janey, with her two brothers and her sister, led a serene and secure life in a Lutyens-designed bungalow on the very edge of the city. Much of the first chapter of Janey's autobiography indicates her early interest in clothes. As well as recording memories of her own dress, she was always aware of what others were wearing, in particular the rickshaw men whose brown cotton tunics and shorts were covered with matching hooded mackintosh capes in the rainy season. Their feet were always bare to grip the unmade road. There are detailed descriptions of what Janey herself wore. Being English, with a strict and elderly nanny, she was made to wear a 'sensible' everyday outfit of a smock in fine unbleached linen over matching knee-length knickers, both embroidered in red. Quite unsuitable for a child in such a hot climate, the Edwardian style of this cumbersome outfit was stuffy and old-fashioned. Her nightwear, also hand-made by convent girls, was more fitting for the heat – silk crepe pyjamas beautifully embroidered with flowers. Fancy-dress parties and annual displays of dancing, when one could dress up in much more extrovert clothing, were therefore a highlight, and the detail with which Janey describes her costumes makes it clear what a relief it was to escape the scratchy Chilprufe combinations and to dress up in shining silk and sateen. Her two favourite party dresses are clear in her memory. The first was in yellow moiré silk with a fitted bodice crossed with brown velvet ribbons each ending in a bunch of artificial flowers, and a full skirt; to go with this there were brown lizard shoes with one-inch heels (agony after the everyday sandals). The other dress was in Janey's favourite colour, pink shot taffeta, with a round neck, short sleeves to conceal the ubiquitous

vest, and a flounced skirt from the hip (albeit cut a little too long in order to cover the essential knee-length knickers). There is also a photo of the young Janey wearing traditional local dress. Her clear description of the colours again pinpoints her interest in textile and garment – indigo, embroidered in scarlet, emerald, yellow and orange, and beautiful pale leather shoes with pink silk pompoms on their turned-up toes.

At the age of twelve, Janey experienced the huge shock of moving back from her secure and privileged life in India to England, where she was sent to live with her maternal grandparents in the village of Fleet in Hampshire ('a kind of Anglo-Indian living graveyard').[3] Much against her will she became a boarder at St Swithun's school in Winchester, which she tolerated but did not enjoy. Like most girls of her age she detested having to wear the English school uniform of unflattering serge gym-tunic, blazer and felt hat, and in Janey's diary of the time there are detailed comments about the way other girls styled their outfits (for better or worse). Holidays were spent with her sister and her female cousins under the relentlessly strict eye of her grandmother, 'Madre', while her luckier brothers stayed happily nearby with their schoolfriends.

When Janey was fifteen, her parents decided that she should return to India (where her father was now Deputy Commissioner in Peshawar) for six months, a blissful interlude of intense social activity. Home was a large bungalow situated in the cantonment on the western side of Peshawar, looking on to the immaculate cricket ground with a view of the Khyber hills 'looming darkly in the distance'. The highlight of this period was learning to ride and, together with her 17-year-old friend Andrew who was also there with his parents 'finding out what he wanted to do', accompanying her parents on horseback while they visited the people of remote villages and explored deserted monasteries and abandoned settlements. At the end of these exciting days, a luxurious welcome was always waiting in an overnight camp set up by the cook and servants, who had gone ahead to prepare hot baths, a delicious dinner and blissfully comfortable sleeping arrangements all in a series of civilised canvas tents.

The six months was over all too soon. Janey was enrolled at a French finishing school in Tours. She enjoyed the sea crossing where she became quite tanned (having always been told to shelter from the sun in India), and with her dark fringe and bobbed hair she had an attractive gamine style. The next three months, spent in the company of an international group of girls, were educational and great fun. Janey's clothes, designed by herself and made up by an Indian tailor, were much admired and it must have been at this point that she discovered her talent for fashion. She also developed a love for French history, culture, and cuisine, a passion which was to last all her life.

By the time Janey left Tours, the family (her mother when she was not in India, her brothers and sister and her cousins) had moved with Madre to a large, rambling Georgian house in Winchester. Janey's chief pleasure, when she was allowed to go shopping in London, was to window-shop at such stores as Peter Robinson, Marshall

Pencil self-portrait by Janey Ironside, 1934

& Snelgrove and D H Evans. She had a knack for finding inexpensive dresses in a sale or a cut-price store, and a skill for transforming them. When she had finished, the pale yellow rayon with black spots or the black lamé evening dress would appear double the original price and Janey would receive many compliments. She also loved visiting the fabric department at John Lewis but could rarely afford the luscious silks and velvets, turning away with tears in her eyes when she saw the price per yard.

On one of her father's summer visits to England, he arranged a party to which he invited all his London friends. The society portrait painter T C Dugdale was one of the guests, and when he was introduced to the seventeen-year-old Janey, who was wearing a romantic rose-printed dress with her French high heels and a white straw hat, he was impressed by her beauty and announced that he 'must' paint her portrait. Janey was thrilled, both to be described as 'beautiful' (a comment that Madre was quick to refute in the interests of discouraging vanity) and at being asked to be the artist's model. She couldn't wait. Finally, in the autumn, an invitation came and Janey, after spending a night in her sculptress aunt's studio, made her way to her first sitting at Dugdale's luxurious Chelsea studio.

Dugdale was professional and friendly, always treating the sitter with respect and encouraging her to view the painting's progress. This experience must have introduced Janey to the studio atmosphere which she was later to find so agreeable, and Dugdale's amiable gossip about the London *beau monde*, art, travel and politics must have alerted Janey's sensibilities to a desirable new world, recherché, exciting and very inviting.

At the age of eighteen, in 1936, Janey made a last trip to India with her mother, joining the 'fishing fleet' of girls being sent to find husbands amongst the hundreds of young ex-pat Englishmen employed in the British Raj. Before leaving England she was allowed to select a new wardrobe of glamorous evening dresses, some from the cheap 'guinea' shops and some specially made by a dressmaker. Janey's memoir records with pleasure the typically 1930s halter-neck, bias-cut dresses she took with her, the clinging line perfectly complementing her boyish figure, and also the cut of the more tailored everyday outfits she had chosen. After an entertaining voyage, she and her mother made a dusty two-day train journey to her father's new headquarters for his appointment as Resident of Waziristan, controlling the troops guarding the border on the North-West Frontier. It was an exciting time, often risky and dangerous for her father and his staff, but it was also the beginning of a highly sociable period for Janey. When not riding, swimming or partying, she would cut out and make herself cotton dresses from *Vogue* patterns or adapted from photos in the magazine, sent from England. She began to achieve a reputation for dressing much more stylishly than most of the other girls. Life was packed with social occasions and Janey did meet a young man with whom she had her first serious relationship – Ian Robertson, the soldier brother of an English friend, who had come out to work with his father. When her mother had returned to England for the summer holidays, Janey travelled to Kashmir to escape the heat and Ian, unable to join her, wrote to her every day. However, the relationship appears not to have

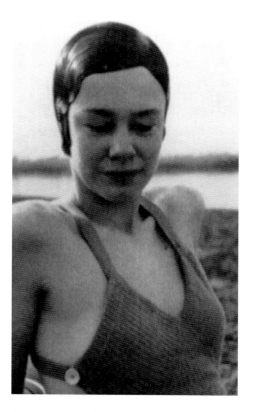

Janey Ironside, c.1934

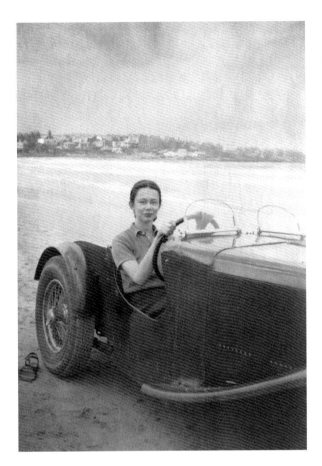

Janey in her brother's sports car, c.1937

lasted much longer than her stay in India when, after about a year, Janey had to relinquish the unreal fairytale glamour of life in the Raj for a return to the safe, dull home counties of England.

After returning home, Janey began classes in 1938 at a private dressmaking school in London, living in a somewhat cheerless room in Earl's Court found for her by her ever-helpful aunt. Through friends at the school she began to meet a new group of people, the kind of circle of which she must have dreamed when sitting for Dugdale's portrait and listening to his musings several years before. With this cultured young crowd there were 'endless parties' in London and Oxford, outings to theatre, cinema and ballet, and at this politically volatile time (several of them fought in the Spanish civil war) much discussion about the unstable world and its future. Janey quickly learned that this educated, liberal group disapproved strongly of the British rule in India, and that it was better not to refer to her previous life, during which she had not really thought to consider its many political implications.

Art School and after

Having stayed at the dressmaking school for three months, Janey had developed an ambition to do more than simply make clothes for herself. While Muriel Pemberton's unique fashion course at St Martins was preparing budding designers for industry, the theatre designer Jeanette Cochrane was running a respected 'dress' course at the Central School of Arts and Crafts, close by in Holborn. Janey joined the classes there, presumably after a statutory interview. It was actually more like today's art foundation courses – specific study underpinned by regular drawing classes from life and from classical casts, lectures on history of art and in Janey's case history of costume too, given by Jeanetta Cochrane herself. This meant that dress design was taught from rather an 'artistic', costume-based point of view which was nevertheless constructive and interesting, and its close relationship with the School's influential school of textiles meant that there were often student collaborations.

By this time Janey had installed herself in a sunny room in South Kensington, where she was able to create more of a home with bits and pieces of her own furniture. The generous living allowance from her parents paid her rent and was meant to feed her, but Janey ate as economically as possible, cutting down on meals in order to spend what she could on clothing herself (a time-honoured discipline common to female fashion students). One day after classes, going home on the Underground, she sat opposite 'the most attractive young man'[4] she had ever seen. After a few more sporadic sightings, it turned out that he was Christopher Ironside, a drawing tutor at the Central: a brilliant draughtsman, charismatic and handsome, with whom, according to a fellow student, 'everyone' was in love. But Janey had made an equal impression on him, and before long he invited her to the cinema and a romantic dinner at Quaglino's. Janey had met the man she was to marry.

After a year at the Central School Janey decided, to Miss Cochrane's concern, that she wanted to leave and get a job. This appears to have been partly in order to get proper paid work and, possibly more important, to alleviate Christopher's conscience in having an affair with one of his students. Janey knew that if she had no reason to stay in England, she would be whisked off again to join the marriage market in India (incidentally, Christopher also had strong family connections there, and he and his friends had a dismissive attitude to the whole colonial experience). She was given some contacts – an interview with a fabric wholesaler which proved useless, and an introduction to Captain Molyneux, where her historically-inclined drawings were not considered fashionable enough for couture. What the cheaper clothing companies wanted was an unending supply of commercial design ideas, to feed the myriad small manufacturing businesses set up as a result of the influx of refugees from Europe. In desperation, Janey accepted an unpaid apprenticeship in what could probably be described as the less scrupulous end of the rag trade – a company which made inexpensive suits, adding inside them bogus labels from big design houses and selling them to dealers who were 'in the know' and would pass them off as the real thing. Supplying the showroom where Janey produced her designs was a series of outworkers, proprietors of steamy East End sweatshops where seamstresses and tailors toiled in cramped, archaic conditions for disgracefully low pay. The arrangement was that Janey would be paid a salary after the first three months, but as it turned out, she was sacked at this point – and another 'apprentice' employed in her place.

Marriage to a Camoufleur

Fed up, and weak with anaemia owing to her unsatisfactory diet, Janey went to join her family on holiday for three months in the west of Ireland. This last summer before the war was precious and poignant, and she enjoyed spending time with her oldest brother James, who was soon to be called up for the Air Force. As the international situation grew more and more worrying, Janey's father was summoned back to India and her mother returned to England with the rest of the family. Along with countless other young couples, Christopher and Janey decided to get married just after war was declared at the beginning of September 1939.

Married life began with Christopher's posting as a Camouflage officer to Leamington Spa in Warwickshire, where the Ministry of Home Security had set up the Civil Defence Camouflage Establishment. Sharing a flat to begin with, the couple later moved to a small Regency house where they lived with their tortoiseshell cat and two Camouflage lodgers. Life was sociable, the Camouflage unit consisting of a lively group of artists, designers and architects who had been uprooted from their studios and dropped into this quietly elegant midlands town to develop decoy and deception schemes in the requisitioned Ice Rink.[5] It was there that Janey first met Robin Darwin, who would later be so influential in her life, on one of his regular visits as Secretary of the Camouflage Committee; and it was there that Darwin himself got to know several of the artists and designers he would later employ as professors and teaching staff at the Royal College of Art.

Evacuee children, the boy on the left holding his gas-mask. Pencil sketches, Janey Ironside, 1940

Janey, needing an occupation, took on voluntary work at a home for evacuee children from the Birmingham slums. To keep them amused she asked them to pose for her, which they queued up to do, and she made some charming and detailed sketches of many of them, always with great attention to the cut and structure of their clothing which usually consisted of someone else's cast-offs. She commented that, at the time, 'Fashion had come to a full stop. Although clothes were not yet rationed they were … already set in a pattern … not so far removed from the later Utility clothes [their design often approved for manufacture by Madge Garland, consultant for the scheme] dictated by the Government to avoid waste'.

Janey was eventually called up to take on local work in the inspection department at Lockheeds' Hydraulic Brakes. A target for enemy attack, the factory was already under camouflage, but was still bombed one night. Janey was a curiosity there on account of her noticeably 'posh' voice as well as her unusual style, but the other women did not resent her. She also worked at the soldiers' canteen in Leamington, and was serving food as the massive air-raid on nearby Coventry began. She rushed home to shelter in the basement. Although Leamington too was affected, covered in broken glass from blown-out windows, all its schools and empty buildings were next day commandeered for vast, disorientated numbers of Coventry refugees.

In 1943, when it seemed the end of the war was in sight, the Ironsides decided to start a family. Janey, pregnant, did not enjoy the change in her appearance and dressed 'as concealingly as possible'. Since their arrival in Leamington she had continued to make clothes for herself, romantic 'artistic' garments considered by Christopher as befitting an artist's wife, depicted in Christopher's many portraits of the time. However, the narrow waistlines of these garments became impossible to fasten, and the only outfit in which Janey felt remotely attractive was an antique blue-grey brocade Chinese coat with bands of silk embroidery, inherited from an ancient relative, worn with silk trousers which she had made herself at home.

Some months into her pregnancy Janey was released from war work. To supplement Christopher's salary and to keep herself busy, she made sets of dolls' clothes for Harrods' toy department. She also adored reading, and spent happy afternoons devouring books sent from the London Library by post, racing through the works of Proust, Balzac, Dickens, the Brontës, George Eliot, E.M.Forster, Anthony Trollope, Henry James, Tolstoy and other major Russian authors – in her own words, 'anything and everything of whom I had ever heard or had been advised to read' by Christopher's theatre-designer brother Robin, whose suggestion it was that she should join the Library.

Their daughter Virginia was born in February 1944. Christopher's father, a doctor, had arranged that as London at that point seemed relatively safe, the baby should be born there under his supervision. Janey was duly installed in a joyless and dismal nursing home just as the enemy decided to return and finish off its devastation of bleak, ruined London, and the arrival of Virginia was dramatically accompanied by the vibrating thuds of a new and vicious series of air-raids.

Janey, oil portrait by Christopher Ironside, late 1940s

The family returned to Leamington to stay there until the end of the war. Janey did not much enjoy life as a young mother. She found wartime life depressing, particularly after the loss of two of her siblings: James, to whom she had been so close, had been tragically lost in an airborne sortie over the North Sea in 1940, at the age of twenty, and her sister Kitty died of a brain tumour in India in 1945, at the same age. Earlier in the war Janey had often been able to see her younger brother Anthony who was on a military engineering course at Birmingham University, but he too had gone back to India to join the army. When Christopher was at work she was miserable and lonely, evidently suffering post-natal depression and desperate to get back to London life. Time dragged to begin with, but finally it happened – the war was over, and Christopher was offered a job, via the ever-influential Robin Darwin, with the new Ministry of Town Planning in London. He often worked with Hugh Casson, previously a fellow camouflage officer, on morale-boosting exhibitions and on interiors for much-needed new community developments. Staying at first in lodgings in Belsize Park, the Ironsides eventually found a 'perfect' house to rent in Neville Street, South Kensington, an area where Christopher and Janey both felt at home. Virginia remembers her mother's practicality and skill in painting walls, laying scrap linoleum and making curtains,[6] thriftily but stylishly transforming the house into a comfortable home.

London life

Happy to be back in civilization at last, Janey began to meet new people. Viva King, the South Kensington socialite, held Sunday parties to which she invited the London arts and literary *beau-monde*: Ivy Compton-Burnett, whose books Janey loved, and her partner Margaret Jourdain; Nina Hamnett, Angus Wilson and 'a nucleus of

attractive young homosexuals' as well as a few 'reasonably decorative couples'. The Ironsides also socialized with Hugh and Reta Casson, and with Diana Holman Hunt, one of Christopher's ex-girlfriends, immaculately dressed and an ex-model for Victor Stiebel. There were often fancy-dress parties, and Janey sometimes wore a dark-brown Victorian bustle dress with a corseted bodice found in Leamington, which in 1948 was very appropriately in tune with the news story of the fashion season, Dior's New Look. Janey made herself a Dior-inspired suit, a full skirt and a jacket with sloping shoulders and batwing sleeves, with several yards of leftover blackout material and some spotted silk for a blouse. Virginia remembers her on another occasion in a full scarlet felt skirt with a black high-collared shirt. She began to make clothes and hats for friends who admired her chic, modern style, and as parties became more frequent with alcohol freely available, Janey, happy and often a little flirtatious, enjoyed the praise always elicited by her appearance. Some of her friends suggested she should try modelling, but nothing came of this, and so she continued to work from home as a designer/dressmaker to her friends and, via them, to an increasing circle of female clients. It was at this point that her working life took a new, unexpected and propitious direction, one that would shape her future and, to a great extent, that of British fashion design.

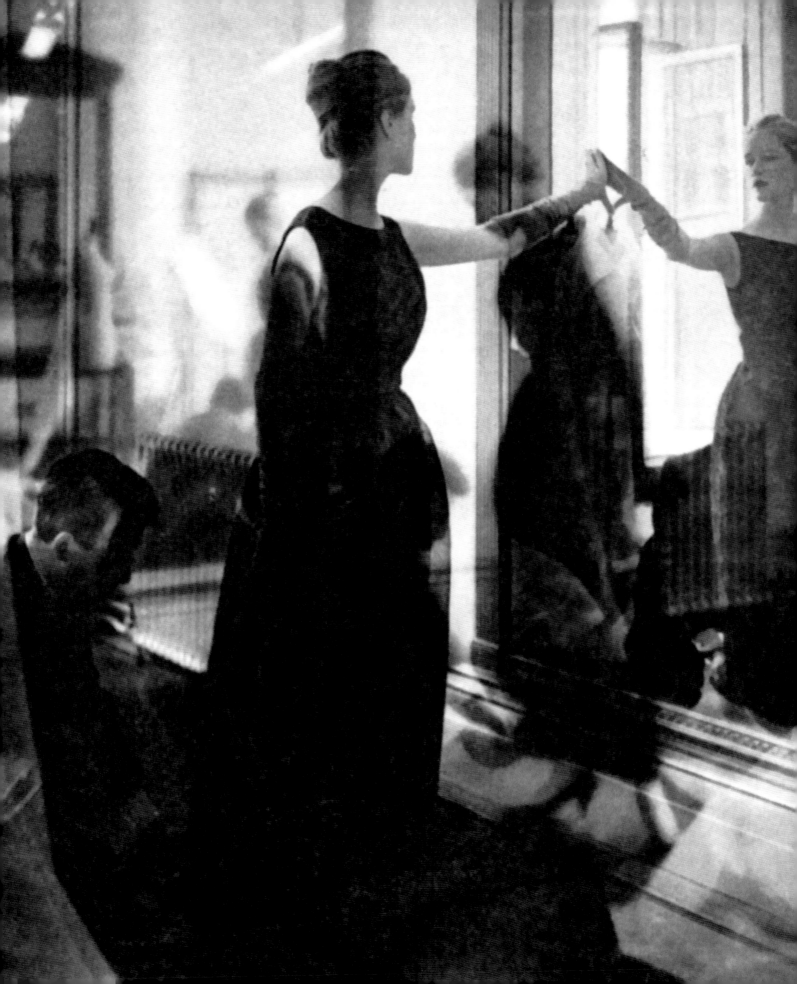

Chapter 5

The Second Professor

Robin Darwin's famously forbidding academic exterior concealed a surprisingly affable man. Living alone and a confirmed *bon viveur*, one of his favourite ways of relaxing after work was to entertain his colleagues. Acting as both host and competent chef, he delighted in holding frequent supper-parties where invited groups of his staff would mix with a cultured selection of other friends. Darwin had given Christopher Ironside a part-time post as drawing tutor for the College's fine art students, and it was at one of his gatherings that he introduced Christopher and Janey to Madge Garland. Soon after this, Madge, spotting Janey's stylish appearance and perhaps wanting to test her skills, asked Janey to make her one or two items of clothing. She then invited the Ironsides to dinner, and followed this with a suggestion that Janey should apply for the post as her assistant in the School of Fashion.

Madge's assistant

Janey Ironside, oil portrait by Robin Darwin, 1958

Janey made an official application and duly arrived at the School of Fashion in Ennismore Gardens, awestruck by the grandeur of the building and a little nervous. Madge was forbiddingly formal but, during the interview, did compliment Janey on her outfit which, naturally, she had made herself: a mustard wool waistcoat and skirt with a white shirt, 'separates' which Madge approvingly pronounced 'the coming thing'. Shortly afterwards, Janey was offered the job, the official title of which was 'assistant craftswoman/demonstrator' in the School of Fashion. Madge's letter to the Registrar, John Moon, stated 'I have engaged Mrs Janet Ironside, 15 Neville Street W7 as Senior Assistant at £500 p.a. beginning on 1 September 1949, for the period of 1 year, subject to 1 month's notice on either side'.[1] At Moon's suggestion, the tenure was increased to a more generous 5 years (with one year's probation) to have parity with other staff of a similar level.

To begin with, Janey found the work difficult and all-consuming. She had no experience of teaching and was slightly in awe of the professionalism and knowledge of the staff. In her early 30s she was only slightly older than some of the students, who all seemed so worldly and sophisticated. Some of the students had enrolled (possibly before the College was evacuated for the duration of the War, and presumably on a more general design course) prior to Madge's arrival as Professor, and as this group graduated a new cohort of keen young aspirants arrived to propel the School into an optimistic new era. In Janey's memoir she remembers early students Gerald McCann and Gina Fratini, who both became big names in British fashion, and Peter Shepherd who specialized in millinery and later became an

Dress Show invitation, 1957 (detail)

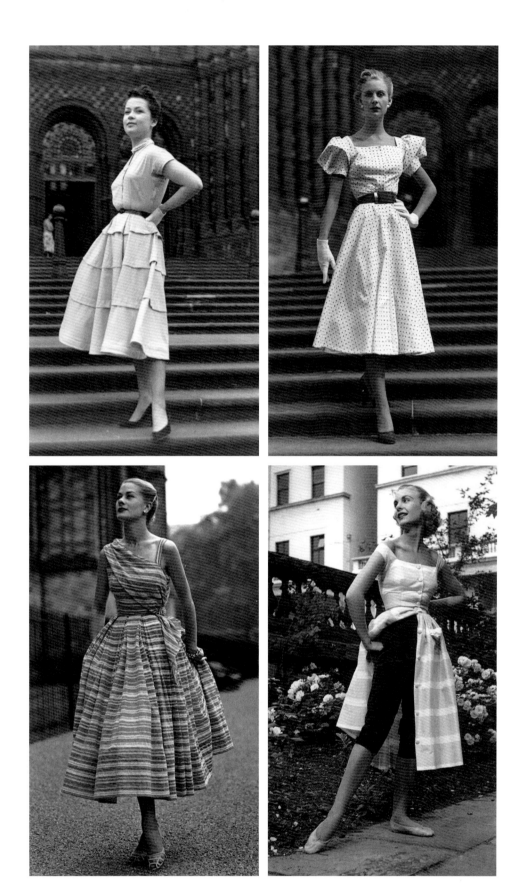

l–r, top to bottom: dresses by Gina Butler 1951, Kenneth Burgess 1952, Joanne Brogden 1952, Helen Jones 1953

influential member of staff. Amongst a small first group of recruits Jean Matthew, Joan Price and Eileen Blackman started with Madge's arrival in 1948, and Kenneth Burgess in 1949. Joanne Brogden, who was later to become such a pivotal presence in the School, arrived with McCann, Mary Gunther and Barbara Winters in 1950, Helen Jones and David Watts in 1951.

Janey's period of probation was 'satisfactorily' completed, and as from 1 January 1951 her salary rose to £575, this followed by a substantial Government increase to £695 the following April. She learned easily and quickly began to feel more comfortable in her work. She describes this as 'general dogsbody and fabric-matching girl', and she must have enjoyed exploring the showrooms of the fabric agents and suppliers around the squares of Soho and in the West End. With her knowledge of dressmaking she could help the students with cutting and construction advice when the part-time professionals were away from the studio. Working to a full timetable, the students were still expected to develop the correct social skills and, as well as their cultural forays into London's world of art and entertainment, they were expected to help host the school's annual Christmas party, to which Madge and Robin Darwin invited an urbane and influential selection of guests. These elegant soirées started out decorously as Madge would have wished but, with the students serving themselves as many drinks as they provided for the guests, rapidly became less orderly, with some of the ensuing new friendships sometimes being not quite what Madge might have envisaged. Janey later made a pertinent comment (by modern standards somewhat risqué) about this aspect of the students' education – '... life *is* a slave market. If you cannot get what you want by ... connections or wealth, there is only one thing to sell and that is yourself – body and/or talent – and you must achieve opportunities to find the right buyers'.[2]

The first Fashion School visit to Paris was another eye-opener for Janey. When they were able to get into the shows with Madge or, if the disapproving *vendeuses* permitted, without her, Janey and the students were enthralled to witness the couture skills and magical presentations of collections by Balmain, Givenchy and Rochas. It was difficult to arrange entry to some of the major shows (the Paris *Chambre Syndicale de la Haute Couture* was not inclined to facilitate arrangements until 1954, when it began to regard the Fashion School as more than an undesirable group of poorly-groomed students) so when it was impossible to get into grand houses such as Dior, they visited the designer's boutique instead. These exclusive own-label shops, rapidly spreading to other major Western cities, were a new departure, signalling the growth of ready-to-wear and the availability of designer collections to a wider, if still moneyed, clientele. When not at shows or being sent on errands by Madge to collect certain chic accessories which she had ordered in advance, Janey would guiltily sneak off to shop in the treasure-troves of department stores Galeries Lafayette and Au Printemps where she would buy French kitchenware unavailable in London, or in the more affordable, excitingly modern Prisunic to get presents for seven-year-old Virginia.

The London shows, both couture and wholesale, were less frightening but equally exclusive, and Janey and any students lucky enough to attend had to crane their

necks from the back row in order to see anything of the clothes worn by the seemingly haughty and inscrutable models. But any experience, as well as being a privilege, was useful in the organization of the Fashion School's annual Dress Show. Janey, naturally, played a major part in the preparation and production of this, working overtime in the weeks before and being hands-on backstage when it took place. Virginia, who resented the School for taking her increasingly remote mother away, was appalled when Janey decided that they would both model in the 1951 show in 'mother and daughter' dresses and, worse, in swimsuits. It was one of her life's worst ordeals and she never forgot it.[3]

Designer-dressmaker

After two years, Janey decided to leave the College. The story was that she gave up in order to spend more time at home with her daughter but, although Virginia was unhappy and often alone after school, her own suspicion is that Janey 'found the imperious Madge too difficult to work with'.[4] Janey herself records that though she knew she was fortunate to have worked with Madge, she never felt at ease in her presence. Her decision was to go back to her private customers, and on April 10th 1951 she submitted a letter of resignation, stating her wish to terminate her contract as from 1 September.

Janey had gained much from her employment at the College, and one benefit was that she had found a number of potential customers through her new contacts. She also placed an advertisement in *Vogue* as 'designer-dressmaker', and the orders began to flood in. Starting with one elderly assistant who came in every afternoon to do the finishing, the business grew, and the small top-floor workroom soon became a cramped sweatshop housing a volatile multi-national group of seamstresses. The whole house was taken over by half-finished garments and bales of fabric and the living room, more often than not, used as a fitting room for the high-society clients. There was more and more to do. In addition to Janey's day-to-day work of customer meetings, designing, cutting patterns and organising fittings she had to deal with the administrative side of the business, keeping up to date with her staff's pay and National Insurance arrangements and also regularly acting as pastoral adviser to emotional employees. She often worked practically all night and Virginia, rather than seeing more of her mother, probably spent even less time with her. The bulk of the work was dresses for special occasions – weddings, balls and debutantes' coming-out parties, all regular society events in the mid-1950s. It is odd to think that while the style of these dresses was an echo of Dior's tight-bodiced, almost Victorian silhouette with enormously full skirts, a short distance away in Chelsea, Mary Quant was about to open London's first famous fashion boutique, 'Bazaar', which was to be so instrumental in setting the scene for a revolution in British fashion.

After several relentless years of full-time engagement in her enterprise, Janey began to wonder if she could continue. There was no shortage of clients and it appeared highly successful, but the profits were small and the commitments were exhausting.

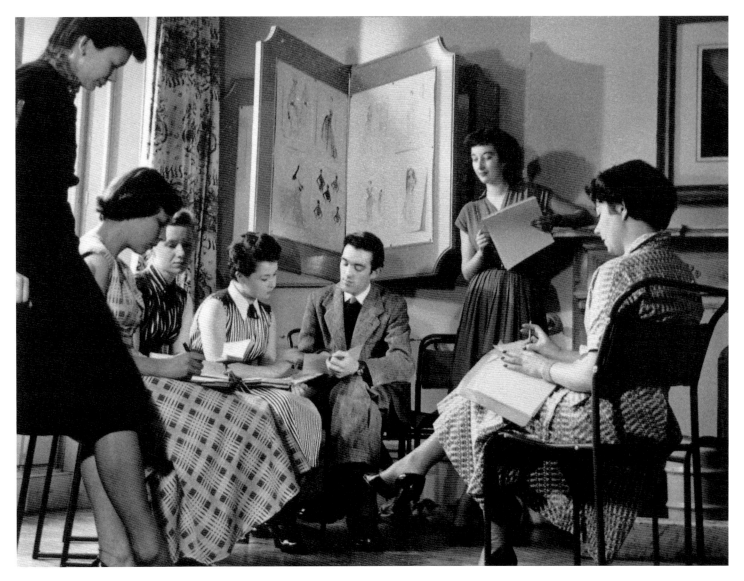

Student discussion, Janey Ironside far left, c.1951

It was at this time that, after a lunch with Anne Scott-James of the *Sunday Express*, she had the idea of designing for children. She had always made clothes for Virginia, who found it embarrassing to be dressed in the smart little French-inspired outfits; there was nothing she wanted more than to be an inconspicuous, normally dressed English girl like most of her friends. But mother knew best and Janey went ahead with her idea.

The first experiment was a collection for Horrockses fashions, orchestrated by Clare Rendlesham of *Vogue*. It featured in a three-page spread in the April 1955 issue, to be followed by a second collection for autumn, this time photographed by Norman Parkinson. But Horrockses were not happy – the clothes were not considered 'commercial' by the childrenswear buyers of the shops and store groups, and were failing to sell. Virginia in her reluctance may have had a point. Disappointed but determined in her mission, Janey had a further collection of her own created in her still-functioning workroom, and made appointments with the appropriate buyers in

Harrods and other high-profile stores. She received much the same reaction. It is hard to believe that no-one had the courage to market a collection with such evidently 'groundbreaking' ideas as sleeveless cotton dresses, simple knitwear in strong colours, plain tailored coats – adult items scaled down to smaller proportions. Discouraged, Janey realised that to succeed in business it did no good to have ideas ahead of their time, but the last thing she wanted to do was to emulate the predictable, tried and tested childrenswear styles the buyers were looking for.

Back to the College

The Ironsides frequently saw Robin Darwin, at their own home or perhaps, at weekends, at his pretty Palladian pavilion on the Thames. This had formerly been the very decorative boathouse to Syon House and in presumptuous Darwin style he had decided it was for him, negotiating its rental with the Duke of Northumberland, one of his trusty network of Old Etonian friends. In late spring 1956, after Madge Garland had announced her resignation, Darwin approached Janey with the offer of taking over the professorship. Stunned at the idea, she was at first doubtful about her ability to follow in Madge's magisterial footsteps, but as she gave the subject more consideration and as Darwin promised her whatever help she needed, she began to find it an attractive proposition.

It is interesting to note at this point that in Janey's staff file at the College there is a mysterious 'Terms of Appointment, Professor, Chair of Fashion Design' dated March 1953, three years before Madge's departure. Could it be that Darwin was scheming to replace Madge with Janey at that early stage? The varying reasons for Madge's later resignation indicate that perhaps the situation was not entirely happy, and perhaps in 1953 Darwin was already pulling strings – but if this is the case, any thoughts (misguided, malicious or not) about replacing her appear to have gone nowhere.

Although in Janey's memoirs she recorded her hesitation that the appointment might be seen as a flagrant 'job for the girls' issue, she evidently attended an official college interview, and on 18 May 1956 she received a letter from Darwin appointing her to Professor at £1,800 p.a. 'in succession to Mrs Garland as from 1 September next'. Her Staff File holds two handwritten letters of acceptance, one formal and one less so. Janey – a wife and mother in the 1950s, when women of a certain class were not expected to work – was a revolutionary. Not only had she already managed her own business, she was now to take over a unique and high-profile position as the world's second professor of fashion.

The press was delighted. The major national newspapers all gave the appointment their wholehearted approval, and Janey was a photogenic subject for the fashion pages. Her style was moving towards the graphic monochrome image for which she will always be remembered – white face, red lips, elfin-cropped black hair, and almost always black or black-and-white clothes, their starkness relieved by strings of pearls. She would often wear dark glasses and, later, her professorial image would become even more defined by the addition of black heavy-rimmed spectacles.

Janey Ironside with student Anne Tyrrell, 1958

Many of the staff who taught in the Fashion School in Madge's time were still there when Janey took over, including Roger Brines, Irene Elfer and Miss Morfey. Gidon Lipman, who had his own business and also lectured at Harrow School of Art, came in to teach flat pattern-cutting and grading, and Miss Frankl couture methods. Shoe design was taught by Eunice Wilson, and accessory design by Monsieur de Donceel, who supplied couture customers in Britain and France. Bernard Nevill, Madge's previous student now designing for Liberty, came in one day a week to set special textile-based projects. The redoubtable Avis Herbert-Smith was Janey's secretary, highly efficient in all administrative duties and yet kind and supportive to professor, staff and students. Janey invited two ex-students to join the team. Reflecting Madge's recruitment of Janey herself as all-round fashion factotum, she asked Joanne Brogden, who was a talented designer and could draw beautifully, to be her own assistant three days a week. Peter Shepherd, again much more than a clever hat-designer, was appointed to teach millinery. As in Madge's time there were many guests invited in to talk to the students and to lunch in the Senior Common Room afterwards. One of Janey's earliest students, Anne Tyrrell, remembered that among many visiting lecturers Madge herself, immaculately dressed and coiffed, was occasionally invited

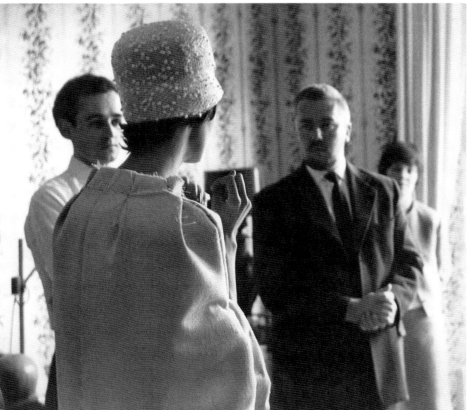

Fashion studio fitting with (l–r) student Lindsey Robertson, model Sevilla Glass-Hooper, tutor Peter Shepherd and dresser Marion Foale

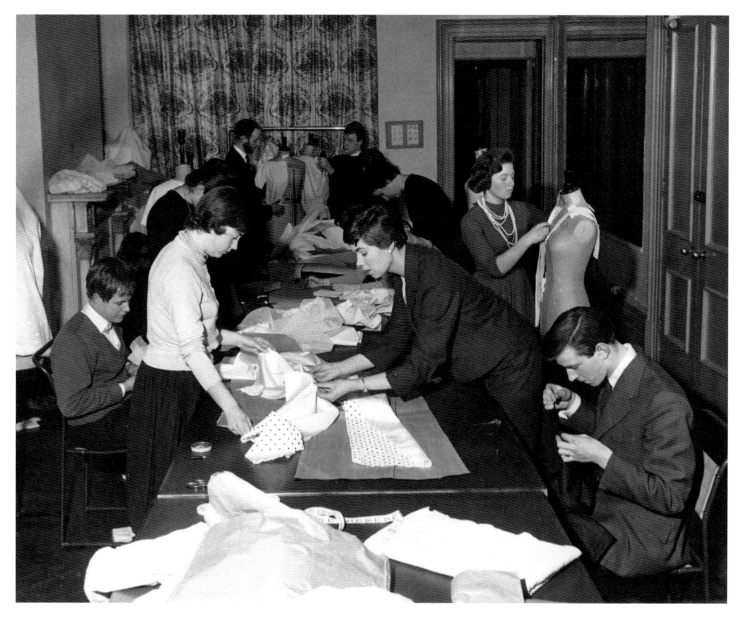

Joanne Brogden, centre, instructing a class in mass-production dresses, 1958

back to lecture on her life in fashion – one wonders what the students would have made of her grand couture style and her 1950s flashbacks, in the approach to the all-new and excitingly futuristic culture which was soon to rebrand itself as the 'Swinging 60s'.

True to his word, Robin Darwin had set up a Fashion Advisory Committee to assist in the management of the school. Its members included high-profile names from couture (John Cavanagh) and wholesale (Frederick Starke), the fashion press (Audrey Withers – *Vogue*) and the textile trade press (Hans Juda of *Ambassador*) as well as Darwin himself. But Janey, realistic and forward-thinking, was concerned that the mass-production business was not represented. Marks & Spencer, who had developed a successful contract manufacturing system in fashion and textiles before the war, had become a national institution playing a 'vital and indispensable

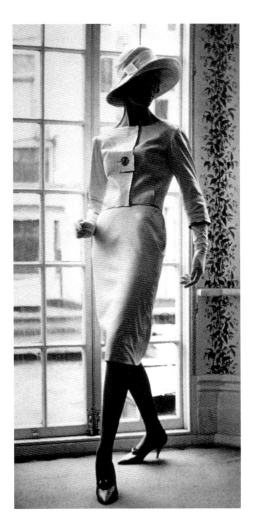

Dress by Julian Robinson, 1958

part in the life of the British people'. During Madge Garland's time M&S had always been generous with scholarships for the students, so Janey went to the top and spoke to Hans Schneider, director of design. In generous response he made arrangements for the students to visit his department and see the workings of a huge company, and he also arranged regular work placements for them in the holidays. This began a College relationship with M&S that was to last many years, extending well into the 21st century. Janey took on a freelance consultancy with the company as advisor on 'teenage garments', and started a series of childrenswear design classes which she herself taught ('entirely approved' by Robin Darwin).[5]

Janey hits the USA

Incidentally reflecting one of Madge's first moves as professor, in February 1958 Janey made a request for funds to visit New York, Chicago and Washington (the latter destination later altered to Detroit) to investigate 'trade conditions and mass production' and 'the market for British fashion goods in the US'. This was agreed, and she was allowed expenses of £5 per day (personally raised by Darwin to the grand sum of £6). To help her image and to advertise the School, she commissioned students Richard Lachlan and Julian Robinson to make her a grey flannel suit and a dress inspired by Givenchy's new 'sack' line. Irene Elfer created a black coat and skirt, tapering in silhouette. In April Janey submitted a thorough report of her findings, and it seems that both the fashion press and the senior personnel of the 'garment district' manufacturers were generous with their time and genuinely keen to assist this unusual and interesting London professor in her research.

She was based at the Commodore Hotel, 42nd Street, New York, and as soon as she arrived she visited Jessica Davies, the imposing Francophile editor of US *Vogue*, who was very helpful and made appointments for her with representatives of three large stores: the fashion directors of exclusive, upmarket Bergdorf Goodman, and Ohrbach's at the lower end of the market; and the fashion co-ordinator of Lord & Taylor, the oldest luxury department store. Janey also arranged a meeting with the fashion editor of the *New York Times*, who made appointments with wholesale dress and jewellery manufacturers, 'the best in their fields', so Janey 'plunged into that really terrifying 7th Avenue area of NY known as the Garment District'.[6] Merchandise sectors were clustered together in monumental skyscrapers, perhaps 10 elegant showrooms of one type to a floor, a situation which contrasted with the tiny factories of their suppliers just a few blocks away, crammed with immigrant labourers working away in cramped and hardly bearable operative conditions.

Janey visited a cross-section of designers, from Norman Norell with his talent for applying French couture methods to factory-made ready-to-wear, right down to the most inexpensive 'commercial' dress and knitwear companies. Even at mid-to-low market levels, designers were well paid and the business, still respecting the skills of the workers, substantially less 'automated' than she had expected. She was allowed a viewing at Mainbocher – the 'last European-type [couture] dress designer in NY', so exclusive that only the most well-connected or richest customers were allowed to

see the collection. Being alone with him for a special showing was 'a frightful ordeal' but well worth it in prestige. Perhaps Mainbocher was surprised at Janey's gamine London appearance, and she was disappointed to find that his designs were actually 'depressingly' restrained and ladylike, 'more English than the English' – exactly the look that the well-heeled American matron wanted to put over, and that the modern young London professor was trying to change.

Janey was also welcomed by the fashion departments of four main New York fashion schools – Parsons, the Fashion Institute of Technology (FIT), the Pratt Institute (Brooklyn) and the Tobé-Coburn School for Fashion Careers. She was disappointed in Parsons (although Madge Garland had to some extent used it as a model when setting up the department), finding it 'less thorough' than the RCA and with much less direct teaching. Parsons' practice of employing active designers as part-time tutors, however, obviously worked well, and their industrial placement system was also good. In spite of inadequate studio accommodation, the final standard of work was very high. Janey found the Pratt Institute's output 'excellent and imaginative', showing exemplary management on a small budget. FIT appeared very commercial (her description was 'tradey'), not surprising as the school was largely supported by industry and its chief remit was to produce creative technicians who would eventually achieve high positions in 7th Avenue. The Tobé-Coburn school specialized in teaching merchandising and promotion, and gave its students a thorough and professional training to launch them into their future fashion-related careers.

One of Janey's strengths from an early stage was her understanding of the power of the fashion press, both British and international. She was a great admirer of the legendary American trade journal *Women's Wear Daily*, with its equal focus on the commercial and social (nowadays 'celebrity') aspects of fashion, and its habit of employing the best fashion illustrators in the world, many of them trained at Parsons. She was delighted to be invited to visit the WWD offices and was very impressed with what she found. It was an exhilarating time to be in New York, and she was treated as a VIP almost everywhere she went. At one of the numerous parties in her honour, Janey met the charismatic designer Charles Eames (with whom her daughter suspects she had a brief fling). She was invited to the most glamorous of New York's marvellous museums and galleries. The Metropolitan Museum opened up its renowned fashion department for a private tour, in which Janey noted that virtually all exhibits were totally accessible to students and designers, unlike those in London's V&A Museum where, in spite of the staff's enthusiasm, much was locked away, viewable by appointment only, or sealed in glass exhibition cases.

Janey concluded that it was easier to become a respected designer in the US than it was in Britain. There was more co-operation from the textile trade and, possibly because media and advertising were at a more advanced stage, the public (at least in the big cities) was more fashion-conscious. The industry was highly regarded and designers fully appreciated by their employers, earning respectably large salaries. Owing to the distance between Europe and the US, the Americans were not such

'slaves to Paris' (although, once available, Paris copies did sell out immediately) and had created their own style in formal wear and, almost more importantly, casual wear and sportswear. The trade was so successful because it depended on a fresh and individual American style.

Just before the American odyssey, Janey had taken two of the final-year students on her first visit to Paris as Professor. It is not clear whether the £20 she was allowed by the Bursar for the five-day visit was to cover the students' expenses as well as her own. Filled with familiar dread, Janey was relieved to find that the *Chambre Syndicale* was marginally less aggressive than it had been a few years before and managed reluctantly to promise admission to four shows – those of Dior, Guy Laroche, Pierre Cardin and Madame Grès. Although the students were accused by the Dior publicity office of sketching after the collection, they were allowed, if grudgingly, to see shows in all these houses. However, there was no invitation to the one they most wanted to see, Balenciaga, and Janey decided that they should just turn up and try for entry. The formidable *madame* guarding the reception area asked to see their passports, and as soon as Janey had offered hers she realized she had made a huge mistake – she had forgotten that her occupation was still listed as 'designer'. Feeling very small, they were escorted out of the building by a haughty and disdainful *vendeuse*, Janey apologizing to the students for her mistake. Her staff file includes a copied letter to 'Mlle Renée, Maison Balenciaga', subsequently sent from Robin Darwin, explaining that the 'designer' status recorded in the Professor's passport was obsolete.

Fashion Revolution

The business of fashion was changing. Madge Garland was later to write regretfully that the post-war New Look had represented 'the afterglow of the sunset of French taste which has led the world for 400 years, the last coquettish womanly clothes before baby dolls, mods and minis took over'.[7] Towards the end of the 50s when Janey took charge of the Fashion School, British couture houses were realising that with a decline in wealthy customers they would need to diversify, and a number of them began to produce ready-to-wear collections. Certain names were snapped up to design special ranges for mass-production (such as the couturier Michael, who worked with Marks and Spencer) and for store groups. British wholesale fashion was on the move. The London Model House Group, successor of IncSoc, invited 28 manufacturers to join the resulting Fashion House Group of London, which was supported by the textile industry in the shape of companies like Courtaulds and ICI and brought the ready-to-wear design houses together in organised shows. The first London Fashion Week took place in May 1959, with showroom presentations and an invitation-only, tightly choreographed catwalk 'spectacular'. Annually-increasing export figures were witness to the success of this new venture, and British ready-to-wear fashion at last became internationally desirable.

There was a different story in Paris. Haute couture was still going strong in France and in 1960 the Fashion House Group of London was allowed to present British

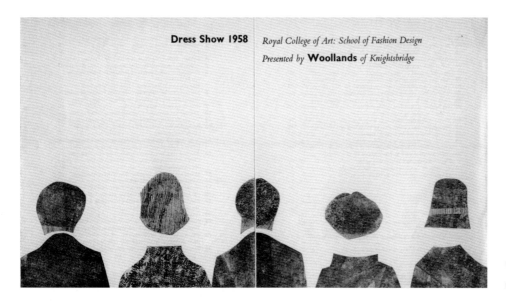

Dress Show 1958 *Royal College of Art: School of Fashion Design*
Presented by **Woollands** *of Knightsbridge*

LEFT 1958 Dress Show promotion by Woollands

BELOW LEFT 1958 Dress Show catalogue

BELOW RIGHT 1958 Dress Show invitation

The Royal College of Art School of Fashion Design Dress Show

The Council and Principal

of the **Royal College of Art** *have the honour to invite you to attend the* **Dress Show**

of the School of Fashion Design at 21 Cromwell Rd, SW7

on Wednesday July 2nd at 3 p.m.

Her Royal Highness **Princess Alexandra of Kent**

has consented to be present

This card will not secure admission
RSVP by 18th June to 20 Ennismore Gardens, SW7
Visitors are asked to be in their seats by 2.45 p.m.

couture in Paris Fashion Week. American buyers were tempted over, and placed substantial orders. Although in the early 60s British fashion was faltering between couture and 'kooky', it quickly gained a reputation for well-made, affordable, cleverly designed clothes, and the Paris success was followed by regular and ambitious ventures undertaken to boost the business. At the same time, in ready-to-wear, a new market level was appearing. It was said that America invented the teenager but 'the initiative for dressing her was, to a large extent, seized by Britain'.[8] Suddenly it

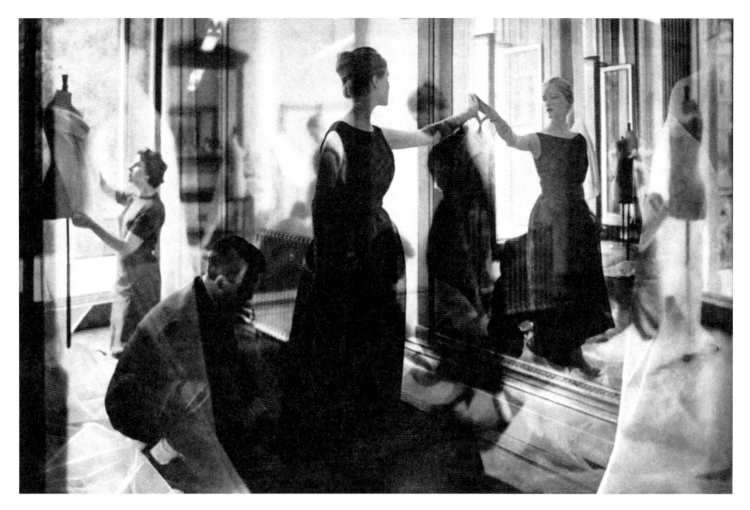

The ethereal invitation for 1957, Janey's first Dress Show, printed on translucent paper

became essential for fashion to 'exist on two levels – "trendy" for the younger customer, and mainstream for a more mature consumer'. There could have been no better time for Janey's first graduating students to enter the business and shake up the rules.

To support Janey's new position as figurehead of the fashion school, in London and abroad, she asked Robin Darwin if the College would give her a dress allowance for her public occasions. Darwin readily agreed to write to the Inland Revenue about this request, and he also sanctioned her expenses for various fashion visits. This was, unsurprisingly, looked on by cynical staff from other departments as preferential treatment; it was at this time that Christopher, too, began to be concerned about the amount of time Janey was away travelling. From the moment Darwin had offered Janey the post, Christopher had been worried. Janey was drinking more and more, and when she drank socially she became flirtatious; Christopher could see that Darwin's offer, professional as it may have been, might well have carried an ulterior motive. Janey, with her new confidence, began to invite 'dangerous men with philandering reputations'[9] as guests to their increasingly frequent dinner parties where she would produce unusual Continental dishes inspired by Elizabeth David's recipe books, with their atmospheric illustrations by college tutor John Minton. The

Christopher and Janey at a Fashion School exhibition, c.1951

Ironsides began to grow apart, though Janey would always make a point of coming home and cooking supper for the family after work, often fuelled by excessive amounts of alcohol. One morning after her parents had been to a party, Virginia woke to find that her mother was not at home. Christopher gently told her that he had advised Janey to stay away for the night, and this was the beginning of a separation which would never be healed. Janey eventually found a flat in Cromwell Place, South Kensington and, although she did her best for a while to return at weekends to cook and to pretend that they were a happy family, Christopher and Virginia embarked not wholly unwillingly on a new, calmer father-and-daughter life without the risk of drunken confrontations. In the 1950s, separation and divorce were subjects not readily discussed and certainly not acceptable (particularly when it was the wife who was leaving; an unheard-of situation). Confusing and disruptive as it must have been for Virginia, the relief of being free from Janey's unpredictable behaviour must in some ways have been a welcome liberation.

Darwin's bombshell

Virginia's memoirs record that at about this time, Robin Darwin invited Christopher to dine with him and, during the evening, dropped a devastating bombshell. Christopher had never really believed (or, at least, admitted to himself) that Janey's behaviour could be more than flirtatious, and when Darwin referred to Janey's 'affairs' with just about every male member of the college staff, Christopher was incredulous. He only began to believe what he was hearing when Darwin, typically insensitive to Christopher's shock, carried on by announcing that he himself was

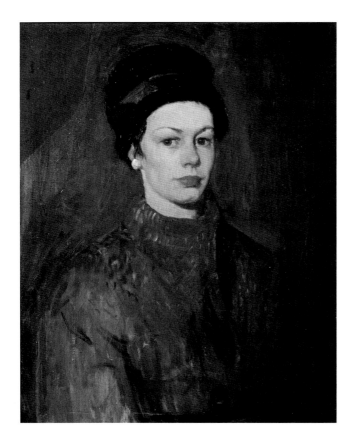

Janey Ironside 1957, oil portrait by Christopher Ironside

included in Janey's long list of conquests. Betrayed and humiliated, Christopher realised that no longer could the 'amicable separation' be continued. Janey's weekend visits came to an end, and from then on Virginia would go, sometimes reluctantly, to see her in her Kensington flat, as near the Fashion School as it was to Neville Street, and conveniently close to the College's sociable Senior Common Room in Cromwell Road.

Worse was to follow for Christopher. On learning that he planned to divorce Janey, the scheming Darwin advised him that the College council would not tolerate divorced couples on the staff. Janey was valuable to Darwin in more ways than one, and in his shameless view it was essential to cover up her reputation and to get her to divorce Christopher on grounds of adultery, however collusive, in order that she could remain in her job. The despairing Christopher, now insidiously let down by his friend of long standing as well as by his marriage, refused to cooperate, and it was not long afterwards that he heard his contract as drawing tutor was to come to an end. Janey did eventually divorce Christopher, and Darwin had got his way in the most despicable manner. However, his private and totally misguided idea that he might spend his future years with Janey as his wife was not reciprocated – nothing was further from her mind and, years later, his niggling memory of this rejection would play a ruinous part in her life as Professor.

Janey threw herself into her work. It is interesting to note that, shortly after the separation, she was asked to speak at a 'Women of the Year' event at the Savoy Hotel. Her five-minute talk on 'Success' refers to the difficulty of living two lives, a new situation for a rare group of women in the mid-50s. 'Most women love their husbands, their children and their homes ... and so will torture themselves ... trying to live two full-time lives ... A woman who has made a success of her career may *look* like a woman – in fact she probably looks excessively feminine as she has her own money to spend on clothes and general beautifying – but a man knows inside she has the makings of a rival and not of a helpmate. On *his* woman he prefers the unsophisticated smell of the flower scent he bought her for her birthday to the sweetest whiffs of the success she has bought for herself'.[10]

Though remorse and guilt had crept into her life they had not held Janey back, and she embarked on a new, exciting period in her life, an unprecedented and effervescent era when the irrepressible creativity of her students would make the RCA School of Fashion such a famous and gloriously British phenomenon.

Chapter 6

Janey's Reign

As Madge Garland's final students graduated, the grown-up couture chic of her era was dissipating and a new youth culture was taking over. During her time, although Madge had selected her students on their flair and their promise, there had been an unmistakable air of 'finishing school' under her strict leadership. Student Gerald McCann observed that, while he was from the north of England, 'most people were from London', presumably comfortably off and living at home.[1] Janey Ironside's democratic and diverse choice of students began to create a new vibrancy within the school. Although it was not essential for applicants to have completed a previous fashion course, the 'feeder' schools where prospective RCA students would study for their National Diploma in Design were all-important. Many of the strongest fashion courses were in industrial cities such as Liverpool, Leeds, Manchester and Newcastle, but imaginative work was also coming out of schools of art in or near London such as those at St Martin's, Hornsey and Kingston-on-Thames. As star students ultimately graduated from the RCA they would often be offered part-time teaching jobs at these schools, and the excellent fashion departments at Walthamstow, Harrow and Bristol, in addition to many others, were all eventually run by RCA fashion graduates who in turn would ensure a steady supply of talent to the College. Until the early 1960s when the Summerson Council set up its advisory committees which would decide whether a school's course should warrant a National Diploma in Art and Design or simply a regional diploma, it was not compulsory for students to have a specified number of 'O' or 'A' level passes. Janey was a strong believer that designers did not necessarily need academic qualifications, and was proud of those of her students, such as Ossie Clark and Sally Tuffin, whose previous educational records would in later years have prevented them from gaining admission to her school.

The College had a rigorous application system. Portfolios were sent in advance and, once accepted for interview, hopeful students sat the general examination for all RCA departments, the main part of which was a general knowledge paper based on art and design. The fashion applicants (around seventy for up to a dozen places) then took a further two-day examination, based in the studios in Ennismore Gardens, in which they had to design, cut and make a toile. Sheilagh Brown remembers this as 'very frightening'[2] – there was no help, and it must have been somewhat unnerving to be working amongst the existing students and staff though, as Ossie Clark recounted, he was '…amazed that so much love and care went into what the students were being taught'.[3] After this (toile finished or not)

Graham Smith fitting a hat on model Verne Schiffer, 1959

Fashion studio, 1963. Far left, Angela Sharp; centre, Alan Couldridge; right, Janey Ironside

there was an interview with a panel consisting of Janey, Joanne Brogden, Bernard Nevill and Peter Shepherd, who would appraise the work, look again at the portfolio containing the requisite 25 finished drawings and generally assess the student's suitability for the course.

As Madge's choice of students left and gave way to Janey's new era, the School of Fashion began to develop the unprecedented character for which it would quickly become world-renowned. The dynamics were changing. A larger number of male students began to apply, the average ratio being one-third male to two-thirds female, whereas in Madge Garland's time the emphasis had been on female students, probably because (in the UK at any rate) fashion design had always been considered a less than masculine subject. Janey appreciated the difference between designers of both genders: in her view women, basing their designs on their own experiences, were 'more practical' producing immediately acceptable and saleable

clothes; men, less subjective, were generally '… more inspired … better at most things' which in her view included cooking, millinery and imaginative dress design. A perfect example of this new type of male was Ossie Clark: in his diaries he recorded his first project, which continued with technicians' help for the whole of the first term, for which he was given two-and-a-half yards of white poplin and a pattern and told to make a white shirt. Having been properly taught at Manchester he managed well, but others, some of them finding it a real challenge, could 'barely thread a needle'. Surprised at first, he understood later that Janey had selected each student for a different reason, her instinct for spotting a talented designer almost always proving to be correct.

To begin with, Janey made few changes to Madge's weekly timetable. In 1958 there were ten regular lecturers at the School, many of them the original practising professionals recruited by Madge. Students, who paid £60 per year in fees, often helped by generous government grants, had to study the needs of all market levels

Students adjusting a hem in the Professor's office, 1960

– haute-couture, middle range and mass production. The introductory white shirt project was followed by a second brief to learn about fit – female students were asked to make a skirt, males a pair of trousers.

Sixties style

Sally Tuffin noted that in 1958 when she first arrived as a College student, vestiges of Madge's dictatorial style still existed. Although the white gloves had disappeared, 'Janey was very particular . . . you had to wear certain shoes, certain clothes, your hair a certain way . . . You were being trained really to be a lady'.[4] There was still an element of formality and the end-of-year successes show that the 'youthquake'[5] was yet to start: even in the early 60s the jobs on offer were quite conservative, at London's big wholesale houses such as Frederick Starke and Susan Small, or in couture with John Cavanagh, and an apprenticeship at Nina Ricci in Paris. Although the business was waking up to young designers, the Sixties were not yet swinging. When the undercurrent took hold, the RCA would lead the way.

Janey Ironside, late 1950s

Although nervous to start with, Janey found it exhilarating to take control of this department where previously she had been at Madge's beck and call. She enjoyed making her monochrome mark in the studios and in her office, where she painted the walls white and hung glazed chintz curtains, also white, to replace Madge's pink velvet and pelmets. Sheilagh Brown remembers the look as 'quite masculine'. Along with her staff, Janey set out to make the students comfortable as well as to be available for them as often as possible – a change from Madge's grand and rather remote style. Throughout her tenure as Professor she had a quiet but authoritative way of teaching, encouraging the students to find their own conclusions. She was certainly not dogmatic. Paul Babb recalls that she was 'friendly, but commanded respect. She gave you enough rope to hang yourself', knowing that one often learns best from one's mistakes. Ruthless in supporting her students outside College, she could be seen as unapproachable and a little alarming. Ossie Clark recorded that Janey was 'a truly startling woman . . . a magic person'. She had 'a special relationship with her students . . . very personal, very warm, very open. We blossomed because we were so encouraged'. Roger Nelson said 'She was always so fair. She let you go ahead and follow your ideas . . . gave us a lot of freedom'. In Sheilagh Brown's view a few years later, Janey's personal style was so inspiring that '. . . she didn't even have to open her mouth. [In her] black suits designed by students (Valerie Couldridge and Ossie Clark), black hair, red lips, whatever the look she had it'. Millinery student Graham Smith remembers 'Always black and white – white legs, black outfit, red lips'. She had the fashion intuition to pre-empt trends, an instinct for the next big thing. Vanessa Denza said that 'she was always on the ball about what was going on' and that her graphic self-presentation rarely changed. She was often the subject of press interviews, and said that although she had a great respect for the intuitive dress sense of French women, she believed in 'dressing to please nobody but yourself'. She favoured '. . . casual clothes, simple lines – black, brown, grey with perhaps a touch of red.' Certain well-cut clothes could last for years, but accessories would make or break the look: '. . . throw [shoes] out the moment they start to date'.

This attention to detail was all-important, and Janey would later add design for footwear to the ever-expanding Fashion curriculum.

When Janey arrived to take up her new post, the Official Visitor to the school was the British couturier John Cavanagh, who was on the Advisory Board. It is a pertinent comment on the new, democratic mood that when he retired from this post the following year, his place was taken by M&S's Hans Schneider. Janey was determined that the British manufacturing industry should have even closer links with the school. Madge Garland had nurtured relationships with the trade but had carefully kept them at arm's length as sponsors and future employers; Janey, more commercially-minded, encouraged such companies as M&S, Berkertex and Wallis Shops to come into the school, to take students on industrial placements and, eventually, to set projects. She built up a particularly strong relationship with the Wallis brothers, who selected Valerie Couldridge as a designer during the first two terms of her final year and offered her a permanent position as soon as she graduated. Janey's awareness of the need for fashion in all fields extended to the corporate world too, and in 1959 BEA (British European Airlines, later to become British Airways) commissioned the College to design new uniforms for their staff. Sylvia Ayton and Julian Robinson produced the winning designs with hats by James Wedge. Sylvia recalls that the air-hostesses approved of the softer, corset-free

LEFT BEA Uniform designs by Sylvia Ayton, 1959

RIGHT Sylvia Ayton with model in prototype uniform, on the roof of the Fashion School

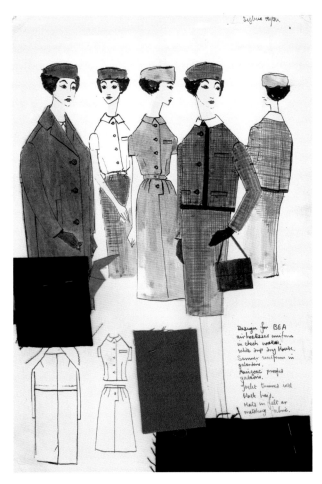

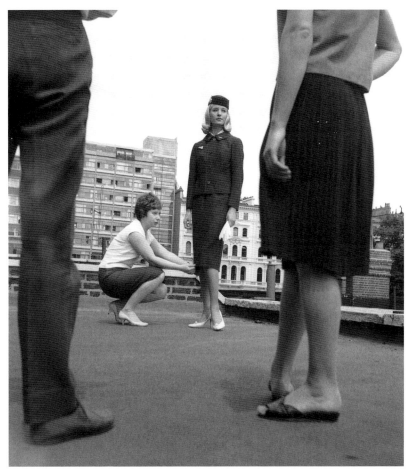

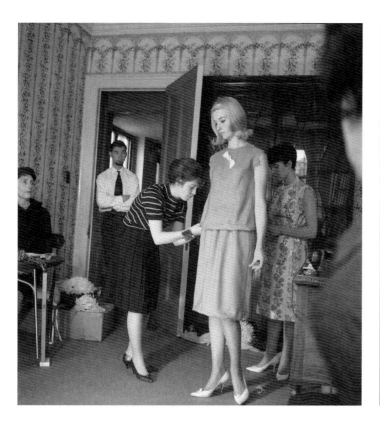

shapes influenced by 'her idol Chanel'. With the £10 she received as her prize, she celebrated by buying a Jaeger suit.

Though the College's intent and purpose was primarily to prepare students as designers for industry, Robin Darwin, with his dream of the College as a place 'of higher learning', had decided late in the 1950s to introduce compulsory General Studies lectures for all students. A news cutting from 17 September 1958 mentions 'a new item on the curriculum – lectures on natural and social sciences', three hours per week. Madge Garland would wholeheartedly have approved. Janey, though objecting strongly to this element (questioning why it was necessary for students of design to undergo academic study of this kind) reluctantly rearranged the weekly timetable to accommodate the classes. At the end of 1961 when the first examinations in General Studies took place, she was shocked to learn that two talented Fashion students would not be eligible to receive the Final Diploma (Des: RCA) as they had failed in this subject. A letter in November 1961 to the College Registrar from a nursing home in Queen's Gate, following what was probably a hysterectomy, mentions the names 'Marion and Sally' and expresses that General Studies would be better arranged as a 'general finishing and civilising course with lessons in ordinary manners and public relations generally'. What good is being a competent designer and 'knowing about Plato etc: if they don't know how to behave'?[6]

Janey was even more outraged when it emerged that current Fine Art student David Hockney, who had openly given up going to lectures in order to get on with

Student fashion designs, 1960

his painting, had also failed the exam but was to be given a special Gold Medal to recognize his talent – a gesture well-deserved on grounds of merit, but ignominiously and outrageously unfair to anyone else who had failed. Furious and upset, Janey seemingly made a vicious verbal attack on the head of General Studies, reducing him to tears in an Academic Board Meeting, about the total unjustness of the situation. This insult to Fashion, along with her disbelief in the perceived need to 'educate' the students, would be a persistent issue for Janey causing, much later, disastrous repercussions on her career which few people could have foreseen.

By 1962 companies were falling over each other to set projects for the Fashion School. The BEA uniform success was followed by a commission from the Coal Utilisation Council – an initiative directed by Arthur Scargill, requiring uniforms for hostesses on a promotional 'Coal Train'. Student Alan Couldridge created the winning design. Lotus Shoes, the Scotch House, and fibre producers Lurex and Acrilan all sponsored competitions that year, to be followed by projects from the Hilton Hotel (staff uniforms for the new rooftop restaurant, again designed by Couldridge), John Lewis ('model' wedding dresses, a commission from the store's dress buyer Eric Newby, later to be such a distinguished writer), Burberry rainwear,

and Heathcoat (garments in their new stretch fabrics). The Board of Trade was keen to promote British childrenswear, and asked the School to produce a special show at its headquarters. In addition to these commercial projects Janey herself would give the students hypothetical design briefs, sometimes with a theme of her choice, sometimes for specific imaginary clients, and would ask designers from industry to 'crit' the results. Several projects would run simultaneously and the students were constantly involved in pattern-cutting and garment making. Tailor John Pallaris and sample-machinist Rose Plunkett were added to the technical staff. Sheilagh Brown later remembered that Roger Brines still continued, well into the 60s, to teach couture methods on Mondays, and on Tuesdays there would be pattern-cutting classes for mass-production. Later on Janice Wainwright, a 1964 graduate who was designer for young label Simon Massey, would come in on Wednesdays. Brown recalls the 'very disparate teaching (good for decision-making)' – the timetable, with all its elements, occasionally seemed a little less than organized, but this was an encouragement for students to self-direct their individual workloads, a useful training for entry to the busy world of fashion.

A Royal commission

There were prestigious commissions too. The connections with royalty were strong, and in 1959 Buckingham Palace sent a request to Robin Darwin that it would like the Fashion School to design a new robe for the Queen, expressly for the presentation of the Order of the British Empire. The brief came with so many official restrictions that it proved almost impossible to fulfil, but eventually a design by Marion Foale, an ingenious combined robe and dress, was accepted by Her Majesty and made up by the royal gown-makers. Although millinery student James Wedge was asked to create a headpiece to be worn with the robe, the Queen chose to wear a tiara to go with the newly-designed Star of the Order, which was conceived by Robert Goodden, the College's professor of Silver and Jewellery. The students may have felt that pomp and ceremony were ridiculously outmoded, but the College was continuing to uphold its royal connection.

Janey may have wanted the students to go into industry, but Sylvia Ayton had other ideas. 'M&S were too stuffy, and the top designers were designing 'mumsy' clothes – all the same length, skirts measured from the floor in medium-height shoes'.[7] Formal little hats were worn. Sylvia was sure that young people did not want to wear this look. There was a new feeling for uncluttered clothes, comfortable but elegant like the black wool crepe sleeveless shift she made and wore for College, 'grown-up', simple and not too serious. One or two manufacturers were doing their best to create young, modern collections, notably Jaeger, Richard Shops and Susan Small, but there was an undercurrent of change – a feeling that fashion needed to be more individual. In 1961 Janey asked Mary Quant and her husband Alexander Plunkett-Green, owners since 1955 of the 'Bazaar' boutique in Chelsea, to give a talk to the students, and it was so inspirational that a group of graduating students including Sylvia Ayton, Sally Tuffin and Marion Foale decided they would rather work for themselves than to someone else's brief. They could draw, cut and sew; they

knew nothing about business – but they knew they wanted to design young, modern clothes for people like themselves and their friends.

Because of the graduating students' new tendency for setting up on their own, Janey was working to give her students the best possible preparation for the world after College. Remembering her own experiences of running a company, she realized it was important (however dull the students might find it) to add a course on Business Studies at the end of the final year, a week-long intensive study covering all the basic aspects of starting a company. The course was based on a 'live' situation, using recent graduate Moya Bowler's successful shoe business as a first case-study, and culminated in a brainstorming session with professionals from the retail world and an independent designer, quite often a successful graduate who could relate well to the students.

There was an alternative to the 'boutique' culture. The celebrated Woollands department store decided in 1961 to open a radical new venture, the '21 Shop' (its style conceived by an unknown designer called Terence Conran with a team of RCA interior design students, and just up the road from the College at the top of Sloane Street). Vanessa Denza, a young buyer put in charge by the enlightened managing director Martin Moss, recalls that its arrival was 'like a dam bursting', the hitherto pent-up demand for its young, modern merchandise was so overwhelming. It opened with three shows in one night, followed by a twelve-page feature in *Vogue*. The shop's displays, minimal, witty and full of fun, were ground-breaking and the brilliant window dressers changed the windows twice a week at a speed unheard-of in the retail sector. Denza, aware of the Fashion School, put in an order for several dresses from Foale and Tuffin's first sample collection, and kick-started their business as well as numerous others. Noting this, Janey asked Denza to come in and talk to the students about what type of merchandise she was looking for in this new world of fast-moving, youthful design. It was a shock for buyers from other stores who had previously bought twice-yearly from more conventional collections: they suddenly had to get wise to the fact that young designers were breaking old rules and providing constantly-updated ranges for a new generation of working girls with disposable income.

The swinging College

Suddenly the 60s had swung into gear, London fashion was what everyone wanted, and the RCA was where much of it originated. Every department was involved: the journalist Marit Allen remembered that 'there was lots of cross-pollination'[8] between the schools of art and design. Naturally related to photography, film and graphic design, fashion now began to influence fine art in its new 'pop' persona, and from 1958–61 painting student David Hockney and his friends were the fashion girls' escorts at all the College dances. These days would be preserved on celluloid when a little later, in 1963, fashion students Sue West and Virginia Hamilton-Kearse designed the wardrobe for singer Mike Sarne's film 'Joanna' – the ultimate mix of pop, fashion and photography, shot in the state-of-the-art block of studios which in

the late 1950s was rising from the ground on Kensington Gore, the College's brand-new home-to-be.

Because the fashionable silhouette was so simple, often relying on cut and colour rather than applied detail for impact, it became very important to wear the right accessories. Janey instigated a shoe design course sponsored by Lotus Shoes and taught by Moya Bowler, and the 'Lotus RCA' range ran for several seasons, always selling out immediately. It was also under her professorship that millinery became a subject in its own right. Both James Wedge and Graham Smith entered the course to study this craft, each of them to leave after only one year to take up prestigious outside commitments. Wedge sold his hats in a boutique at Vidal Sassoon and created headgear for Paris's edgy Emmanuelle Khanh. With model Pat Booth, he was to set up 'Top Gear', one of the King's Road's most influential boutiques. Smith was headhunted at the end of his first year by Lanvin-Castillo of Paris. He remembers that Peter Shepherd was a brilliant tutor but that in general he just 'got on' with the work in the top-floor millinery studio ('when I got there I was doing my own thing anyway') and would make final collection hats for 'practically everyone' at the end-of-year show, as well as showing his own work on the top models, often from Paris, whom Janey would persuade to take part in the show. Alan Couldridge's arrival as a student in 1960 strengthened the school's millinery output and commenced what was to be an enduring relationship with the RCA.

Graham Smith and his hats, millinery studio, 1959

Alan and Valerie Couldridge:
hat for Valerie's final collection,
1963

Childrenswear designs in
Valerie Couldridge's collection
sketchbook, 1963

The final garment collection, which inevitably took up most of the third-year students' time, had to be backed up by a large set of design drawings, their 'Major Work' based on a given theme. Valerie Couldridge remembers that in her final year the subject was 'Hyde Park'. She decided to concentrate on the practical everyday workings of the park for her inspiration – activities around the Serpentine, military events and displays, while her husband Alan (they had met at College and married at the end of their second year) chose a more romantic view, looking at the park's sculptures in differing weather conditions and generally creating a more abstract impression for his designs. The third element of a diploma submission was the much-dreaded thesis, supposedly resulting from the cultural studies lectures which, for students of design as well as of fine art, was required to be based on research into the work of a selected artist. This must have troubled Janey, with her continuing feelings that the lectures were not entirely relevant to students of design subjects.

The Show

Fashion shows under Janey Ironside's professorship, now held in the College's junior common room in Cromwell Road, were to become legendary. A seat at the RCA show, or even standing-room, was the most sought-after, fought-over ticket in London. The invitations themselves, designed in collaboration with graphics

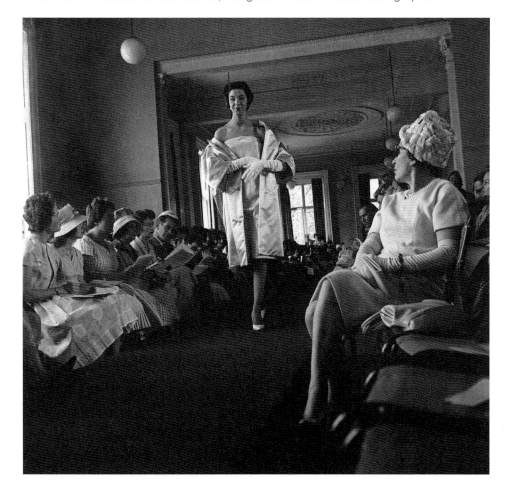

Dress Show, late 1950s

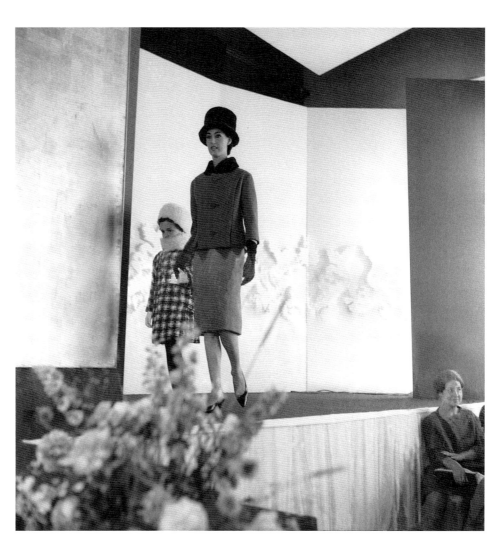

Dress Show 1960, the style radically updated

students, are an accurate mirror of the latest in British design. Janey remembered that her first show in summer 1957 was still quite conservative, beginning with 'day clothes' followed by tailoring, leisurewear, and evening wear with a wedding dress as the traditional finale. The following year, Princess Alexandra sat in the front row as the royal guest and the show was presented in much the same style, although it had a flavour new and vibrant enough to convince Martin Moss that he should re-stage the show instore at Woollands for his customers. In the late 50s the final-year students were given a limited budget for 'a varied collection of diploma work'. At that point the students' inspiration often came from the Paris collections of Balenciaga and Givenchy, these influences giving structure and modernity to their somewhat grown-up designs. 'Front row' culture was already kicking in with celebrity guests high on the RCA invitation list, and there are images of chart-topping clarinettist Acker Bilk gracing the show with his presence in 1961, the year his haunting 'Stranger on the Shore' hit the number one spot. Formality reduced naturally as the decade developed, with the new youth culture influencing the look of the clothes, the models and eventually the venue when, in 1962, the College moved into its smart, purpose-built new block on Kensington Gore. After the 1963

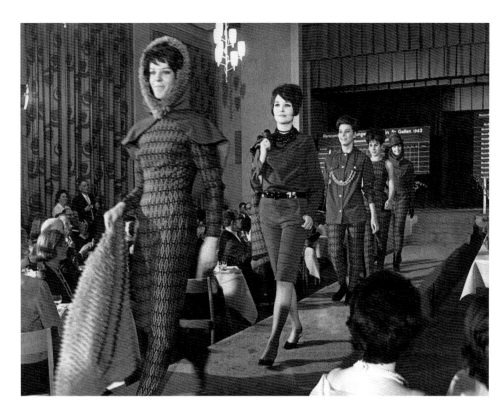

Janice Wainwright's collection for the student *Rencontre* at St Gallen, Switzerland, 1963

show Jean Rook wrote in *Flair* that '[Alan Couldridge's] hats are big and bold as contemporary architecture ... she [Valerie] cuts clearly and simply'. Every year of the 1960s produced outstanding collections, and the fashion students (often working together with students from other departments) explored new technology, producing revolutionary ideas including Ossie Clark's evening coat with flashing lights (1965) and, later, Jim O'Connor's flying coat with model-aeroplane epaulettes and Victor Herbert's ground-breaking moulded plastic macs (both 1968). Janey herself said that the revolutionary Paris collections of such designers as Courrèges were 'the hyphen joining yesterday and tomorrow ... in ten years' time there'll be no future for clothes as we know them'.[9] The 1966 show was so futuristic (at least, to the blinkered British press) that Jean Rook, now at *The Sun*, pronounced the students 'sick' – the collections showed some of the most memorable ideas so far, including Paul Babb's strobe-lit Disney-inspired suits with Mickey Mouse hats, all perfectly wearable. (When Ms Rook later wanted to feature the commercial 'Twiggy' range, designed by Paul Babb in collaboration with the model who epitomized the moment, he refused to give an interview, sending Twiggy's agent and boyfriend Justin de Villeneuve to deal with it instead).[10]

The press was vital to Janey. From the start of her career, she had understood the importance of strong relations with the top magazines and newspapers, and for the first time a press-book was kept in the department. The School never had any trouble attracting interest, and the *grandes dames* of Fleet Street as well as the new breed of young female journalists were always ready to write about what the students and their charismatic professor were up to. It was an exciting time for the

fashion press. Every newspaper gave more space to its women's pages, and distinguished writers such as Katharine Whitehorn and Fiona MacCarthy began to change traditional attitudes to female readers. In 1962 the Sunday press published colour magazines for the first time, largely devoted to style and a modern way of living. The established glossies began to include sections for young, design-conscious readers, *Vogue* leading the way with David Bailey photographing Jean Shrimpton in a gritty and groundbreaking New York shoot for its *Young Idea* pages. French *Elle* was the inspiration for the informal new women's magazines that were appearing: *Honey* in April 1960, followed by *19* (for which, incidentally, Virginia Ironside was to contribute a regular column) and a stream of others aimed at this new, fashion-hungry demographic. Even the homely *Woman's Mirror* defied tradition and printed a full-colour centre spread featuring Foale and Tuffin and their influence; in a later edition in 1962, they offered a 4-piece pattern by Valerie Couldridge. *She*, not to be outdone, then asked Valerie to design a dress pattern for their readers in February 1963. *Woman* followed suit the next year, with several colour spreads highlighting work from the fashion school. The glossies continued their interest, and *Queen* magazine (July 31 1963) carried an article on student design, with new model Grace Coddington photographed by David Montgomery wearing clothes by RCA students. They themselves, with their noticeable style and ultra-modern ideas, were naturally of interest and could always be relied upon to provide news items to fill column inches. Unwittingly, the press also helped RCA students earn a little pocket-money when the *Daily Mirror* offered a dress designed by Barbara Hulanicki, on the cusp of launching her 'Biba' empire: she lived a few doors along Cromwell Road from the Fashion School's studios, and would employ the students to make up dresses for a few shillings a time. Janey's school was always in the news, and the fashion writers happily continued to feature it by tracking the graduates' progress once they had embarked on their careers. Interestingly, though, when they represented England in a high-profile international competition at St Gallen Swiss Cotton and Embroidery Centre, their designs were evidently not considered raunchy enough, and the *Daily Express* summed it up: 'Elegance can beat pure bad taste but it can't beat sex'. The College students could design with wit and style, but blatant immodesty was something they didn't do – very occasionally, depending on who was judging, to their loss.

Janey was herself an eloquent writer. In 1962 her witty, comprehensive and down-to-earth *Fashion as a Career* was published by Museum Press, with a cover by the cartoonist Osbert Lancaster, one of her regular escorts. The style is lively and encouraging while informed and completely realistic. Janey's fictitious case studies are a clear, easily-understood and very often amusing way of explaining the business. Perhaps partly due to the success of this book, a year later she was asked by *The Observer* to produce a weekly fashion page under Katherine Whitehorn's direction. The offer specified 1000 words per week plus supervision of photography and layout, and 'additional travel'. The salary of £2000 a year would double her income, and Janey was sure that, as well as having time to research and produce the piece, her assistant Joanne Brogden and the recently-graduated 'Mrs [Pauline]

Denyer' could manage the school one day a week when Janey was required to check the proofs. Robin Darwin, critical and concerned because of Janey's increasingly nebulous health record, insisted that she get the approval of Council, and also that if she were to take up the offer there should be a six-month trial period. In addition he suggested that the newspaper should make a contribution to the College for a part-time tutor to cover Janey's time. Council disapproved, suggesting 'a single column a week' (still quite a commitment), but was ignored, and Janey's first article appeared in November, credited to 'Janey Ironside, Professor of Fashion Design at the Royal College of Art'. Darwin, incensed that Janey had gone against his advice, put out a request that the College's name should not be mentioned. In the event, the alliance was short-lived. A handwritten letter dated 22 January 1964 from Janey to Darwin states that '… I have left the *Observer* … couldn't see eye-to-eye with them about anything'. However, she also records that she didn't regret the experience, which must have exposed her to the pressures of dealing with the press as well as to the impossibility of juggling so many commitments.

Since Darwin's arrival at the College in 1948, it had expanded enormously. The elegant but motley collection of premises spread over South Kensington was not big enough to house the ever-increasing student numbers. The need for a new building was constantly discussed but an appropriate site and enough funding for this project were elusive. Throughout the 1950s, Professor Robert Goodden, an architect by training, had made a study of what each department needed in terms of accommodation and equipment. This was converted by Goodden and Darwin into a brief for a new, bespoke building professionally equipped with workspaces and machinery adjacent to the design studios: a state-of-the-art 'factory' anticipating students' needs over a span of 25 years.[11] The government finally offered the College the prime site next to the Albert Hall 'set aside by the Ministry of Works' in 1949, and a beautiful, run-down row of Regency houses was given a demolition order to make room for what many would see as a monstrous, alien monolith, totally out of keeping with Kensington Gore's decorative red-brick magnificence.

In 1962 the building, designed to a very limited budget by the independent architect H.T. 'Jim' Cadbury Brown with professors Hugh Casson as main consultant and Goodden as project manager, was more or less finished and the students moved in. The Fashion School was, at last, united with most of the other departments (although Painting, Printmaking and Graphic Design remained in a wing of the V&A, awaiting new premises to be completed later). The fashion students were thrilled with their spacious new studio, finding themselves 'eyeball to eyeball with Prince Albert'[12] seated in such gilded grandeur opposite, and Janey Ironside adored her office under the top floor of the studio block, with 'the most wonderful view over the [Albert] memorial and Kensington Gardens'.[13] The fashion shows were held in the College's double-height Gulbenkian gallery and became more and more memorable as the students broke all the old fashion rules and invented exciting new ones. Janey had an intuitive understanding of how closely the worlds of fashion, graphics and pop were related to each other, and with the phenomenal rise of the British music scene she began to use records by groups from Liverpool, Manchester

RIGHT The new RCA building, Kensington Gore, 1963

BELOW The spacious new fashion studio, 1963

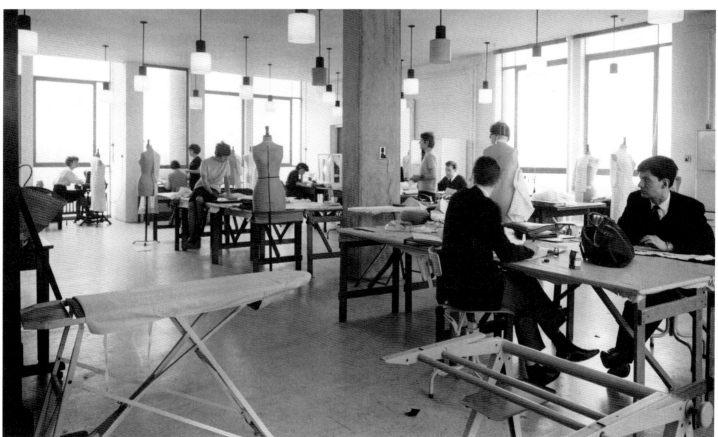

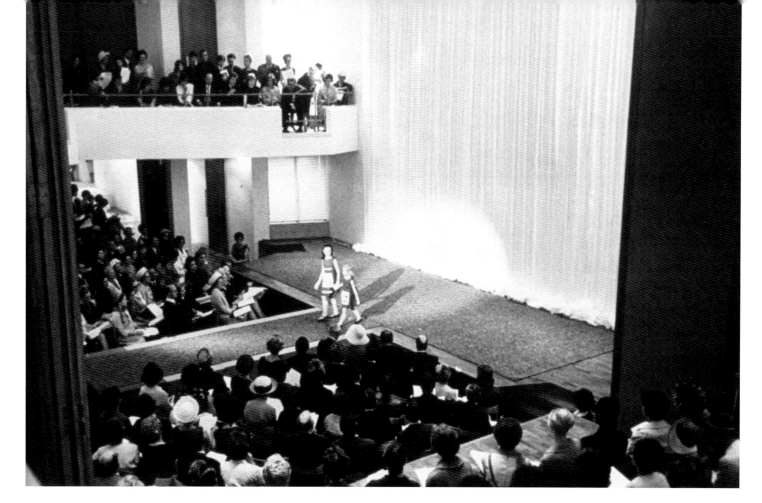

Fashion show at Kensington Gore, 1963

and London as the soundtrack to the student collections – something that had never happened at fashion shows, which had hitherto usually had innoffensive tinkling as a discreet musical background. Everyone loved it, and of course it gave the models the opportunity to show the clothes with a vibrant new energy. With the College leading the way, the world had gone mad for England's individuality and its brand-new pop culture.

RCA takeover

Industry was queuing up for Janey's students as they graduated. Those who did not wish, or dare, to set up on their own were snapped up by a variety of high-profile employers. By the mid-Sixties the younger, more modern Association of Fashion Designers (AFD) was taking over from the Fashion House Group and showing British collections in various London venues as well as at trade fairs in Paris and Dusseldorf. Its members included companies such as John Marks, André Peters and Wallis, and numerous others suddenly aware that an RCA designer might change their fortunes. During the 60s Richard Lachlan went to Hardy Amies and Lindsey Robertson became assistant to John Cavanagh; Val Couldridge and Leslie Poole went to Wallis Shops (where Sylvia Ayton also became a designer, having shared The Fulham Road Clothes Shop for four years with textile graduate Zandra Rhodes) and Pauline Denyer also went to Wallis after a time at Rhona Roy. Granville Proctor designed for Susan Small,

where he set up a tradition for special royal commissions, David Bond got a job at Slimma and Alan Couldridge was asked to create hats for Liberty; Roger Nelson set up his own label at Reldan; Christopher McDonnell worked for *Queen* magazine before starting his own business, and Janice Wainwright was at Simon Massey. Many of these companies were enlightened enough to understand that it would benefit their sales if the young designers were released from time to time to go back and teach at their former colleges, creating good relationships between education and trade. Frances McDonagh went to Bally Suisse to design shoes, Jane Elson and Julia Fortescue to Mattli, and Stella Brooks became designer at Paraphernalia in New York. Brian Godbold also went to New York, and then came back for a position at Wallis, while Bill Gibb secured a job at Baccarat. Smart young companies which had cut their teeth as King's Road or Kensington boutiques snapped up the RCA talent: Sheilagh Brown and Anthony Price joined Jane Whiteside at Stirling Cooper, and Jim O'Connor started by cutting patterns for Biba before moving on to design for Mr. Freedom. Ossie Clark joined Alice Pollock at Quorum; Rose Bradford went to Bus Stop, and both Price and Whiteside moved on to Che Guevara. Representing the mass market and always loyal to the school, Marks and Spencer consistently offered placements

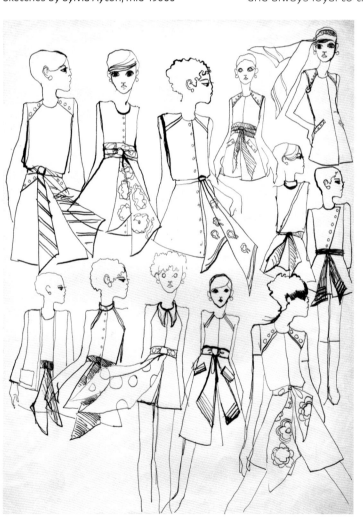

Sketches by Sylvia Ayton, mid-1960s

and employed graduating designers over the whole of Janey's period as Professor. And inspired by BEA's collaboration with the fashion school, other notable corporations began to realize that their staff uniforms needed an update, and RCA graduates such as Gerald McCann were suddenly in demand as designers of new, more modern corporate identities.

It was not only the manufacturers of women's clothing who were keen to employ College graduates. A revolution was happening in British menswear. John Stephen had opened 'His Clothes' in Carnaby Street in the mid-1950s, and followed this by taking over several other premises, many of them previously small tailoring businesses. Other boutiques followed and the pop stars who led the 60s music scene set the trends, shopping in Carnaby Street and King's Road and influencing a new type of young fashion-conscious male customer. At the suggestion of Sir Hardy Amies, the RCA Fashion course expanded to include menswear as a major subject. The *Financial Times* (27 February 1963) stated that 'the RCA is now to start training designers for men'. Hepworth, the multiple tailors, were to back this section of the course, financing it with a budget of £20,000 over seven years. The *FT* went on to say that Sir Robin Darwin held up his students' reputation as model fashion designers, while he added, in typically bombastic style, a hope that his men's fashion graduates would not turn out a 'regiment of prancing ninnies' (whether this referred to the students themselves or their catwalk collections is not clear). Referring back to the early,

Corporate clothing by graduate Gerald McCann, mid-1960s

uncharted days of the Fashion School, he intended to leave it all to the professor and her team of experts. Janey asked Dennis Hayes, fashion editor of *Sir* magazine, to be her assistant, effectively running the course which was to take five students a year. John King-Morgan, a 76-year-old retired Savile Row tailor, was to teach two days a week; Douglas Hayward, the 'top tailor to the celebrities', gave his time to advise on the latest cuts and techniques, while Gordon Deighton of Simpsons 'Trend' department provided a mass-production point of view. Anthony Powell of Sabre taught design for knitwear, and Hardy Amies himself was appointed senior lecturer and occasionally attended crits as well as giving lectures. Other visiting tutors included John Michael and John Stephen, whose original Carnaby boutiques had completely changed the British perception of menswear, giving it a youthful 'pop' identity; Peter Golding, Digby Morton and, a masterstroke for the school, Paris's Pierre Cardin whose minimal and elegant collections were the most futuristic in their use of modern technology and materials.

The first menswear intake arrived in September 1963. After one student dropped out there were three that first year, and their syllabus was much the same as that of the womenswear students – a mixture of designing, cutting and making interspersed with visits to factories, workrooms and fashion shows. Towards the end of the academic year Janey decided to include menswear in the fashion show, a mistaken choice as the subject was too new and the clothes not yet up to standard. The second year everything was much more professional, including the selection of

Menswear student Simon Foster, 1964

models. The agency models were what Janey described as 'the man's man variety',[14] in other words a bit on the camp side, so she asked good-looking amateurs such as Barrie Scott, a painting student, and the knitwear designer Kaffe Fassett, to model in the Show. This idea of using non-professional models continued as a menswear tradition in College shows, giving the already individual product an extra shot of edgy originality.

Like the womenswear course, the menswear course relied on sponsorship and goodwill from the trade, and Janey had no trouble finding eager companies to support projects. Viyella, the British cotton/wool textile giant, gave a generous travel award for a collection of shirts, and ICI sponsored in a similar way. Cecil Gee set up an annual travel award. Burtons, the high-street menswear chain, were extremely supportive and welcomed parties of students to their enormous Leeds factory. The RCA students, unique as fully-trained menswear designers, became sought after in the fashion revolution which was in full swing on the streets of mid-sixties Britain, and it was not long before students were making their mark. Early on in the course the *Daily Express* reported on the stage outfits that first-year student Michael Cavanagh created for the pop group Manfred Mann – patchwork Madras cotton trousers and grey pea jackets. Larry Willcocks was soon snapped up by John Michael, to be followed there by Brian Dower. It was not long before RCA graduates could be found in most of Britain's established menswear companies as well as at the new names which were infiltrating the hallowed ateliers of Savile Row, upstart companies such as Tommy Nutter and Tom Gilbey whose arresting ideas were suddenly challenging the traditional, reliable image of British tailoring.

Chapter 7

The Degree Debacle

By the middle of the 60s the reputation and success of the Fashion School were at an uncontested high, but privately Janey's confidence was travelling in the opposite direction. She appeared outwardly to be settled in her new flat and had met a young, handsome new partner, RCA interior design student John Wright, but she was continuing to drink heavily. The main cause may have been her guilt at the family breakdown and the personal shame of abandoning her daughter. The teenage Virginia, exhausted by her mother's behaviour and brought even closer to her father by the rift, was content to stay with him and see Janey from time to time. Christopher did everything he could to care for her, but Virginia was dismayed when she found that he too had fallen in love with someone new – a young woman named Jean Marsden, whom he had met while teaching at Maidstone School of Art. Virginia has herself documented the increasing, appalling difficulties of being Janey's daughter in her book 'Janey and Me – growing up with my mother'.

A telling interview with Ena Kendall in the *Western Mail* describes Janey's feelings. 'Her earlier feminism has become more subdued: "... I think women will always find life more difficult than men until some way is found for them not being the people

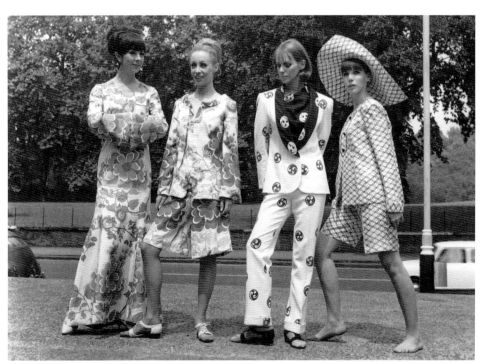

OPPOSITE Jim O'Connor's cartoon character, 1968

RIGHT Early flower power, 1964 - student designs photographed on Kensington Gore

who have the children ... if you are born to be a woman you have to get used to it and be grateful for the nice aspects of it". There were plenty of pleasant aspects, but not sufficient to rid Janey of her insecurities, and the students were beginning to notice. However, Janey's unpredictability did not put them off; it seemed to increase their respect for their revered professor. Ossie Clark's diaries record how she frequently plucked up Dutch courage to 'stealthily teeter into College' in her dark glasses; Anthony Price's admiration went further: 'We knew that she drank ... It was like having a fabulous head who took Ecstasy at work; everything she did was OK as long as she wore her long black boots, she had that ashen white face, and those big red, almost Grace Jones lips'.[1] The ever-loyal Avis Herbert-Smith would act discreetly as bodyguard, fielding tricky situations, sometimes even locking Janey into her office on particularly difficult days and asking the students to represent her at the more public meetings.

Fashion in exile

In addition to her personal insecurities, Janey's confidence had already been severely shaken by the General Studies débacle. Worse was to come. Robin Darwin, still rankling from Janey's rejection of his advances and quite probably jealous of her presentable new partner, added another insult. The Fashion School, in its rightful place high up in the Kensington Gore building, found that it was to be banished again – to a crumbling Victorian terrace, one of the College's old outposts at 23 Cromwell Road. The excuses given were that more space was needed for research projects and for the School of Stained Glass, which since it had won the prestigious commission of designing a series of enormous windows for the rebuilding of Coventry Cathedral had expanded and taken on further contracts. The fashion studios (immediately below Darwin's top-floor domain, with its double-height private *atelier*) were singled out to be requisitioned. There may have been another reason. Although the College as a whole was enjoying enormous interest from the worlds of art, design and media, Fashion (by its nature and via Janey's assiduous networking, a magnet for the press) was by far the highest-profile and best-known department. It seems that Robin Darwin and some of his professors, particularly those who still couldn't believe such a subject was more than female folly, were resentful of Fashion's success and would do anything to detract from its reputation and to denigrate its leader.

Furious and disappointed at this exile, Janey's self-respect was so seriously damaged that the drinking became much, much worse and eventually she was admitted to a drying-out clinic, staying away from work for several months. Her loyal and committed staff stoically helped the students to get on with their work, and the press was never far behind them. From 1964–66 Ossie Clark and his designs were frequently on the fashion pages of *Vogue* and other journals, and his girlfriend Celia Birtwell's prints were used for a Simon Massey collection designed by Janice Wainwright and Maggie Derrick, sponsored by the *Daily Express*. Janice Wainwright was also featured by Anne Batt of the *Evening News*, modelling her own 'gold lamé pants' with pop singer P.J.Proby (himself notorious for splitting his skin-tight

RIGHT The Fashion School's home in exile, Cromwell Road

BELOW Ossie Clark's final collection, 1964, with prints by Celia Birtwell

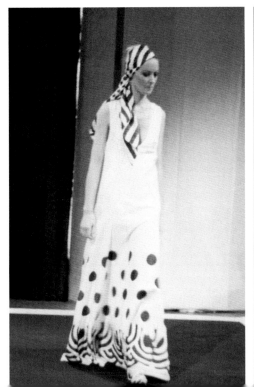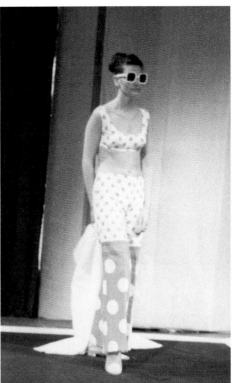

Student designs l–r, top to bottom: Angela Sharp, evening coat 1964; Roger Nelson, lurex suit and hat 1964; Anne Matthews, print resortwear 1965; unknown designer, space-age metallics c.1966

Psychedelic Show invitation, 1966

1966
Dress Show

The Council and Principal
of the Royal College of Art
invite you to attend the
1966 Dress Show of the

School of Fashion Design
to be held in the Hall
Kensington Gore SW7
Tuesday 28 June at 11.30

This card will not
secure admission
Please return attached
postcard for ticket

Please send
ticket of admission

Dress Show
28 June at 11.30

name

address

trousers on *Ready Steady Go*) to prove that 'five of London's swankiest restaurants' would admit such a couple. There was also much interest in students whose arrival at the School was not by the usual art-school route, and several journalists held interviews with Hylan Booker, the School's first black student who enrolled after four years as an airman at a US air base in Gloucestershire. (Incidentally, the writer Iris Murdoch who was lecturing in General Studies at the time, befriended him and helped him finance his first visit to the Paris shows.) In more general terms, prior to the end-of-year shows in 1965, the *Observer* published a major article entitled 'Students Change Gear'. The *Sunday Times* featured a collaboration between the RCA and Kangol headwear; an exclusive pattern for Frances Last's cowl-neck shift was offered by the *Daily Telegraph*, and Jean Rook of the *Sunday Express* ate her former vitriolic words and printed do-it-yourself party-hat patterns by Brian Harris for Christmas 1966. *Harpers Bazaar* honoured Janey with its annual award for Creative Design (though she was quick to credit the students rather than herself). It was no wonder that the legendary Ernestine Carter of the *Sunday Times* wrote 'the students of the School of Fashion, RCA, must be the busiest designers in the business'.

While the Fashion School was keeping the industry well-supplied with designers, and the press with stories, a calamitous storm was brewing. Robin Darwin, knighted for services to education in 1964's New Year Honours, had ever grander ideas for the College. The government's Coldstream educational report of 1960, in whose recommendations Darwin had been involved, had resulted in a great improvement in the quality of student work coming out of regional and other London art schools, and Darwin felt that the College's unique status as an institution of advanced learning in art and design now needed to be recognized. He set out on a mission to achieve this upgrade, its target to gain parity for the RCA with the peerless ancient universities for which British education was so admired.

A committee was appointed, consisting of members of Council, professors and tutors. The process of preparing for the Royal Charter application was a massive undertaking, and many staff, though not entirely disapproving of the idea, resented the time they had to spend working on it, away from the students who were their real reason for being there. Because the practical side of the College's output was unique and therefore genuinely beyond compare, the aspect most discussed was the scholarly side – research, general

studies and the relevant support systems such as the Library. Over the next two years the draft Charter document was adjusted and readjusted. There were many issues under discussion: staff tenure was one, as Darwin had a strong belief in short contracts so staff could not 'stagnate' in their jobs; retirement age was another, set at 60 for women and 65 for men (though, unexpectedly democratically, Darwin would have liked it to be 63 for all).

A monstrous slur

Although certain members of the University Grants Commission found it hard to understand that a school of art and design deserved higher academic status, in 1967 the Ministry of Education finally agreed that the College should have the power to award degrees to all courses considered appropriately academic. But there was a stumbling-block – Fashion. It may be that Janey's early reluctance for fashion students to attend General Studies lectures was an excuse dug up by Darwin to sideline the subject as flippant, lightweight frippery, in spite of the school's obvious success and the emergence of so many talented designers for industry. In Professor Hugh Casson's classic statement, fashion was a word that 'stuck in academic gullets'.[2] Every other school was to be enabled to award a degree to its students; Fashion students would simply get a diploma. The official reasons given for this malevolently unjust decision were unconvincing and could have been applied to any of the design schools: the subject was 'ephemeral' (as, by its synchronous nature, is much design); the school was too involved with industry (odd, when the college's original remit was to educate industrial designers); apparently it did not fulfil the criteria set out to assess suitability for a degree. There were uncomfortable divisions amongst the College's senior staff; several of them were bold enough to risk enraging Darwin and to give the devastated Janey their backing, realizing Fashion's undeniable value to the College. Across the College the disgusted students reacted strongly, with the Union summing it up in a letter to the Academic Advisory committee: '… if once the cause of fashion or contemporaneity were to be denied, the work of the College as a whole would be swiftly impaired'.[3] Union activists also circulated a document titled 'An Insult', stating '… unless the fashion school … is granted the same status as the rest of the College, that status will be meaningless and an insult to the intelligence of all the students of the College, and the design profession as a whole'.[4]

The industry and the fashion press were quick to express their scandalised reaction to the decision. The president of

Miami-style mirror invitation, 1967

The Council and Principal of the Royal College of Art invite you to attend the 1967 Dress Show of the School of Fashion Design in the Hall, Kensington Gore, London SW7 on Wednesday 28 June at 5.00. *This card will not secure admission.* Please return the card below for admission ticket.

the Incorporated Society of London Fashion Designers and the chairman of Courtaulds organized petitions and letters to *The Times* signed by powerful heavyweights including Mary Quant, Geoffrey Wallis and Miki Sekers. Influential wives of press magnates and eminent politicians added their support. Fashion editors of all the major newspapers gave up their pages to a unanimous attack, and the formidable Beatrix Miller of *Vogue* wrote '… the decision to withhold university status from the Fashion School is harmful to the prestige of the whole industry'. The Student Union continued to fight the monstrous issue. Janey's health took a dramatic turn for the worse, and in July 1966 she was admitted to Regent's Park Nursing Home with 'a serious liver complaint'. Throughout the following academic year her fragility affected her ability to teach, and a letter from her doctor dated 23 October 1967 states that she was 'now suffering from nervous debility and … should absent herself from work for approximately 3 months'.[5] The School soldiered on and with credit largely due to Joanne Brogden, Anne Tyrrell and the rest of Janey's loyal team, the students did their best to ignore the disruption and carry on regardless.

The Royal Charter giving University status to the College was finally conferred on 2 November 1967, in a grand and splendid formal ceremony in the Gulbenkian Hall in the presence of HRH Prince Philip. This was followed the same evening by a 'soirée' attended by HM the Queen and HM Queen Elizabeth the Queen Mother. Janey naturally declined the invitation, but her decorative and eye-catching students were

Royal party for the Charter ceremony, l–r: Lady Darwin, HM the Queen, HM Queen Elizabeth the Queen Mother, Sir Robin Darwin, with HRH Prince Philip in the background

insensitively asked to act as waiting staff and, never ones to miss a good party, some of them accepted. The Queen Mother's ill-advised comment on being introduced to a Fashion student, 'oh, you're one of the poor ones who hasn't been given the accolade',[6] didn't go down at all well. Although as a group they had ignored the charter disruptions as much as they could, preferring to get on with their work, Sheilagh Brown remembers the 'fracas': the pomp and quite ridiculous ceremony, the royal guests, the trumpet voluntary and (probably as a sop to the disgruntled students) a huge all-night after-party with unlimited alcohol, and music provided by Pink Floyd and the Rolling Stones.

One of Robin Darwin's later comments was that the Fashion students rarely went into the teaching profession and therefore had no need of a degree. This further snub could have applied equally to graduates from other schools and was yet another insult. Just because the Charter had been conferred, it didn't mean that the matter was laid to rest, and it was taken up by the National Union of Students. Darwin began to get scared. After talks with the executive member of the NUS responsible for art school affairs, he appeared to give in a little, admitting that perhaps students receiving a diploma in academic year 67/68 would be able to convert to a degree the next year. This made a mockery of the whole issue, indicating that a severe and unnecessary error had been made. But it was all too much for Janey, and on the 20th December she wrote a note to Darwin offering her resignation at the end of the academic year. Stating that she found it impossible to follow policies she did not believe in, she added 'An unhappy professor is no use to bright young people . . . events put me into a ridiculous position. A professor can't be seen to be openly against the authorities . . . it is better for everyone that I grasp the nettle firmly now'. Almost by return of post she received a reply accepting her resignation, with no question of discussing the situation. In this Darwin professed to be sorry that Janey had been unhappy, but (digging up yet more old excuses) could not pretend that she had made things easy regarding the school's move out of Kensington Gore. He was quick to emphasise that 'the idea of not renewing your contract hasn't entered my head', clearly a blatant lie which Janey refuted 'on good authority' in her reply.

In Janey's RCA staff file there is a surprising letter sent to Darwin shortly afterwards by John Moon, the College's amiable registrar, who had supported the Fashion School's cause against Darwin's will; he had even gone so far as to tell the *Sunday Times* that Janey was 'irreplaceable'. It seems odd, therefore, that in this letter he agrees that Fashion should not be given Master's status. He pronounces a feeling that 'the glamour of the Fashion School is losing its appeal in the provincial centres [this was entirely untrue]. I wonder if the RCA has now done its job by training a large number of proficient and successful designers, and fathered fashion schools like Kingston and Walthamstow.' He then makes a bizarre suggestion that perhaps Fashion should now be phased out of the College – 'The timing of the announcement is of paramount importance'. Could Moon have been bullied into writing this? His statements are in total conflict with his normal supportive attitude, and seem suspiciously out of character with his customary fairness and diplomacy.

The resignation notice went public on 5 January. The College switchboard, correctly expecting to be bombarded, was given a list of possible answers to phone queries:

1. Janey had been ill for 3 months. (This statement was supported by a letter, perhaps solicited by Darwin, from Dr Selby warning that severe stress might 'precipitate a recurrence ... with serious consequences.' He strongly recommended that she find alternative work with less mental strain).

2. 'The Rector himself doesn't know the reasons – a complete surprise'. (Obviously a blatant lie).

3. The whole question of degrees is up for review in February. (This again underlines the dishonour of the whole situation).

In the meeting of Council on 28 February, item 7 was 'To convene a joint committee of Council and Senate to consider many questions affecting the academic future of the College, the first of which shall be the future of the School of Fashion'. Item 13, well down the list, was to note the resignation of Mrs Janey Ironside from 31 August 'owing to ill health'.

In spite of the shame and anguish of the situation, Janey was encouraged to continue working for the rest of the academic year, boosted by the loyal support of the students and staff, many of her colleagues and numerous eminent names in fashion. It must have been agonising for her to be at the College, but her interest in the students overrode her distress and she stoically continued. One of the subjects

Moulded PVC collection by Victor Herbert, 1968

which fascinated her at that time early in 1968 was the idea of new technology in clothing, garments which were moulded and welded rather than sewn. She procured a grant of £1000 to set up a research section within the schools of Fashion and Textiles. Victor Herbert, a third-year fashion student who had previously studied woven textiles, used some of this money to perfect a method of vacuum-forming PVC on an aluminium mould (developed in the school of Silver and Jewellery) and

Catalogue cover for the 1968 Show, Janey's last, with students looking decidedly dejected

created a garment with no stitched seams, its details heat-welded on. Herbert's designs had been inspired by the work of the French designer Courrèges, whose much-admired 'futuristic' collections Janey described as 'the hyphen joining yesterday and tomorrow',[7] and the moulded jacket was immediately shipped out to New York to feature in an exhibition at the city's Museum of Contemporary Art.

The show had to go on, quite literally, for Janey's final Fashion Show was looming, travesty as it may have seemed. The NUS, continuing discussions with Janey, suggested that the Show would be a powerful platform for a large student demonstration but Janey, though determined not to let the miserable matter rest, did not want the disruption. With the help of Bruce Archer, the RCA's Senior Research Fellow, she drafted an address for her professorial colleagues clarifying how fashion as a subject was no different from any other design discipline intended for commercial consumption. Her arguments were picked up and supported by the press, and the staff had no option but to agree (many of them with relief). Darwin reluctantly re-opened the matter with the Academic Advisory Council, the NUS upheaval was abated, and in the end it was agreed to give Fashion degree status the following year, with retrospective degrees awarded to the 1968 graduates. Too late for Janey, she described this as a 'pyrrhic victory', a battle won at too great a cost – in this case not only the distress of the students but also the unfair loss of a prestigious job, leading to severe depression – to be remotely worthwhile for the disgracefully displaced victor.

Janey's last Show

The Show was scheduled for 26 June 1968. Janey threw herself into the planning and preparations, but was again admitted to hospital on 12 June. In Virginia's account she reports that at this time Janey often made disturbing references to suicide, but she managed to be discharged in time for the big day, finding on her return an unctuous and blatantly insincere letter from Darwin: 'I do hope you are yourself … will be able to be at the Dress Show. Poor Janey, what a time you have had'. The graduating group was a particularly flamboyant one, memorable moments including Anthony Price's smouldering glamour-girls and zingy strip-cartoon style by Jim O'Connor. Victor Herbert showed his revolutionary moulded PVC. Project work took two directions, experimental and romantic. Vidal Sassoon did the hair (without a fee, a generous gesture which was to continue at College shows well into the 21st Century) and the soundtrack was a mixture of live and recorded music, ending at full volume with The Beatles' *She Loves You*.

It seems almost impossible that Janey's second book, *A Fashion Alphabet*, was published in 1968 during this very turbulent period of her life; presumably she had been working on it for some time. It was a stylishly designed, simple yet comprehensive illustrated dictionary of fashion and textile terms (some now near-obsolete), divided into generic sections. The publishers, Michael Joseph, must have been happy with it, and after her resignation, Janey was asked by them to write an account of her College years. In an interview in *The Daily Telegraph* she said 'I've told

Menswear design, 1968: John Hicks's modern sportswear, Lily Parker's man-about-town

my literary agent that I thought the whole of it would be libellous, but he said just write it and we'll worry later'. It seems that in August 1971 Michael Joseph talked to Prudence Glynn of *The Times* (who had been an eminent member of the RCA Council) and that in Darwin's view she had subsequently published 'false and defamatory statements' although, if the article is read, it appears to contain nothing slanderous or untrue. Darwin, on the point of retirement himself, wrote Glynn a disingenuous 7-page letter in order to set the record straight, on his own terms at least.[8] Obsequiously explaining how assiduously he had supported both Janey and Christopher in their professional lives, he reported how well everything had gone until the General Studies issue in 1961, when her vitriol had caused the resignation of a senior member of staff. As a result she lost the confidence of her colleagues and, in spite of her being wrong, Darwin excused her 'partly because she is a very attractive woman' and partly because she was so outspoken that she could be dangerous to the College's reputation.

The next item in Darwin's letter discussed Janey's reaction to the relocation of the Fashion School to 23 Cromwell Road. He pretended that he didn't understand what all the fuss was about. Janey from this time 'ceased to be for practical purposes a real member of staff, declining to lunch in the Senior Common Room (though, due to the Fashion school's ejection, it was not within easy reach) and losing 'all credibility with her senior colleagues'. He then moved on to the Degree debacle, wrongly blaming Janey for a smear campaign starting with students, then absorbing a handful of staff, Council and finally the Press when she got the support of Ernestine Carter to whom, according to his somewhat scurrilous words, she 'leaked confidential Academic Board information'. Darwin then cynically proceeded to make

light of the whole issue, emphasizing how diplomas received that year could be converted to masters' degrees the following one, and stating that Janey 'had no reason for her disgruntlement whatsoever'. Her resignation, contrary to the notices he had put out earlier, came as no surprise, and he disagreed with Prudence Glynn's view that 'this action was as unnecessary as it was mutually disadvantageous' – she had burned her boats. Darwin's letter implied that he felt Janey regretted it later, and summed up by referring to the fact that although she had personal difficulties, these were no excuse for her behaviour. He ended by saying that this experience was the saddest in his 22 years at College; without question Janey was 'such a very brilliant and electric person for whom there never will be a proper replacement'.

Janey's memoir was finally published in 1973. It is truthful but diplomatic, never accusatory and often very funny – although she disliked writing, it came naturally to her and her words constantly highlight her pragmatic character. The concluding paragraphs sum up the things she loved best in life – travel, teaching and of course fashion, and the enormous pride she felt in having been able to nurture the star designers whose work represents British style – 'not necessarily 'chic' but *beautiful*.' The following year, on the twenty-fifth anniversary of the Fashion School, came a plea from Barbara Griggs of *Femail*: '. . . isn't it time the fashion world put up a statue to Janey Ironside . . . or struck a medal or SOMETHING?'

Janey Ironside's influential life ended in April 1979. She had spent her post-RCA years as a designer, consultant, part-time tutor and writer. The phrase 'fashion icon' is nowadays too frequently used, almost always incorrectly. But, as Virginia Ironside says, her mother **was** an icon – shining, fragile, to be admired and to some extent worshipped – a stylish symbol of everything to which she aspired for her school. Janey, self-deprecating and astute, had 'often wondered if I'm just a cartoon figure' and her graphic, individual appearance certainly set her up as an idol for her students. She moved the Fashion School out of the 50s into the Swinging Sixties, set it up as a model of its kind (though for a long time after, nothing else was comparable) and shaped the business of London fashion with the talent of its students. Beatrix Miller summed up her charismatic leadership when she said 'One rarely finds an exciting new venture in fashion without finding an RCA student there too'.

Chapter 8

Joanne Takes Over

Fred Dubery, *Symphony in Pink, White and Blue* (detail). Joanne and Fred on holiday with friends

Gina Lavender's sharp daywear, 1969

No-one can easily succeed a genuine star, and Janey Ironside's legendary reign was the most challenging act to follow. Although the latter part of her leadership was marred by ill-health and absences, it was her dedication, her charisma and her presence as Professor at such a seminal time in the College's history (and particularly in that of the Fashion School) which so solidified her reputation as an unforgettable influence in fashion education. One of Janey's key talents was her ability to select the right staff. Soon after her arrival as Professor, she had recruited Madge Garland's ex-student Joanne Brogden (1950–53) as her personal assistant, echoing Madge's recruitment of Janey herself. Joanne had been 'a bit of a favourite' for Madge, a strong and successful student who had been singled out (for better or worse) to adjust or repair Madge's couture outfits if attention was needed,[1] and Janey described her as a 'frightfully good' designer who possessed 'tremendous taste'[2] – perhaps not groundbreaking in concept, but chic and modern in style, uncompromising and technically excellent. Joanne accepted Janey's offer of a part-time position as 'assistant and tutor', and a shining career at the College was in its infancy.

Little is known about Joanne Brogden's early years. There are differing accounts of her childhood, but what is consistent is that she appears to have been abandoned by her parents at a very young age. She was born in 1929 and originally christened Winifred; in one version of her history, she was an only child brought up by her grandmother;[3] in another, she and her brother were adopted and brought up by an aunt and uncle.[4] Her childhood was not happy and her education probably patchy, as indicated by her poor spelling and written English. Her home address in 1940 was Kenton, Middlesex and as a student she got a place at Harrow College of Art, which must have been a welcome liberation. Her fascination with the three-dimensional figure suggested that she should study either fashion design or sculpture. Fashion narrowly won, and in Winifred's final year she was taught by Maggie Shepherd (married to Peter Shepherd) who was herself freshly-graduated from the RCA, having started there before Madge had arrived as

professor, and who encouraged this talented student to follow in her footsteps and apply for a place.

When Winifred arrived at the College, Madge Garland (curiously echoing Gertrude Stein's advice to her years before) insisted that she change her name to something more fitting for a designer. So 'Joanne' she became (though variously recorded as 'Joan' and 'Joanna'), and proceeded to flourish as one of Madge's most successful students. In 1952 she won the first Bianca Mosca scholarship, and as a result went to Rome where she worked in the grand, rather conservative fashion house of Fabiani, known for its luxurious but uncluttered style; an experience which, though Joanne's own designs were similarly inclined towards the minimal, she did not really enjoy. The scholarship then took her to Christian Dior, where she loved working and discovering the ways of the highest echelon in *haute couture*. Joanne graduated from the College in 1953 and was immediately offered a job at Susan Small. After the happy experience at Dior, she found it difficult working with people who were 'set in their ways, and wouldn't adapt'.[5] It is not clear how long she stayed there, but there were other jobs (even including one in Carnaby Street, then a dilapidated backstreet), which she undertook at the same time as teaching part-time in the small fashion departments at Brighton (where she taught Barbara Hulanicki, later to become famous for her phenomenally successful 'Biba' brand) and Hammersmith schools of art. She was offered the position of head of the fashion school at South-West Essex Technical College and School of Art, Walthamstow at the very beginning of 1960, following the formidable Daphne Brooker, who herself went on to run the highly-respected fashion course at Kingston School of Art. Joanne, managing the school at the same time as keeping her part-time post at the RCA, evidently felt more comfortable passing on her knowledge as a teacher rather than as a professional designer in a commercial situation: Tom Bowker remembers, as an RCA student, seeing some of her freelance design work for an unknown company and being horrified at the surprisingly 'unworkable' shapes she was offering – 'her real forte was teaching'.

Exciting times at Walthamstow

Walthamstow in the 1950s and early 60s was an exciting college. The enlightened heads of fine art, fashion and textiles were employing young tutors, themselves barely out of college, to work with the students. Fine art tutor Peter Blake, who had graduated from the RCA in 1956, remarked that it was his proximity in age to that of the students which made them so receptive to his 'pop' vision. A young tutor from Manchester called Celia Birtwell (later to form such an important partnership with Ossie Clark) came in to teach textile design, and there was a general creativity and a vibrancy which nurtured such students as Derek Boshier, Ian Dury, Sylvia Ayton, Marion Foale and Sally Tuffin, all of whom went on to the RCA. The future film director Ken Russell and his costumier wife Shirley met at Walthamstow as students at the same time; in 1962, Russell was commissioned to make the film 'Pop goes the Easel', a portrait of RCA artists Peter Blake, Pauline Boty, Derek Boshier and Peter Phillips, for the BBC programme 'Monitor'.

The work ethic at Walthamstow was strong: Sylvia Ayton remembers that drawing was very important and there were evening classes every night, with the outrageous Quentin Crisp often posing as a life model, dressed in costumes borrowed from the Players' Theatre in London. There was no let-up for fashion students at the weekend, when they were given a project to be handed in on Monday morning. The pressure worked, and from the late 50s until the middle of the 60s, an unprecedented number of Walthamstow students made successful RCA applications and played an instrumental part in the great explosion of talent, the 'youthquake' which created Swinging London and put Britain so firmly on the international cultural map.

When Joanne arrived at Walthamstow she was married to Don Higgins whom she had met as a student, a graphic artist employed by the advertising giant J.Walter Thompson, whose work was becoming well-known through his illustrations for *The Radio Times* and other publications. Don was 'a very cool guy with sharp mohair suits' who reminded student Paul Babb of 'a young Gerry Mulligan'. They lived in a small modern house in Dulwich and also part-owned a cottage in Antibes, on the Cote d'Azur in southern France. Don contracted tuberculosis and, once Joanne had nursed him through it to full recovery (an additional and difficult commitment in her already demanding programme) he took on a new, reckless persona, drinking hard while perhaps imagining he was living on borrowed time. Married life was evidently not tranquil and the students observed that Joanne, a private person by nature, would come into college in a troubled state, smoking incessantly and finding it hard to share her problems. In her early years at Walthamstow she noticed, amongst the charismatic crowd of fine art staff, an unusually-dressed young man who wore, untypically for the tutors, a beautifully tailored tweed suit. His name was Fred Dubery and he was to become her second husband. A Surrey boy, also an only child and the son of a dental mechanic, he had experienced a happy and protected childhood. In the Second World War he was a mapmaker for the Allies, and wherever he was in France or Germany, his subscription copies of *Vogue* would follow him. His parents had been nervous about allowing their son to enter the risqué, bohemian and, possibly on account of the *Vogue* habit, suspiciously effeminate world of art and design, but from his local foundation course in Croydon he had applied to the RCA and had got in (he was there at the same period as Joanne but they appear not to have met). Once he had graduated, as well as teaching at Walthamstow Fred became a visiting tutor in the Royal Academy Schools where he rose to the post of Professor of Perspective, and he later taught regularly at the RCA. He was a rigorous and disciplined worker, painting two of his 'firmly figurative but gently impressionistic' paintings each day.[6]

Fred's comfortable stability was just what Joanne needed, and once her divorce had come through they decided to get married in the summer of 1965. In her open-top Triumph Herald, they drove to Antibes, where they were aiming to wed; unable to arrange this (possibly as she was a divorcée) they were eventually married at the British consulate in Marseille. She wore a black-and-white floral suit designed by Maggie Shepherd, and with her high-gloss glamour and his English professor, corduroys-and-pipe style the French must have found them a strikingly unusual pair

Wedding day, 1965

(though Joanne did proudly recount how she had persuaded Fred to wear a formal jacket, white shirt and tie for the wedding). Visual opposites, they embarked on a life of complete devotion to one another, always spending as much holiday time as possible in France and Italy where they pursued their shared love of local cuisine, regional wines and their admiration for French and Italian art. They continued to live in Dulwich, and rented a romantic, crumbling moated house in Rattlesden, Suffolk where they would spend idyllic weekends scouring junk-shops and markets, creating a garden and entertaining friends.

Joanne's leadership at Walthamstow continued Daphne Brooker's record of regularly supplying the RCA School of Fashion with talented students. It was evident that her success was much admired, as was recognised in 1962 when Robin Darwin, in an exchange with Janey Ironside, indicated that he thought Joanne was doing an excellent job.[7] Teaching part-time at the RCA while running the Walthamstow course gave her inside (some might say incestuous) knowledge of Janey's department. She was able to nurture and prepare appropriate candidates for their RCA interviews, and she made arrangements that they should always see the College end-of-year shows. Out of her first group of graduating students, four successfully obtained 1963 places – Paul Babb, Frances Cowper, Hilary Dyer and Brian Godbold. Stephanie James, in the same year, actually applied early and was accepted in 1962. This little band, christened the 'holy year' from Walthamstow, took advantage of already knowing Joanne and by the time they arrived at the College were so well-absorbed into the student social scene that the resident barman assumed they had been RCA students for some time. Babb describes Joanne at that time: in the mornings she would come in to Walthamstow 'immaculate – perfect hair and nails; she would put her bag down, her cigarette out, a petrifying presence'. In critiques she could 'crucify' a student, following a terrifying and well-worn path set by Daphne Brooker and

filtering down from Madge Garland's days. Her forthright manner hid a second side – compassionate underneath, Joanne was thoughtful and encouraging, and Tom Bowker remembers that when he failed to get directly into the College from his foundation course his tutor received a letter from Joanne indicating that he 'must not be allowed to give up'. Like Janey Ironside, Joanne evidently had a talent for recruiting the right staff, and in 1965 she brought a new young visiting tutor in to teach at Walthamstow, Janey's ex-student Anne Tyrrell, who was working as designer at commercial fashion house John Marks. The following year Anne was asked by Janey to go back to the College to teach part-time there alongside Joanne, launching a close relationship with the fashion school which was to last well into the 21st century. Although some of the students decided that pattern cutting, the crucial technical element of the course with which they always needed guidance, was not Anne's forte, they were admiring of her understanding of creative design and her tireless commitment to the course. They adored her Sloane Ranger glamour, gold bangles clanging as she worked, and the tongue-in-cheek humour in her plummy Knightsbridge drawl.

When Janey Ironside resigned early in 1968, Joanne had already been doing her best to keep the fashion school on its feet for the previous devastating year. She was dedicated in her support of the students, these 'delightful people … whose skills are right and whose knowledge is erudite'.[8] In addition to the goings-on at College (where Fred was now also employed, as part-time senior tutor in painting) and her commitments at Walthamstow, this must also have been the year that she received a commission from publishers Studio Vista to write a book titled 'Fashion Design'. Personal life was busy too. She and Fred had found the perfect Suffolk home, a former dairy farm at Buxhall near Stowmarket. The house was originally Tudor with the addition of a Georgian façade, and its rambling garden and outbuildings overlooked an orchard and a meadow. It says a lot about the couple's energy and, particularly, the stable nature of their relationship, that they managed to buy and begin to work on this large project at such a crucial and busy time in Joanne's career.

Taking over Fashion

On Janey's departure Robin Darwin carefully announced the appointment of Joanne Brogden as senior tutor and head of department, 'pro tem' for academic year beginning September 1968. In an interview with Ernestine Carter for *The Sunday Times* in April of that year, he said that the future of the School within the College was assured. Miss Brogden would have a head start 'for whatever post the Council eventually decides to offer', and the students would almost definitely be able to receive degrees, retrospective or current. Ernestine Carter quotes Darwin in the same article as stating that 'Mrs Ironside has proposed a new syllabus of training' for a degree course in fashion; before her departure Janey, in spite of being the subject of such demeaning treatment, had seemingly worked on a 'Degree Course Curriculum'. Joanne handed over her Walthamstow duties to Frances Cowper (of the 'holy year') and took on the upkeep of the School of Fashion, hoping to instill a new era of calm and security after the drama of recent events.

Although Janey had been such an inspiration, it must have been a relief for the staff and students to regain stability within the School. However, with degree status in Fashion finally agreed for 1968–69 graduates, another major change was taking place. Mainly as a result of financial cuts, it was decided to reduce the length of the College courses from three years to two, with commercial projects becoming all the more important as necessary sources of funding for the school and the students. Joanne's first Annual Report (her more pedantic style taking the form of lists, unlike Janey's less formal approach) records projects with Antartex sheepskin, Liberty prints, Jaeger (with Madge Garland's graduate David Watts) and the couture house of Bellville Sassoon (David Sassoon was another star from the same era). During the year mini-shows were staged for projects with ICI Fibres (new laminated fabrics), the International Wool Secretariat, and the silk producers of Lyon – European industry was getting interested. The list of visiting speakers included established designers and notable figures from the business, as well as such admired luminaries as Cecil Beaton, and Joanne included a warm paragraph of personal thanks to the staff for helping so efficiently with the changes at the top.

Puzzling mini-skirt image for the 1969 Dress Show programme

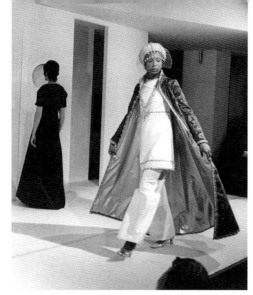

Graduate collections 1969: Graham Wren's exotic elegance; laid-back glamour from Tom Bowker; childrenswear by Jenni Russell

It seems that the School of Fashion was the first in the College to reduce the length of its course. The transition of students from three to two years of study took place remarkably smoothly with the first cohort graduating in 1970, and although the number of commercial projects allowed less time for independent personal development they encouraged freedom of design within a given brief. Up to this point, much of the timetable had been unstructured and the College's new need for industrial support encouraged a more focused way of learning – the creative 'head of steam' suggested by Lord Esher (the architect Lionel Brett) as he prepared to take up his post as Rector on Robin Darwin's retirement in 1972. In addition to projects set by industrial partners, the school's new Masters degree status meant that research was high on the agenda. Victor Herbert's experiments with vacuum-forming and welded clothing inspired an ongoing project, one of his collections featuring 'pre-fashioned' knitwear. Joanne, while appreciating research into modern techniques, was adamant that the students should understand the structure of 'conventional clothing' before taking off in a futuristic direction. She felt strongly on the point of taste (something which, being totally subjective, is perhaps impossible to teach) and quality: '. . . there *are* standards in the art of living . . . we're growing out of the era of the quick, slick throwaway. I feel that this [emphasis on quality] has only to be encouraged to grow stronger'.[9]

The early 70s saw a revival of interest in knit fabric and garment, resulting in 1971 in the setting up of a new knitwear option within the course led by Louis van Praag, creative director of the upmarket Sabre knit company. The majority of other projects were British-led and diverse (Harris Tweed, 'Lybro' denim, moulded accessories for BXL Plastics), but there was also increasing interest from abroad. Paris's giant *Semaine du Cuir* continued to commission a promotional collection, supported by several large British tanneries and the British Leather Institute. Illustrious international schools Bunka (Tokyo) and New York's FIT both visited the school in 1970. Though there were many enquiries from industry in both Britain and Europe, Joanne recorded that students were very 'choosy' about jobs (an attitude which may have been seen as arrogant, particularly at a time when Britain was

 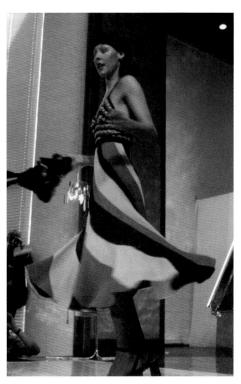

A vibrant new era – men's, women's and knitwear from the 1971 collections

about to join the European community) and it is interesting to note that graduates often took up work with smaller London businesses rather than large manufacturing companies. This may have been partly because many of the jobs offered were with little-known names which were nevertheless sizeable suppliers of the successful 'young fashion' departments of stores such as Miss Selfridge, Harrods 'Way In', and Peter Robinson 'Topshop'; or simply that some of the established companies offering jobs had a less than modern image, unappealing to a young designer. Many students preferred the idea of working with boutique names that meant more to them such as Tuffin and Foale, Jeff Banks's 'Clobber' and 'Mr Freedom', even if they were small companies existing on a shoestring rather than the bigger, more commercial manufacturers who would offer the security of a better salary. Since the previous year, Clobber, Quorum, Stirling Cooper and John Marks had been amongst the British brands receiving financial assistance from the Clothing Export Council (established in 1965) in order to show together at the Paris *prêt-a-porter* fashion trade fair. Jeff Banks reported that the British 'tore into the French' and their more reserved fashion labels, making Paris sit up and take notice if not actually invest in these alien designers.[10]

From the early 1970s most of the major design houses also used contractors and outworkers, ranging from individual seamstresses and family businesses to units of up to 100 workers. Since the 50s, industry had sourced labour, often female, away from London, and the bigger companies had set up huge factories in south Wales, the north-east, and western Scotland. These suppliers were able to use advanced administrative and streamlined production methods. They understood and supplied classic designs, as opposed to small-production 'boutique' methods. It was a time of

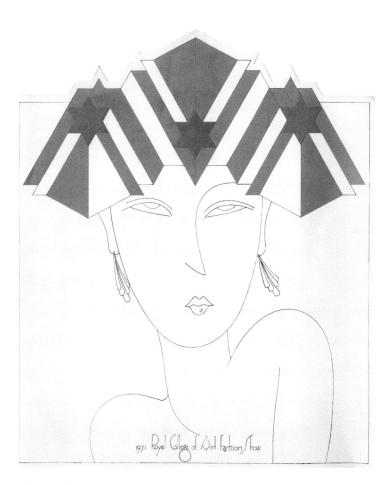

1971 Royal College of Art Fashion Show

1971 invitation – the title 'Fashion' has replaced the somewhat outmoded 'Dress'

change for many independent ready-to-wear houses which were private companies with limited capital, reluctant to spend their assets on up-to-date manufacturing methods. Many were absorbed by larger 'parent' companies, while doing their best to retain their original individuality. Dereta was bought by Ellis and Goldstein; Susan Small by Courtaulds; and Frank Usher by the huge Selincourt group, which owned 21 other companies and also manufactured for M&S.

1971 was a major year for Joanne. In Darwin's final months as Rector she was made professor of fashion, and at the same time her book *Fashion Design* was published. The modest paperback handbook sets out to introduce someone with visual training and a genuine interest in the subject to the historical and practical aspects of design in 'this fascinating trade'. Joanne (in a style of writing much more prosaic and earnest than Janey Ironside's easy delivery in 'Fashion as a Career') affirms that one short book cannot teach the art of dress design, but that this provides an outline of the world in which the designer works. The first chapter, 'The Great Fashion Designers' (almost half the length of the book) gives a brief history of the fashion business, beginning with the Parisienne milliner Rose Bertin (1770s) and progressing via a list of personal favourites chosen for their innovative ideas. The following chapters concentrate on design training and ways of formulating ideas; colour, fabric and silhouette; how to develop ideas and preempt trends (although this, understandably, appears to sideline the undeniable fact that intuition is the

Fashion Design
Joanne Brogden

Basic bodice and sleeve shapes

Cover design and illustrations by Joanne from her book *Fashion Design*, 1971

most important attribute for a really strong designer, and one that can't be taught); designing for particular markets, and how function affects design. The book moves on to discuss the levels of fashion ('Haute Couture, Boutique and Ready-to-Wear') and explains each area and its systems. Joanne's interest in production indicates her understanding of the rapid advancement of technology and how it will revolutionise the business. A final chapter entitled 'The Profession' explains how to get into it, and the options: in-house designer, own business, freelance designer, teacher or consultant. There are a few examples of clear fashion sketches, uncredited and probably by Joanne herself. The book is a realistic view of the business and does not glamorise it; the text reflects the state of the industry at the beginning of the 1970s, when the carefree, idealistic attitudes of the 60s were no longer viable. Largely thanks to the British art-school system, every company now had its young designers and competition was strong; impetus needed to be maintained in a much tougher, more commercial world. Having taken note of how London had been at the creative forefront in the 60s, the eyes of the international fashion world were focused on Britain, and the Clothing Export Council worked closely with the AFD to bring overseas buyers to London. From the late 60s twice-yearly shows were supported with Government funds, initially showing spectacular export results, and

any young British companies who wanted to survive had to up their game. Creativity and innovation were no longer sufficient for survival; they now needed to learn about accountancy, planning, marketing and communication.

Once Joanne had received the title of 'Professor' she made it her business, following Madge's and Janey's examples, to visit New York in order to make contact with its design schools, and also to acquaint herself with the American fashion trade. Her experience must have been radically different from Madge's post-war trip. The tables were turned – instead of Britain being the poor relation in terms of design and manufacture, the 60s had ensured that swinging London was firmly on the map and British design still highly desirable to the big American fashion stores. As the head of such an acclaimed breeding-ground for creative talent, numerous invitations arrived for Joanne and she was given a proper New-York style welcome wherever she went.

An influential tutor

Tongue-in-cheek staff group, Joanne seated in front of Anne Tyrrell, Dennis Hayes, Valerie and Alan Couldridge

Soon after Joanne took over the running of the School, she had recruited a new young visiting tutor. She was aware of the high standard of work submitted by student applicants to the College from Harrow School of Art, and knew that two of Janey Ironside's star students, Valerie Couldridge (who had previously studied at Leeds) and her husband Alan (ex-Wimbledon) had shared a teaching post at Harrow since their graduation in 1963, while both continuing to work as designers – 'neat, precise, ambitious'[11] Valerie at Wallis, and Alan as Libertys' in-house millinery designer. Valerie, on Anne Tyrrell's recommendation, was appointed tutor in 1970 and began to teach at the College one day a week while still remaining part-time at Harrow. A year later, Alan Couldridge was invited by Joanne to oversee a project with the students; at that point there was a vacancy for a two-day tutor and it soon became evident that he was the perfect candidate for the job. This was the beginning of a commitment to the fashion school which would last 20 years. Valerie herself continued to teach there regularly for 10 of those years, and after that her links between the industry and the College provided the structure for many illustrious sponsorships and partnerships.

Alan Couldridge had a clear understanding of the balance between commerce and creativity, and one of his first moves was to set the students a 'diagnostic' project on their arrival, in order to assess their differing styles and abilities. This period of independent study ran alongside regular work reviews, smaller design projects, technical classes in pattern-cutting and garment making, talks from visiting speakers related to the worlds of fashion and textiles, and the compulsory humanities lectures which would gradually lead up to the writing of a dissertation. The culmination of the project was an end-of-term presentation where each student showed an oufit on a professional model, in front of a panel which included professor, tutors, technical staff and at least one visiting luminary from the world of fashion design.

ROYAL COLLEGE OF ART
1972 DRESS SHOW

Wednesday 28 June
11.30 am
The Hall, Kensington Gore

Please bring this card with you
it admits ONE only

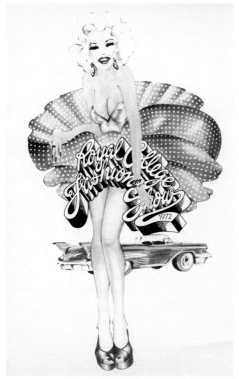

Hollywood-style
invitation and
catalogue, 1972

The rest of the first year would be given over to sponsored projects with commercial companies. Valerie Couldridge, with Wallis, was responsible for a cotton print project. Textile giant Viyella set a nightwear brief with a scholarship for the winning student. There was a promotional project with Swiss fabrics, and students' work was shown in New York as well as Tokyo's famous Seibu store. For this event Joanne took a small collection of current work from graduates Valerie, Brian Godbold, Christopher MacDonnell and Anne Tyrrell, all working in the industry, and it was shown three times daily for an impressive three weeks. The fact that Prudence Glynn of *The Times* reported after that academic year's Show that students were 'suffering from an epidemic of movie nostalgia' didn't put prospective employers off (who could criticize a bit of vintage glamour, a 70s backlash against the minimal, modernist 60s?) and although international sources continued to show an interest, the jobs secured by graduates were still mostly in Britain – for example with Bellville Sassoon, Burberry, Feminella, Marks and Spencer and John Michael. However, certain high-profile European houses were beginning to take notice, and in 1972 Geoffrey Bubb, who had graduated two years before, landed a job as designer for Nina Ricci in Paris. Italy was the favourite RCA destination, and when Peter McCullough (1970–72) secured work on graduation at both Krizia and Avagolf, the way was open. The following year Carolyn Freeman went to Valentino and Christina Tontini to Walter Albini; Derek Morten followed up in 1974 as chief designer for Fiorucci. The ultra-

Old-school style, 1972: menswear, Basil Kardasis; dress, designer unknown

talented Keith Varty, who had 'more enthusiasm and vitality in himself than in a whole year of students'[12] went to Complice in 1975 and then set up a team at Byblos, where he succeeded Gianni Versace as design director. Suddenly RCA graduates were fashion gold-dust, and the College and the top Italian houses were forging a mutually-respectful, highly profitable and long-lasting relationship.

In the students' second year the emphasis was on the final collection, usually with one high-profile industrial project to support this work in the first term. With Alan Couldridge's arrival came refreshing additions to the list of visiting lecturers. Moya Bowler was invited to teach shoe design, and Eddie Lloyd for menswear; John Bates and Roland Klein represented *haute* womenswear design while Ronnie Stirling, with his nose for creative individuality, convinced the students that 'commercial' was no longer a dirty word. With an eye on business, Vanessa Denza lectured regularly on basic essentials such as range-building, costing and how to work with store buyers; and Lorna Cattell on fashion journalism. The early 1970s' decline in the British fashion manufacturing sector made students increasingly aware that they must look realistically to industry in order to find jobs, which in Britain were becoming scarcer and scarcer as companies shifted their production units abroad. Loyal manufacturers such as Mansfield, Horne Bros, Wallis and M&S sponsored student projects, with M&S also generously giving 'design policy' classes at their headquarters in London's Baker Street. Along with fashion editor Suzy Menkes' unexpected comment in the *Evening Standard* that the 1973 College collections were 'unwearable', and a lukewarm report in *Menswear* that Anthony Hendley's was the only 'possible' student collection, the severe restrictions of the three-day week early in 1974 and the concurrent financial recession acted as a reminder to the students

Menswear by Laurence Roberts, 1972

that although the British industry still looked for creativity, the results, in order to be offered a job, must be desirable and wearable. However, recession or not, there were still some notable commissions for the students. In 1975 Bush Boake Allen, creators of fragrance for cosmetics and toiletries, set a 'Fragrance in Fashion' competition with substantial money prizes and a 6-month placement with Zandra Rhodes for the winning student. Its judges were Prudence Glynn, Janey Ironside and (in the absence of Zandra) Bill Gibb, and the awards took place at a grand dinner at the Savoy Hotel with Georgie Fame and his band in cabaret. Prestigious recognition came from Europe too when, perhaps as an acknowledgement by the recherché French industry that British designers were now worth considering, the College's

'English Look Collection' sponsored by Yardley of London was shown alongside Paris shows in Spring 1977 at the *Cercle Interallié* in the ultra- chic Faubourg St Honoré.

The British fashion industry was now realising that, if it were to compete with the highly-organised international exhibitions in Paris, Milan and Dusseldorf, it would have to get its act together. A fragmented collection of shows and exhibitions in different venues (London and the provinces), mostly aimed at middle and mass market, was not conducive to attracting overseas buyers. At the suggestion of a group of young London designers, the Clothing Export Council provided funding for a venue (the Ritz), PR provided by the charismatic Percy Savage and a show for the 'new wave' of talent who included Bruce Oldfield, Anne Buck and Juliet Dunn. Its success spawned a second show joined by Wendy Dagworthy, Yuki, and Anna Beltrao. On the CEC's request that they then join the gigantic commercial exhibition already established at Earl's Court they refused and a 'designer collective' was set up – the London Designer Collections, started by Annette Worsley-Taylor in 1974 and funded by contributions from its members. The first year was successful and the group grew, but every member was strictly vetted, resulting in a certain exclusivity – no mass-market companies, always designer-led, which encouraged press exposure.[13]

Gala and glamour

Royal reception, 1974 Anniversary Gala Show: far left Joanne Brogden; l–r foreground Lord Snowdon, Lady Esher (just seen), Lord Esher, HRH Princess Margaret. Background right, Alan Couldridge and Richard Guyatt

In the autumn term of 1974, the School decided to put on a gala evening to celebrate its twenty-five years of existence. The massive amount of preparation for this special royal occasion to be attended by Princess Margaret and Lord Snowdon included the production, masterminded by Alan Couldridge, of a glossy mirror-silver folio containing photos and biographies of 'those graduates of the School who are active in the fashion industry' as well as a list of those in the teaching profession. Madge Garland wrote an account of how the School originated, and Janey Ironside a poignantly brief but outwardly appreciative piece about her time as Professor. Central to the dazzling evening was a fashion show featuring two current designs from each of seventy companies, every one employing an ex-student who had graduated since 1948. Just about every major British fashion name was represented, and the range included all levels of the industry – from couture through top-level ready-to-wear, via creative mass-production to boutique and independent designer names. Alan Couldridge designed a mirrored structure as a spectacular backdrop to the stage, on which were the top tables, the remainder spread amongst silver sculptures around the gallery floor. The glittering show wholeheartedly supported Madge Garland's comment that, when the School was born into a post-war world, '… if members of the fashion industry were involved in the teaching at the School then … not only would they be interested in, but partly responsible for, what the students were taught'.

Gala Show 1974, with mirrored catwalk amongst VIP tables

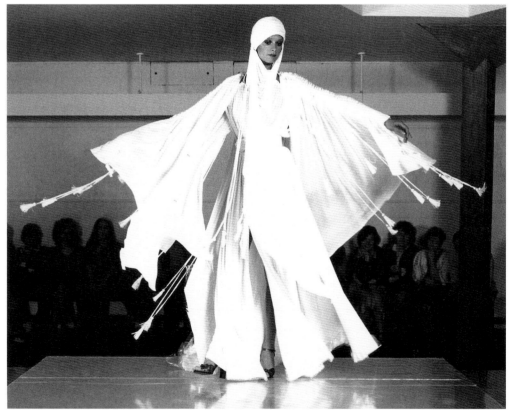

Dress by Valerie Couldridge, Gala Show 1974

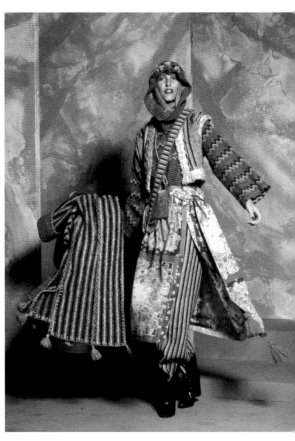

1975 student collections: Fred Spurr, menswear; Roy Peach, knitwear; Keith Varty, womenswear

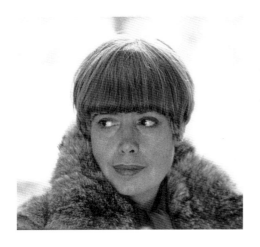

Joanne Brogden, 1974

The royal couple were, of course, entertained by Joanne and her chosen entourage on the top table. Joanne was dressed in a blue Hurel jersey dress by Roland Klein, with a matching marabou jacket which shed tiny feathers throughout the evening. Valerie Couldridge witnessed the amassing of these by the Princess, who proceeded to make a small fluffy pile of them next to Joanne's evening purse on the table. At one point she asked Joanne to explain something in the programme for which Joanne had to put on her spectacles, unperturbed by the fact that they were broken and bound together with adhesive tape. All in all, the evening was a huge success and sowed an important seed which would grow and transform the format of future College shows and sponsorships.

Joanne's lively, sideways-glancing photo in the silver folio perfectly illustrates Paul Babb's description, with her 'Vidal Sassoon fringe, immaculate and unchanged throughout her working life'. According to Joy Law, her style was 'chic and smart': always beautifully and subtly made-up, the smooth and symbolic hairstyle often controlled by a series of scarves which became her trademark. She favoured minimal lines and described herself, in an interview at the time of her Tokyo visit, as 'a tailored lady'- a meticulous, carefully edited look described by Sheilagh Brown as 'a bit Paris'. Joanne was fascinated by the way the French constructed garments, and she loved analysing and ironing the bits and pieces of vintage clothing and textile she would pick up at French markets and *brocantes* on holiday; if staying with friends, she would go out exploring and shopping while Fred methodically

completed two paintings per day, one before and one after lunch.[14] Joanne had a 'pernickety' attention to detail, and this extended into the stylish decoration of Buxhall Lodge. There were two front parlours in the 18th century part of the house, one painted red and one yellow, containing their collections of French pewterware and Delft pottery. The elegant wallpapered staircase led to several spacious, book-filled bedrooms. One of Joanne's favourite words was 'crumbling', and though not a description of the old house, its warm, lived-in feeling, comfortable and not over-tidy, made it the most welcoming place for a visit or an overnight stay.

Joanne and Fred were hospitable hosts. Every summer they would throw a party for the graduating students, one year's activities triggering the question of how much time it might take to 'get cannabis fumes out of the wallpaper'. Joanne herself was an inveterate smoker (tobacco only), and well into her career the decision to give up must have been difficult and stressful. She was persuaded to undergo hypnosis in an effort to kick the habit, which finally disappeared when she succumbed to a bad dose of 'flu a month after the 'useless' hypnotist had signed her off. Another activity she adored was cooking and she was an elaborate cook, a 'crank' about food,[15] frequently inviting friends to dinner, often to stay the night (usually homosexual male couples – according to Joy Law, Joanne had few women friends). The big kitchen/living room in the ancient rear part of the ground floor was the centre of activity, with its oil-fired Rayburn and its piles of shopping lists, notes, sketches (often including a dashed-off portrait or two), cookery books by her heroines Elizabeth David and Jane Grigson, and the dinner-party diary she kept with details of recipes, drinks, guests and how each occasion had worked. An experimental cook, she was nevertheless fastidious about methods of preparation. She firmly believed that 'you can't be a fashion designer without liking food', and it is true that building a successful dinner-party can bring the same satisfaction as designing and creating a beautiful, wearable garment. She appreciated the College's Senior Common Room for the same reasons, and when her staff came together at lunchtimes would make the occasion more special by ordering and sharing a bottle of good red wine.

Although neither she nor Fred was bookish, Joanne was a voracious reader, probably making up for the culture she had missed as a child. Both of them, being visual people, were in awe of their more literary acquaintances: Joy Law remembers that when they met the notoriously volatile Kingsley Amis and his wife Elizabeth Jane Howard at Joy's house in France, they were 'transfixed'. They appear never to have wanted a family and this, along with Joanne's tremendous sense of vocation, may explain her fierce dedication to teaching students. Under her low-key but confident appearance there was a vulnerability, and when her opinions were challenged she felt obliged to defend herself. One of her noticeable characteristics was her 'short fuse' – she lost her temper quickly, though Joy Law remembers that the only time Joanne and Fred quarrelled was (as is typical for so many couples) on a car journey, most often when driving through France on holiday. Working in the big garden at Buxhall (they employed a gardener during the week) must have offered a weekend escape from the everyday rigours of studio or Fashion School, one which Joanne and Fred grew to appreciate more and more.

Commerce and creativity

In spite of several difficult years of recession in the 1970s (or indeed perhaps because of them) industry continued to court and support the Fashion School. Although too little investment had caused a huge decline in the British manufacturing sector in textiles and fashion, major companies still queued up to set projects and employ graduates, and in 1975 the job list was impressive: Dorothée Bis, Maggy Rouff, Laura Ashley, Browns, Howie, Wallis, Janice Wainwright, Feminella and Dalkeith. Alan Couldridge introduced a new way of working – several projects could run concurrently, a small group of selected students managing each one. This kept industrial sponsors happy as well as introducing the students to the discipline of working in a studio situation, a small-scale taster of what they might find in the future. Companies for whom the School produced collections in the mid-70s included Lee Cooper, Fiorucci, Wallis, Barrow Hepburn, Hornes, Harris Tweed, Burberry (drawings only), Cantoni and M&S for whom they created 'knit, sleep and childrenswear: new looks at a reasonable cost'. Lucille Lewin, who had opened her first 'Whistles' shop in 1974, set up an annual project and stocked the resulting RCA designs in the store. It is interesting to note here that some students also worked on a fur project for Swakara (South African Persian lamb), a collection whose doubly politically-incorrect status would have drawn a vitriolic response had it been shown a few years later. Another area for development was knitwear, and Joanne enabled some of the more clothing-led textile students to show collections alongside the fashion students in the end-of-year show. Although she and the head of textiles, Roger Nicholson, did not always see eye to eye, she allowed several knit students (including Clare Dudley Hart, Esther Pearson and Sarah Dallas) a slot in the show. Sarah Dallas remembers working in the fashion studios in Cromwell Road and, although she found Joanne terrifying, Anne Tyrrell and research fellow Victor Herbert were always helpful, and Alan Couldridge assisted her in making turbans and headwraps for the models from her intricately-ruffled fabrics. This new emphasis on knitwear attracted industrial attention, resulting in sponsorship from businesses such as Mary Farrin with her considerable production based in Maltese factories.

By now, students were regularly visiting the big fabric fairs in Paris and Frankfurt as well as seasonal fashion shows, and the menswear group were introduced to *Pitti Uomo* in Florence. In addition to supporting these eye-opening international visits, many projects offered financial awards as prizes for winning students, and Fiorucci's generosity allowed four students to win bursaries in 1977 – Sara Jane Owen, Jane Arnold, Antony Kwok and Barbara Kennington. In this new commercial climate students (willing or not) needed to understand the industry and Vanessa Denza, having lectured on merchandising for several years, set up a compulsory business studies course in the School. As Christopher Frayling pointed out: 'In many ways, the Fashion course at this time was the most 'industrial' in the College'.[16]

It was just after this point that the menswear option, which had faded into the background somewhat since Janey Ironside's departure, was revived, with three

students in its first year. Charlie Allen remembers being the only boy in a year of thirteen girls (not to mention the only black student at the College), his natural courtesy making him feel obliged to do all the dogsbody work in the school, in return for which the girls would regularly buy him lunch. His tutors included Jane Rapley (who went on to be dean at St Martin's), Paul Smith and Vanessa Denza. He adored the grand surroundings of Cromwell Road, 'like an old couture house', a finishing school with Misses Brogden and Tyrrell there to 'knock him into shape' and John Pallaris on hand for tailoring skills. The crits, with their huge panels of visiting experts, were terrifying – they 'tore you apart but it was all constructive'.[17]

Joanne herself had been uncomfortably aware for some time that she was not following the College edict, set up by Robin Darwin on his arrival at the RCA, that all staff should bring their own practice into the studios, therefore allowing the

John Pallaris, menswear tailoring technician

students to learn by example in a real-life scenario. Although in the studios there was a genuine sample-room atmosphere, the Professor's office was used more as a fashion showroom, for crits and presentations, than the 'drawing-office' environment suggested in Robin Darwin's original brief for the College. Joanne was used to dedicating all her time to the school and did not see herself as a creative designer; she had no private business or freelance clients, unlike many of her staff. Late in the 1970s a project materialised that seemed to suit her way of thinking – a brief for a new corporate image for the Automobile Association, then a very visible organisation with hundreds of staff patrolling Britain's roads on motorcycles and in vans. The brief may or may not have been destined as a student project, but its structured nature must have appealed to Joanne and she took it on. The Wallis factories were commissioned to produce the uniforms, and the results must have given Joanne a sense of fulfilment previously lacking, although it is not clear whether or not the experience acted as a spin-off for further independent work.

With project numbers reaching a high in 1978 Alan Couldridge, always able to see things from the students' point of view, began to worry that their creativity was to a certain extent suffering at the hands of commerciality. In order for the two to co-exist beneficially, the curriculum was reorganised in 1979 to allow the students more time for 'academic development of design work' (what many of them had expected, in fact, when they applied for the course) balanced with a handful of carefully-selected commercial projects. In politically-unstable times, comfort is often sought in homely and informal situations, and the mid-1970s saw an enormous surge in the development and manufacture of casual clothing, with denim and jeanswear of every description being the key product. New denim-led fashion companies, manufacturing mainly in the Far East, flooded the British market, and every self-respecting label from street to designer level had its own jeans range. The major project for 1979 was set by Peter Golding, an extremely successful menswear designer who had opened his starry King's Road boutique 'ACE' in 1974. Falmer International, the giant jeans company for which he had previously worked, financed the project and provided a travel budget of £1000 which allowed all second year students to visit shows in Paris, Milan and Florence.

Travel bursaries also took the students to Vienna where they were the guests of the Optyl eyewear company, an established manufacturer which had developed an ultra-light synthetic material for frames and had become the licensee for Christian Dior eyewear. As the 1980s approached, fashion gradually moved towards a more structured silhouette and there was a new interest in accessories, which became an all-important foil for the strong, often monochrome clothing looks. The search for individuality resulted in a fast-growing market in footwear, bags, belts and eyewear and Optyl began a mutually beneficial relationship with the College. Uli Haas, design director for the company, had a huge respect for the way that RCA students were nurtured individually in order to develop their personal style, and also for the 'placement' system of work experience. His admiration for Joanne and her course led to a lasting bond with the School.

The professor of Fashion at Cromwell Road, mid-70s

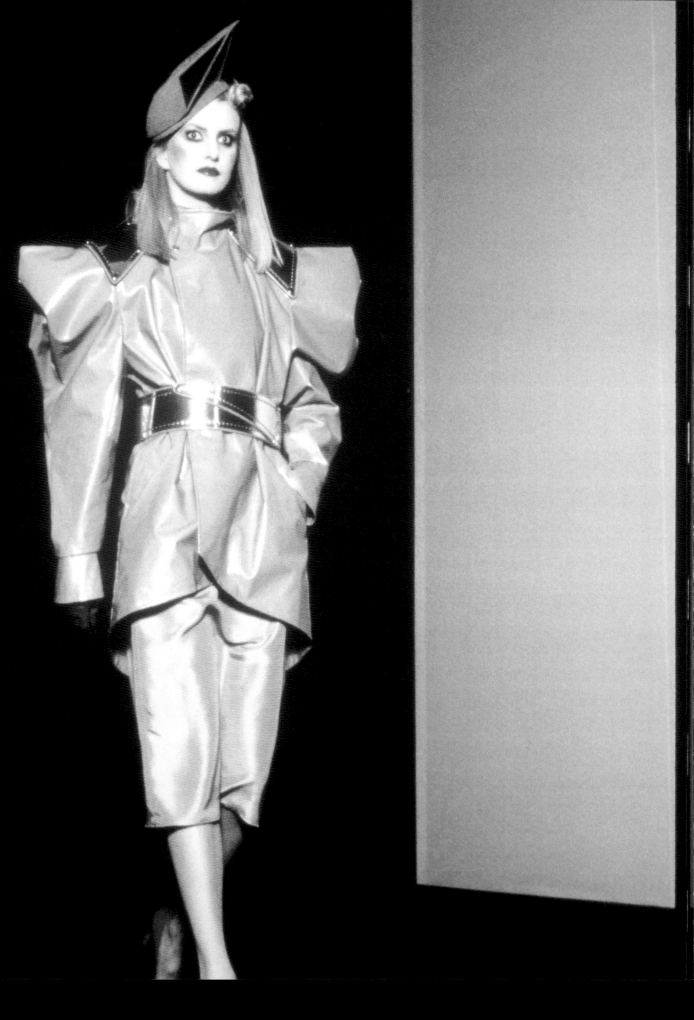

Chapter 9

The Unquiet Eighties

Student Eric Bremner, far right, working on a toile with Joanne Brogden, 1983

Lord Esher retired from his rectorship of the RCA in 1978, the experience of heading up the College in the volatile, unstable 70s a much more strenuous challenge than expected. With the College's appointments committee unable to settle on a new Rector (and, when it thought it had achieved this, finding itself thwarted) it was decided to ask Esher's pro-rector, Richard Guyatt, head of the School of Graphic Design, to act as 'caretaker' for the duration. The three years he served as Rector saw the institution take on a new character – not a return to the effervescent Darwin days (though elder statesman Guyatt had been one of Darwin's first professors) but a period, albeit sometimes shaky, when the structure of the College and its Schools were reconsidered and remodelled. The erudite Guyatt was a dedicated educationalist and his first two years saw some favourable experiments and adjustments; the college almost seemed to be reflecting the strongest aspects of its old self while looking positively towards the future. His final year, however, was beset by disagreements, 'squalls and storms'[1] mainly relating to the ever-rankling arguments about the College's close relationship with industry, and the question of how symbiotic this partnership should be.

Guyatt was succeeded in autumn 1981 by a second Lionel, this time with the surname March. A seemingly odd choice for a distinguished school of art and design, he was a systems-related mathematician whose work had often involved him with high-profile architectural projects, and his expert knowledge in new and developing technologies was a key element of his appointment (the final approval of which, ominously, had caused noticeable rifts between members of the College's Senate). March's personal mission was that the College should take the model of eminent schools in the USA such as Massachusetts Institute of Technology (MIT) and become much more of a research centre for advanced study of art and design,[2] an idea which went offensively against the grain for many staff and most of the students, for whom the College's active studio environment was the reason they were there. Though March appears to have early respected the importance of research in all institutions of advanced study, his seminars on abstract design theory seemed to many (if they were understood at all) to have little to do with the creative intuition for which the College was so admired. The institution, its original *raison d'etre* compromised, struggled into the 1980s in confusion, not really knowing any longer its true direction.

Serious national recession early in the decade caused stringent cuts in finance for education. The generous grants of the 1960s and 70s were no longer available and colleges had to look for other ways of financing students' courses. The School of

Pre-80s exaggeration by Sandra Dodd, 1979

Post-punk graffiti in the RCA lift for the 1980 show invitation

Fashion, respecting the students' wish to develop their own personal concepts, took part in 1980 in an early inter-departmental project with the schools of jewellery and textiles, but concurrently continued to work with industrial partners in order to generate funds for student maintenance and tuition. Eager sponsors just 'came to Joanne – she never went out to find work and expected to be approached'.[3] From 1980 to '82 collections were produced for Liberty, Harrods, Antartex, Jaeger, the Institute of Motorcycling ('well-styled protective clothes'), and the Cotton Institute, for which the students created a range of promotional garments. Projects with the newer brands were popular with the students – Stirling Cooper organised a tie-up with Harvey Nichols (previously Woollands) 21 Shop, and Jeff Banks introduced a project for his new 'Warehouse' chain, with first and second-year students working on an RCA collection to be promoted and sold in the Spring 1982 season. Marks & Spencer, with graduate Brian Godbold now design director, continued its relationship with the School, and new visiting tutor Betty Jackson was put in charge of the first project. It culminated with a small and very well-received show (masterminded by Lesley Goring, who had produced every one of Betty's shows

since her Quorum days) in the Senior Common Room, and the experience completely changed students' ideas of M&S which, previously, had appeared to them a frumpy, out-of-date British institution. M&S, philanthropic and modern-thinking, put the winning garments into limited production overseen by the students. The project was a mutual success and continued to run for three years.

Lady Di's dress

The College's royal connections were never far away. One of the highlights of the School of Fashion's history was the moment in 1981 when Lady Diana Spencer, bride-to-be of Prince Charles, selected two ex-students to create her spectacular wedding dress. David and Elizabeth Emanuel had met and married as students at Harrow School of Art in the mid-1970s, and both had subsequently been accepted by Joanne Brogden as RCA fashion students. Joanne was delighted with the publicity this generated for the school, coming almost a decade after ex-student Granville Proctor, working at Susan Small, had co-designed Princess Anne's wedding dress. This new royal commission was an even more exciting and high-profile development, giving a boost to Joanne's plans for the future of the department. In years of recession the fashion *zeitgeist* often effects a paradoxical backlash to austerity (as was seen with Dior's New Look) and London's designers in the post-punk early 80s, in spite of further industrial unrest, the ever-threatening presence of the IRA and high unemployment, maintained a strange stability, albeit a fragile one. The spirit of London fashion, described by Suzy Menkes as a mixture of 'the wild and the tame'[4] (the emergence of a new band of maverick designers to rival reliable established names) attracted the bolder American buyers looking to Britain for a new 'commercial eccentricity' which would rejuvenate their market. This resulted in a favourable economic climate for the advertising and design sector, and got Joanne thinking about how she could promote the School in order to raise funds for student fees and maintenance.

Early in 1982, the School issued a 'Fashion Newsheet', a smartly produced folded broadsheet explaining that financial cuts and safety regulations meant that the annual College show might have to be reconsidered and, at any rate, that it would now be impossible to continue with the extra shows for colleges and friends. The text stated that industrial contacts were being approached for funds to make up for cuts in bursaries and grants, and thanked prospective students for their patience in waiting for confirmation of their places. The circulation was targeted towards influential business friends and possible new sponsors, and contained illustrated profiles of both graduates and present students with their work, along with an impressive list of projects undertaken in 1980–81. One of these was a brief set by old-established Scottish textile manufacturers Reid and Taylor, which culminated in a presentation of men's and women's tailoring staged in the splendid surroundings of Leeds Castle, Kent, in the presence of HRH Princess Margaret who, several years before, had so enjoyed the School's 25th Anniversary gala. As a modern Royal with a husband well-connected in the arts world, she may have found these glamorous occasions more to her taste than her normal daily duties, for she was soon to

accept an invitation to be the school's Guest of Honour at the first RCA Fashion Gala in the summer of 1982.

Joanne had been producing College fashion shows for a number of years, but this was to be something else. Along with the planning of the regular show, Gala arrangements started at the beginning of the 1982 spring term and continued nonstop into June until the minute it began. Joanne had started by tentatively asking if sponsors would pay £100 per person for an invitation, and this sum was willingly accepted, industrial partners falling over one another to secure a table seating up to twelve. A Royal guest was *de rigueur*, and everyone was delighted when the Princess agreed to honour the event with her presence.

The final performance of the end-of-year fashion show took place as usual in the College's galleries. The rows of seating facing the catwalk in the Gulbenkian Hall had been replaced by a series of round tables at which sponsors would entertain their parties of VIP guests, who included journalists, designers and distinguished fashion-related friends. The police preceded the event by inspecting the galleries with sniffer-dogs, and to open the evening everyone was required to stand in line as Joanne led the Princess into the Hall. Copious champagne preceded an elaborate dinner and the models enjoyed the different format, showing the student collections in a re-arranged setting to a high-profile audience. The show also included pieces from past graduates now working at Byblos, Daniel Hechter, Lumière, Reldan and Marks & Spencer. The general rationale for the Gala was that its profits should support 'one student for one year', and it achieved considerably more than this. Although it was time-consuming, costly and frequently challenging to organise and produce, its repercussions were significant and generous support was received from loyal business partners, notably the Wallis brothers. The following year the School received £18,000 from industry in bursaries which would support a number of students for a year's study. The tricky aspect was that all but two of the donors wanted student collections in exchange for their funding, and Joanne, with Alan Couldridge, had to find diplomatic ways of pleasing all sponsors without risking loss of income. As well as a potential timetabling problem, the most important issue was the balance between creative and commercial projects and the ever-present danger of overloading the students to the point where their individuality might become stifled.

Over the next few years the Fashion Gala became the most sought-after event on the graduate fashion calendar. In the early 1980s, few other design courses ran Master's degree programmes and the College was still unique in spite of somewhat-reduced morale and lack of money. Joanne had a genuine loyalty to the place and, although the Fashion School remained in its crumbling Cromwell Road home until mid-decade, she pushed to have as many project presentations on the Kensington Gore site as were possible (but she was latterly concerned with the low ceiling in the Henry Moore gallery, to which the Fashion Show moved when the Gulbenkian Hall was remodelled).[5] She rightly felt that as the College owned such fine exhibition spaces, they should be used and not sidelined, and with more sponsors funding Fashion School projects the various galleries were often the stylish backdrop for

Alan Couldridge with student drawings, c.1984

Hat designs by Alan Couldridge, mid-1980s

final presentations of work. Several of these were for the international design houses who were constantly seeking RCA-trained graduates to join their design teams, a development that may have triggered journalist Sally Brampton's piece in August 1982 for *The Observer*, 'The Design Drain', in which she bemoaned the lack of British support for young talent and the fact that all the best fashion graduates were taking up offers from big European manufacturers. Joanne Brogden's rejoinder was that only overseas were 'the very high standards and extra flair and verve' of the British student appreciated.

London, however, did still maintain a growing culture of independent fashion labels. From the late 70s many experimental small design/retail outlets had popped up in less expensive areas like Covent Garden where pioneer Nottingham designer Paul Smith (whose fashion graduate wife, Pauline Denyer, had taught with Janey Ironside) had set up in Floral Street. In the West End, studios and shops in modest premises in Newburgh Street were resuscitating the Carnaby spirit of the 60s, and because rents and materials were cheap in London's East End, adventurous designers began to settle in that side of town too. At the close of the 1970s the V&A, impressed by the success of the London Designer Collections since 1974, had put on its first exhibition

of contemporary British fashion, 'British Fashion Design 1979'. This was a confirmation of the vibrant own-label culture, showing pieces by designers including Murray Arbeid, Wendy Dagworthy and Michiko Koshino, which set the pace for the following decade. With the Individual Clothes Show following closely behind the Designer Collections, both the established and the younger, more experimental labels were brought together by the British Fashion Council in 1983 as London Fashion Week. In the words of Wendy Dagworthy, 'London Fashion Week evolved from a somewhat fragmented affair into an event where designers showed together as a united front. The British government started to take designers seriously for the first time, providing funding, hosting receptions and championing the industry … British designers in the 80s started to sell in significant quantities abroad … across Europe and the U.S.'[6] Perhaps Sally Brampton's article had created a much-needed reaction. By mid-decade an organised schedule of twice-yearly shows at a single major location, with the

Sara Sturgeon's design sketch 1984, and part of the resulting collection

necessary infrastructure of promotion and press coverage, brought international buyers to London each season. The Americans arrived in force, and young designers like Wendy Dagworthy and Betty Jackson reported in 1985 that around 50% of their orders were from big US stores such as Saks 5th Avenue, Nieman Marcus and Macy's. Towards the end of the 80s fashion became Britain's fifth-largest industrial sector. At her newly-introduced Downing Street soirées, Prime Minister Margaret Thatcher would state 'Fashion is big business' and although, a little mischievously 'We tend to think of it as not quite so important because it is fashion' she admitted 'dressing well raises the quality of life ... and provides mass employment'. Whether Brampton's article had triggered this sudden acceptance or not, she herself followed up with this comment in April 1984: '... this attention could well dissipate if ... the Government persists in its policy of stringent cuts in education'.

Post-punk rebellion

London was an exciting place to be in the mid-1980s and although the aggressive mood of punk had evaporated, an edgily rebellious spirit was still in the air. Fashion inspiration came from the street, from pop music and from the vibrant club scene, often a spin-off from art and design courses, notably St Martin's School of Art with its location in the heart of the West End. Unlike the European industry, British fashion was still rarely supported by business, and though this made it hard for young designers they were able to remain creative and experimental because, as Betty Jackson pointed out, 'we are not dictated to by anybody'.[7] Furthermore, international buyers appreciated the bold and often eccentric spirit of the London shows, the French daily newspaper *Le Soir* even admitting that 'the English have an advantage over the French and the Italians – they don't get overruled by notions of good and bad taste'.[8] Youth culture belonged to Britain and the designers were celebrating it; new labels, grown out of punk origins, were attracting international attention. The masterful cutting in both Vivienne Westwood's subversive attitude to British tradition, and John Galliano's showstopping '*Incroyables*' graduate collection at St Martin's, influenced the more established designers (such as Princess Diana's favourite, Bruce Oldfield) whose collections became more experimental. Technical fabric developments heralded an era of 'body-conscious' clothes, and textile design became all-important, with ex-RCA textile designers Zandra Rhodes, Timney Fowler, English Eccentrics and The Cloth supplying Paul Smith, Betty Jackson, Jean Muir and others with boldly-designed prints. Following the success of Lycra and other new yarns, the British tradition of knitwear regained importance: Sarah Dallas, Esther Pearson and Clare Dudley Hart, all RCA textile-based graduates, began to show their own successful collections. Traditional tailoring for both men and women was reinvented with modern thinking by Paul Smith, Workers for Freedom and Margaret Howell; a more urban, post-punk edge was provided by John Richmond. Katharine Hamnett's sometimes anarchic point of view was inspired and grounded by the practicality of army surplus clothing, and Wendy Dagworthy was producing collections in British fabrics, spiced up with her personal ability to mix texture and pattern in new and unexpected ways.

The mid-80s retail boom, triggered by easily-gained credit and by the consumer passion for everything 'designer' (the word appallingly misused) led to a competitive high street. Design-led chains such as Warehouse, Monsoon and Jigsaw, all established in the 1970s, brought a new young demographic and left the traditional stores looking old and tired, although M&S was doing its best with its RCA connections. Miss Selfridge and Topshop continued the accessibility of young inexpensive fashion. The British clothing business was still developing faster than most other industries, and exports were strong. The Clothing Export Council was joined by store groups M&S, BHS, C&A and individual labels Jasper Conran, Janice Wainwright, Bellville Sassoon and Bruce Oldfield. With the growing interest in knitwear it was rebranded as the British Knitting and Clothing Export Council. And back on the high street, a storm was brewing. The old-established Hepworth gents' tailoring chain had bought up Kendall & Sons' retail ladieswear shops, with Terence Conran (now buying into fashion) as chair of the group. In 1981 he had asked George Davies to transform the Kendall shops for a new womenswear customer, and by the end of 1982 there were more than 70 branches of Next, with the Hepworth sites allocated to Next for Men. Design for home interiors and a phenomenal mail-order business followed. The label swept the board, offering high quality and modern design at more than reasonable prices, and providing fierce competition for the original high-street giants, one of which, BHS, was soon added to the Conran portfolio.

The College fashion show was so popular that in 1983 it was announced that, instead of allowing students from other colleges to see it free of charge, a ticketing system was to be introduced. With the success of the annual Gala and the interest from big manufacturers who were lining up to sponsor projects, it was becoming increasingly difficult for the fashion school to keep the balance between creative and commercial design. The projects kept coming in, and in 1983 students Bryan Rodgers, John Lloyd and Nigel Luck were selected for the Grand Gala at the *Rencontre du Jeune Talent*, organised by the Swiss textile town of St Gallen. Another group of students oversaw the production of twenty designs for the Danish Saga Fur collection. Selfridges launched a Design Award with a scholarship for two years' study, and the coat company Mansfield Cache d'Or set up a lucrative trust fund as well as giving an annual award. Harvey Nichols (formerly Woollands) turned over its 21 Shop to young talent and provided a one-year RCA bursary, stocking the selected student's collection. There was a vibrancy in the School's work with the arrival of new staff members in addition to Betty Jackson who, with her all-round understanding of both the creative and commercial points of view, helped the students realise that manufacturers wanted inventive new ideas and not watered-down versions. But the *doyenne* of fashion editors, Suzy Menkes of *The Times*, disapproved. In a July 1983 analysis of how schools were becoming too commercial in the interests of employment, she wrote about the College '… I do not want the students of an MA course after 6 years' training to be showing their fashion paces in 10 different (or should I say indifferent) projects for the rag trade … Professor Joanne Brogden says her aim is to promote ideas, style, taste, and to forecast future trends'. Menkes also lamented how, in the design-obsessed 1980s, training for

technicians was not respected in British schools: this ominously foresaw the government's upgrading of polytechnics to university status, thus obliterating the excellent vocational courses previously available to support British industry, in favour of degrees, appropriate or not, for everyone.

Throughout these difficult yet ultra-productive years Joanne never lost faith in her school and its proud rationale. She was not going to give up the prestigious offers constantly arriving from industry, in terms of both projects and graduate employment, and she cared hugely about her students. The 1984 gala show repeated the style of the first fashion gala, when a select group of former students were invited back to show their current collections. Princess Margaret, once again happy to be the Royal Guest of Honour, was introduced to graduates Sylvia Ayton and Valerie Couldridge representing Wallis Shops, and Janice Wainwright, Charlie Allen and Sarah Dallas, each showing an eponymous current collection. The dramatically sculptural set was designed by Alan Couldridge, Elizabeth Arden supplied the models' make-up and the illustrations in the catalogue were by final-

year student Eric Bremner. That year, graduates gained jobs at Alberta Ferretti, Bill Blass, Levi Strauss and Gina Fratini. Beverly Barron won the International Award of £6,000 at the prestigious Osaka Design Festival, and seven student bursaries were allocated with funds earned by the School.

The projects, resulting from proposals masterminded by Alan Couldridge, kept rolling in, and in the autumn of 1984 the students took on something that may have seemed light relief from commercial industrial briefs. Thames TV, with consultant designer Jeff Banks, commissioned the School to design the costumes for a new weekly 50-part series, *Gems*, about the fashion trade. Projects were always interesting, but this one was set to be fun as well. The addictive American soap-operas *Dallas* and *Dynasty* were compulsory watching for fashion students, more for their outrageous 1980s 'bling' than for anything else, and this could be their home-grown rival in high camp and glamour.

1984 collections designed by Eric Bremner, Clare Woodhouse and Karen Baker

Dressing-up was *de rigueur*: the fashion studios hosted numerous parties, the most unforgettable being the one for Joanne's birthday where every student arrived in flowing beige, topped with a Brogden-style matching turban or, alternatively, a Miss Piggy headdress referring to the nickname of the knowing Miss Tyrrell. So what could be more appropriate than a tongue-in-cheek costume design contract?

Disappointingly, the TV series didn't happen. 1985 arrived with the now-customary international focus, and the School hosted visits from Benetton, Daniel Hechter, Missoni and, particularly impressive, Issey Miyake (for whom every student wanted to work, but without spoken Japanese this proved an impossibility). These arrivals were time-consuming to arrange and manage, all the visitors needing to see presentations and portfolios as well as being entertained to lunch in the Senior Common Room, and not one of them resulted in a job or a work placement for the students. Perhaps the School's fortunes were changing; perhaps the developing Master's programmes, often shorter in length and less costly at other colleges, were diverting international attention from the College, and encouraging would-be postgraduates to look elsewhere. A horribly low point came just before the Fashion Show, when there was a serious burglary in the department and a number of collections were stolen. There can be nothing worse for a fashion student than losing the output of a whole year's work, particularly just before its presentation when, not to mention the immense effort in producing it, recognition and a first job might be the end result. It also seems a pointless exercise for whoever is the culprit: the unique and easily identifiable garments cannot be shown or worn anywhere else, and this encourages the thought that the RCA thefts were a devastating act of spite. Whatever the reason, it did nothing to improve any feelings of unhappiness or unrest within the School.

Stevens steps up

The College mood in the early years of the 1980s was gloomy and discontented. But change was afoot. In 1984 the volatile and uncompromising Jocelyn Stevens was appointed to replace Lionel March as Rector, a choice which was seen alternatively

as a positive move and a terrifying prospect. Stevens was a product of Eton and Cambridge, who had finished his education at Sandhurst Military Academy. His upbringing had been financially privileged but parentless. His father had abandoned him after his mother died in childbirth, and being brought up in his own grand apartment in Marylebone solely by a series of nannies, a chauffeur, a priest and an entourage of paid staff must have given him a very particular point of view – many would ascribe his autocratic, often belligerent nature to this unusual childhood. In the late 1950s he had bought the high-society magazine *The Queen* and had completely remodelled it, modernizing its image and transforming it in the 60s to a best-selling glossy retitled simply *Queen* and giving Condé Nast's *Vogue* some serious competition. Stevens's years in publishing were legendary and his stormy reputation preceded him at the RCA. In many ways he was remarkably similar to Robin Darwin – his family and social connections were influential, his ambition for the College was enormous, and hidden under his irascible exterior was a genuine fondness for students and a great admiration for what they could do if given the right environment.

Stevens's brief, reminiscent again of the Darwin era, was to revive an unhappy institution which in many ways had lost direction. In his view, the College had little contact with first degree colleges and a very poor liaison with industry. Its relations with the Department of Education and Science were abysmal, resulting in severe cuts in funding. So, true to form, he began to shake up the structure of the College, reducing the number of departments from an unruly nineteen to just four, and sacking long-standing staff in favour of new appointments, some successful, some less so. Fashion became part of the department of Architecture and Design Studies (soon to reemerge as the Faculty of Design for Manufacture), and the dynamic Stevens at first put the subject high on his agenda. Within a year or so of his arrival the Fashion School moved back into the Darwin Building and everyone, particularly Joanne who well remembered the miserable mid-60s expulsion, was thrilled to be

A New Romantic feel for the 1985 student collections

reinstated at last. Betty Jackson remembers that Joanne's grand office, now situated in what had been Robin Darwin's north-facing studio, took up the whole of the 6th floor with its beautiful parquet floors, its huge swivelling glass doors, its own bathroom and its access to the College's 'greenhouse' drawing studio. It was the venue for all the Fashion project critiques or 'crits', in which Joanne could be 'scary beyond belief. She had a vocabulary, and if she ever stood up in a crit you knew you were in big trouble. If roasted by her, students either fell by the wayside or did better – there were no apologies, Joanne didn't mind upsetting them … she couldn't tolerate laziness or unprofessionalism, and didn't put up with non-attendance, believing that the least a student could do was to be there for the staff'.[9] The academic staff were present at crits although, oddly, technicians were not invited even though their input was the backbone of most projects. Anne Tyrrell, as Senior Tutor, took on the role of 'carer and sharer', agreeing with Joanne on most things but picking up the pieces after a particularly devastating crit (though she herself had her sharp-tongued moments if a student had not tried hard enough). She would give her unbiased backing when talent really showed, and both she and Joanne celebrated success wholeheartedly. They had such a close, mutually supportive working relationship that at times other staff found it almost impenetrable. Anne was totally possessed by the world of high fashion, later becoming Vice-Chair of the British Fashion Council and receiving an MBE for her services; with her bias towards international designer labels she was sometimes seen as a 'fashion snob', but her huge loyalty to the students, her Knightsbridge chic and her naughtily camp turn of phrase continued her popularity as a much-loved lynchpin of the School.

Anne Tyrrell had a talent for moving things forward. Joanne appreciated that she was the hands-on one with industrial links, knowing absolutely everyone who was anyone in the business. She enjoyed using the Senior Common Room as a venue in which to wine, dine and 'schmooze' potential and current sponsors, many of whom were based in Milan, in her opinion the ultimate fashion city. She brought in prestigious projects and would guard them possessively, solicitous of the sponsors and their generosity. From autumn 1985 she instigated an annual project with the International Wool Secretariat to launch the RCA Wool collection for which the co-sponsor, initially London company Stephen Marks, paid for the final-year students to visit Paris's giant *Premier Vision* textile fair to choose fabrics. Once the collection was made, it was sold to selected international buyers from Bergdorf Goodman, Seibu, Printemps, La Rinascente and Harvey Nichols at London Fashion Week, taking place in September 1986 for Spring '87. On the basis of its success the School was instantly invited to produce a 1988 collection, and thus was launched an important project which would continue to forge new international fashion relationships for many years.

In February 1985 *The Guardian* had published an article on Anne Tyrrell's design consultancy in Kensington Gore. On the RCA site was a building which had formerly housed the Yugoslav Embassy, and Joanne was rather surprised when the College agreed to let this to Anne as a studio for her freelance fashion business. John Marks, the company for which she had risen to be senior designer, had recently been sold,

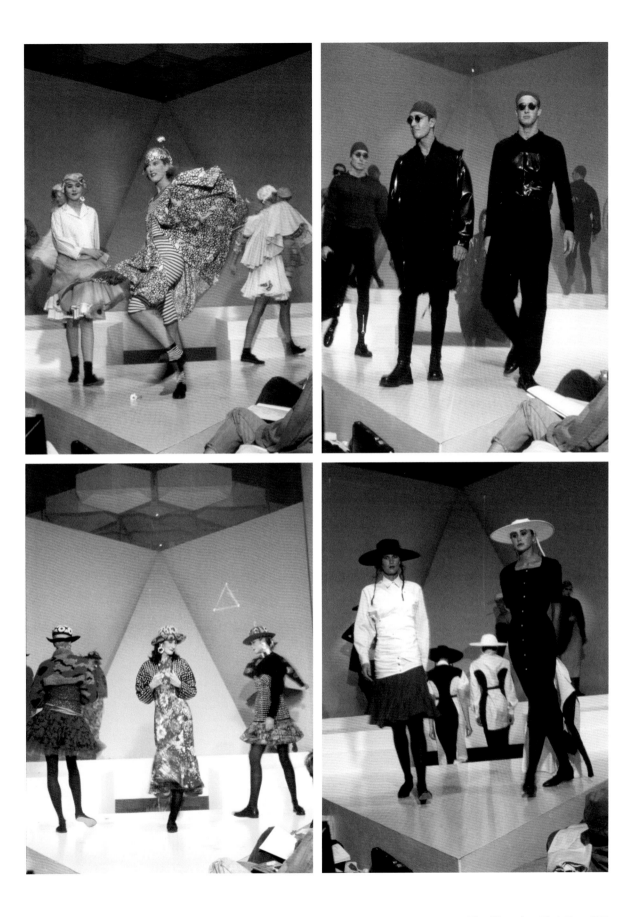

1987 student
collections

and Anne had picked up some of its previous contracts. Working so closely with the School she was able to hand-select a supply of young designers to work freelance with her on a variety of projects with distinguished and diverse clients such as Astraka, Benetton, the Design Council, Sinclair electric cars and numerous others. Around this time Alan Couldridge had written a paper for the College about the way in which groups of fashion students acted as design teams for industrial projects, and it became uncomfortably clear that Anne was also working on this idea within her own private studio. It was inevitable that, within the College, there was guarded discussion about this business: some saw it as a 'creaming off' of individual talent and even sometimes of sponsors to the School, but on the other hand it provided students with experience of working with industrial clients, and with money to help them through College. The studio was the origin of what would later become Anne Tyrrell Designs, the business which she was so vigorously to mastermind for the rest of her working life, always returning to College for the annual degree shows where she would select exciting new designers from the fashion and textiles courses.

In spite of the College's lacklustre credentials at the time of Stevens's arrival, the Fashion School's reputation kept it a desirable source for the industry. Largely thanks to the Indesign recruitment agency, new interest was now arriving from the US, several prestigious Italian companies continued to be supportive, and job offers continued to come in: the year saw students take up appointments at Cerruti, MaxMara, Dorothée Bis, Daniel Hechter, Escada and, closer to home, Bruce Oldfield and Stephen Marks. Joanne's tactful quote in June 1985 for *Observer Weekend* explained that 'Most of the best graduates will go abroad to work, the British are so very cautious when it comes to fashion'. She was invited that summer to the World Linen Congress in Monaco to speak about the department, and a further three students represented the RCA at the annual *Rencontre* in St Gallen.

The American invasion was encouraging. According to Betty Jackson, illustrious designers such as Calvin Klein and Donna Karan would 'just phone up and turn up looking for talent and if students weren't in with their portfolios, bad luck'. Even at short notice Joanne would orchestrate their visits seamlessly and the Senior Common Room would come into its own, doubling up as an interview space and embodying Robin Darwin's original concept as a venue in which to entertain and seduce future employers. Karl Lagerfeld was another visitor, delighting the awestruck students by accepting an invitation in 1986 to judge the annual Selfridges Design Award. Joanne, while not entirely in agreement with his selection, saw him as the cleverest man she had ever met in the world of fashion – his decision was 'not to be questioned'.[10] His passion was the importance of drawing, and the development of the image rather than the manufacturing techniques. His statement 'there are people to do this for you' fully endorsed his resolute support of Paris's *ateliers* with their rarefied *petits mains*, fine craftspeople whose unique skills would otherwise disappear in the ever-advancing progress of technology.

Lagerfeld's emphasis on the ability to draw was one echoed by Alan Couldridge, himself a highly competent draughtsman. Although students enrolling on a master's

degree had almost invariably graduated from an undergraduate design course, drawing skills were often varied. They came to MA study with differing requirements, and the important thing was that their designs would be clearly transferable to a pattern-cutter or machinist; this often resulted in drawings being in a somewhat diagrammatic shorthand, as was often seen in the work of top designers. At the College there were chances to further drawing skills at life and illustration classes, and therefore to learn techniques of draughtsmanship and presentation which would enhance the work necessary to build up a fashion portfolio.

The Crash

The mid-80s renaissance of British fashion was to be short-lived. In the stock market crash of 1987 many businesses closed. British fashion in the US suddenly became, in the words of Jasper Conran, a 'novelty act'.[11] Less established labels were ditched by international buyers, and it was partly as a result of this that British-trained designers were suddenly more available to the Italian and American fashion houses. By the end of the decade the young businesses which remained had grown up, offering a sophisticated, commercial yet creative product, properly supported with the appropriate finance, marketing and promotion. Vivienne Westwood observed that 'the gap is closing between street fashion and the fashion of the establishment'. Whether this was a good thing or a disappointment to the originators, London was still firmly on the fashion map. Princess Diana, often referred to as Britain's 'fashion ambassador', made international headlines wearing respectable and smart clothes by British designers Jasper Conran, Jacques Azagury,

1988 collections: Reebok sportswear; Neil Barrett Barber's menswear

Home life took on a renewed importance, and Joanne and Fred were together for over twenty more years before he had a series of strokes. Realising he was not to live much longer, Joanne (who, not religious, had up to that moment no contact with the local church) arranged a meeting with the vicar who put her in touch with the regional dean. In true straightforward style, Joanne asked the dean to lunch and, in her no-nonsense way, announced 'now – Fred is ill, so we need a nice plot with a good view'. The dean, impressed with Joanne's upfront honesty, obliged and when her beloved Fred died in 2011 his carefully-selected place of rest was waiting for him;[20] Joanne demonstrated her thanks by a generous donation to the church, and by providing funds for the foundation of a new arts guild for the county of Suffolk.

Joanne's was a life directed by her tremendous sense of vocation. Her fierce dedication to her School was matched only by the unswerving devotion between Fred and herself. Her self-effacing nature was further exemplified by the fact that she twice turned down national honours, stating that she was just doing her job. It is interesting, however, that when the French government proposed to award her the *Legion d'Honneur* for her contribution to the fashion industry, she was happy to accept, showing her unremitting respect for French culture and fashion. She was the essential structure supporting the School, and in fragile times she provided a stable environment for her students, launching them towards the highest levels of fashion and giving truly international status to the course. Latterly, she did realize that her need to be in control was sometimes too rigid and she admitted this to the Couldridges after Fred's funeral, apologizing to Alan that she had 'sometimes got things wrong'.[21] The length of time she served the College is an accolade to her integrity as well as to her style of management; one illustration of the loyalty of her team is that of the School secretary Avis Herbert-Smith, the 'power behind the throne', whose services Joanne inherited from Janey Ironside. At one point Mrs Herbert-Smith was poached by the pro-rector's department, but the minute she was able to escape and return to Joanne she did so, rivalling her Professor in the longevity of her service to the School.

When Joanne Brogden died in the winter of 2013, a remarkable congregation, representing just about every notable name in the world of British and global fashion, braved a howling East Anglian gale on a bitterly cold day to attend her funeral. The little church where she had said farewell to Fred was full of white flowers, amongst which were perched her bronze birds, and Joanne herself lay at rest in a pink wicker coffin with two more of her fowl as accompaniment. Her new friend the Dean officiated, and as part of her eulogy admiringly related the story of the 'plot with a view', where Joanne was so soon to be joining her husband. It is astonishing and unjust that there were no national obituaries to such an extraordinary and internationally respected force in fashion education, even though Sir Christopher Frayling did his best to remedy this unaccountable omission.

Twenty-odd years did little to assuage Joanne's personal pain at her departure from the College. Although the Fred Dubery and Joanne Brogden Bequest continues to provide scholarships, via the East Anglia Art Fund, for painting and fashion students

ABOVE Ceramic hat sculpture by Joanne Brogden

RIGHT Fred Dubery: *Portrait of Joanne*. This seems to have remarkable similarities to Ruskin Spear's 1961 portrait of Robin Darwin in the Senior Common Room at the RCA

at Norwich University of the Arts, Joanne left nothing to the Royal College of Art. It seems that, understandably, what remained of her resolute will deserted her after Fred's death. The beautiful Buxhall Lodge, the scene of so many parties and so much happiness, was deprived of its spirit. Possessions were packed away in boxes, and amongst the notes, sketches and photos are several images of Joanne, the period of each one recognizable, in the words of Graham Wren, not only by the clothes but by the pose – the fashion *zeitgeist* which drove a passionately committed educator forward in supplying the world with its next generation of international designers.

Chapter 10

Interregnum

The exodus of Joanne Brogden was to bring a radical change in style for the School of Fashion. Alan Couldridge, while devastated at the underhand and callous circumstances of Joanne's departure, nevertheless felt it his duty to continue supporting the School he so loved. Jocelyn Stevens asked him to write a document setting out his thoughts on its future and as a result of this Couldridge, after being interviewed by a panel of senior College staff including Stevens himself and his deputy John Hedgecoe, was appointed head of the Fashion School. Having been, for well over a decade, the discreet dynamo behind the workings of the School, with his informal pragmatism the ideal foil to Joanne's punctilious leadership, he was now in charge. To Stevens' approval, Couldridge had for some time been itching to make the department truly modern, to bring it in line with 21st century technology, and the first thing he did was to computerize every area of the department – new word-processors and printers for the office, up-to-date machinery for students and technicians, and a space-age pattern-cutting computer, complete with its own technician, sponsored by the American giant Gerber Technology. Relying on the close involvement of Valerie and, later, with Betty Jackson as visiting tutor, his *atelier* system continued to grow. With the school's Fashion Project Studio enabling industrial assignments to be separated from course work, different staff members managing small teams of student designers, sponsors could be closely involved with the development of the product. A wide variety of projects could thus be undertaken while students were still able to give time to their personal work. Couldridge, with Anne Tyrrell as senior tutor, brought in a group of new young members of staff, most of them Fashion School graduates. Sheilagh Brown had been running her own successful fashion business but, in the mid-80s, was finding the going tough. With her practical knowledge of the industry and her understanding of structure and fit, Sheilagh was the ideal candidate for the post of tutor in womenswear, and when Couldridge approached her 'out of the blue' she willingly accepted the 3-day-a-week commitment. Over the next few terms, Couldridge would invite alumni Gary Edwards (then at Jaeger's Country Casuals label) and Eric Bremner (in charge of MaxMara's Sportmax) to be joined by the sharp-witted Brian Baker in the part-time team, each of them given the responsibility of working with students on particular industrial briefs. The team was harmonious, the School system becoming ever more professional, and Couldridge's seemingly easy, self-effacing approach was complemented by the sometimes less compromising attitudes of his cutting-edge group of youthful staff.

Lizzie Andrews's menswear, 1993

Creative textiles in Bernard Güssregen's final collection, 1995

However much the staff and students had admired Professor Brogden's style, the *grande dame* era was over at the RCA. Couldridge ran the course with a relaxed discipline. The week always started with a staff meeting, detailing timetable structure and discussing any school issues. The informality of the new system was in keeping with a softer, less aggressive fashion style which was replacing the excesses of the eighties. The Project Studio was busy. Anne Tyrrell made sure that

the IWS continued its sponsorship for a third year, taking students to *Premier Vision* to select fabrics, with the resulting collection appearing in window displays in both Henri Bendel, New York, and Harrods. In August 1989 a press report remarked that this collaboration with European mills was a prime example of the Italian textile industry's enlightened view of promoting themselves through innovative fashion design. Sheilagh Brown led three first-year teams in a project, engineered by Valerie Couldridge, for British textile giant Viyella, a collaboration with the distinguished American companies Brooks Brothers, Liz Claiborne and Coach. Betty Jackson masterminded a tie-up between Whistles and DuPont Lycra. Inspired by the Italian model, these projects went a long way in encouraging the British textile industry to work closely with young designers and clothing manufacturers.

However, once again the British press was not entirely happy with the results of these industrial collaborations, essential for funding or not. After the 1989 student shows the fashion editor of the *Independent* remarked '… Congratulations all round. But there were no ideas'. The piece went on to complain that British design schools, as the result of 'ten years of a puritanical government which distrusts originality', were simply creating factory lines for the nation's industries. By the press's own admission, some of its journalists were partly to blame for the blandness, having previously criticized the work of young experimental designers as 'unwearable' and pushing them towards commerciality. In fact, the puritanical government's withdrawal of funding for the increased number of universities it had itself created was the main factor contributing to the less-than-exciting design quality; the schools really needed the sponsorship of their industrial partners who, in addition to supporting the courses, could often be relied upon to snap up graduating designers and give them jobs afterwards.

At the College the quality of production was paramount. Since Madge's days the school had always had a reputation for the high standard of its garment-making, and under Joanne's leadership, though she tended to keep technical staff in the background, this tradition continued (the word 'tradition' being appropriate, as Joanne could be seen as a little old-school in her approach). The quality was superior but the methods were not always modern, and the machinery somewhat outdated. Shortly prior to her departure, she and Couldridge had been interviewing for two new technician posts to replace two seamstresses, now retiring, who were both excellent makers but resistant to change. Usha Doshi was one of the shortlist of 40 applicants. In charge of production at a large manufacturing company, she was invited for a one-day trial, at which she had finished the requisite silk shirt by lunchtime in spite of having been supplied with incorrect materials to begin with. Her interview was successful, and after a 3-month notice period she arrived at the College with a second new technician who had been recommended by Anne Tyrrell, Isabel Garabito. Usha and Isabel were the perfect partners, Usha's calm industrial expertise complementing Isabel's Latin temperament and more boutique-based background – she had worked for Ossie Clark and, appreciating his extraordinary talent, had worked magic with his inspired visions, transforming them into flattering reality with the wizardry of her touch.

John Pallaris works with menswear students, 1989

To begin with, Alan Couldridge requested that Usha make a list of new machinery needed in the School. Up to that point, methods had been old-fashioned and the department did not even possess a buttonhole machine or an overlocker for finishing seams. Working with Alan Couldridge and Sheilagh Brown, Usha and Isabel set up a completely new sample room for womenswear students. John Pallaris, longstanding as the resident menswear tailor, felt a little uneasy at all the changes but eventually accepted that modernization throughout the department was necessary. One of his concerns was that some of the obsolete vintage machinery was irreplaceable; Usha understood this and, along with new state-of-the-art equipment, kept several of Pallaris's valued old machines, hence allowing students to discover original techniques which opened up new paths for design inspiration. Usha and Isabel would always encourage this: if a student wanted to base a dress design on the structure of a cabbage, or a 3-tiered cake for *Vogue*'s 75th anniversary, very little would stop the technicians from working out the best way possible to achieve a perfect and beautiful result. If an architectural student came to them wanting to use construction materials to make a garment, they would set their minds to the problem and work out the best possible method to solve it.

Like the technicians, Alan Couldridge had a perfect understanding of the student mind. Rarely confrontational and, in the words of one of his team, 'incapable of being harsh', nothing appeared to be a problem for him. He would go out of his way to accommodate challenges: for example, when a particularly tall student arrived on the course, Couldridge had sewing machinery adapted for his height. His friendly approach allowed him to know the students well, but he expected a lot from them and he expected his staff to be tough on them when necessary. He was devoted to the College, having known it since arriving as a student in 1960, and loved its traditions as well as its mission to transform the future. Some of the newer staff felt

it unnecessary to lunch every day with a bottle of wine in the Senior Common Room: Couldridge understood that inter-departmental networking was as important as it was fun, and enjoyed the SCR much in the way Joanne Brogden had done but on a much more inclusive basis, without the (surely unintentional) disdainfulness that tutors from other departments had sometimes previously accredited to the fashion staff. He loved sociable lunchtimes with his design and fine-art colleagues, but would never let them get in the way of afternoon commitments in the studios.

The milliner prodigy

One area about which Alan Couldridge felt strongly was, naturally, millinery. Hats, since the college reopened in 1948, had been an important element in the teaching of the School. Couldridge was keen to start an official millinery option as a separate course within the School, having already undertaken a project with commercial hat manufacturer Kangol, and plans were made in 1988–89 to set this up with sponsorship from Bill Horsman, chairman of the British Hat Guild. Horsman was

Left: Philip Treacy's first-year dress and hat

owner and director of milliners W.Wright and Son, for whom Alan had long acted as consultant designer. The first RCA millinery student was Philip Treacy who had enrolled to study womenswear in 1988. Treacy, from Dublin, already showed an interest in hats when he applied, and had undertaken work experience in star milliner Stephen Jones's studio. During the first year Treacy worked on garment-related projects, finding it helpful to be with womenswear designers and to see how their minds operated. Usha Doshi remembers his 'diagnostic' outfit in pale blue lace and satin, with its graceful undulating hat. Initially in a dilemma as to what route to take, Treacy was encouraged by Couldridge and, particularly, Sheilagh Brown, to follow his heart. At the end of his first year Isabella Blow, the outrageously eccentric Condé Nast fashion editor, spotted his work and introduced him to John Galliano for whom he began to make hats. Treacy persuaded Couldridge to employ Galliano's milliner, Shirley Hex, as tutor for one day a week, her maverick skills contrasting with the Parisian chic and more traditional methods of teaching demonstrated by resident weekly tutor Marie O'Regan. Suddenly Treacy was in huge demand, making hats for several student collections and appreciating every moment of doing 'what you do, in the case of the RCA, in a fantastic environment'.[1] A project with Harrods, based on Lewis Carroll's 'Mad Hatter's Tea Party', was so successful that the store commissioned him to design a special collection. This was the beginning of a long relationship, and an early introduction to Treacy of the importance of business skills, something not always learned at college. His prodigious creativity continued to develop in his second year, supported by his appreciation of the opportunities available in the department. His final collection in 1990, keenly endorsed by *Harper's Bazaar*'s Hamish Bowles,

was featured at Harrods as well as in *The Times* and *The Daily Telegraph*, and a meteoric career was launched. Alan Couldridge was instrumental in helping Treacy set up in business with backing from Bill Horsman, whose invaluable support continued until Horsman later closed his own company. In the years after his graduation, Treacy's style and his phenomenal success served as inspiration for many generations of millinery students, and he never forgot the way that 'we were treated as young professionals … not like students … Just by being there we were learning, everyone was intelligent enough to understand that'.

Projects and tutorials were rigorous, and the students appreciated and enjoyed the challenges set to them. Depending on the nature of the work, new part-time tutors would be invited in, and in Couldridge's first year in charge, the regular staff were joined by John Galliano, Bruce Oldfield, and graduates Keith Varty and Alan Cleaver from Byblos, with Nicole Farhi as external examiner Although numbers had been gradually increasing over the years, the RCA's method of teaching students one-to-one was still easily manageable with its relatively small intake. There was little competition from European colleges and British-trained designers were sought after. Student successes that year got them jobs at Italian houses Gucci, Byblos, Adrienne Vittadini and Fendi, at Daniel Hechter in Paris and with New York's Donna Karan. Although Jasper Conran and French Connection each took on a graduate, the emphasis was still on working abroad, but the profile of mainstream British fashion was slowly changing. The outdated high-street giants had been woken up by the success of Next to the need for designers, and they began to cash in on the growing list of creative young names whose businesses had been wiped out by cash-flow

issues. Many of the multiples were setting up production facilities abroad, primarily in the Far East, and sending designers out to work on collections. BHS and Tesco increased their fashion ranges, and the Burton Group, its outlets now including Debenhams as well as Topshop, Dorothy Perkins and Evans, performed steadily. The whirlwind success of Next had been the catalyst for urgent change in the British retail industry.

Towards the end of the 1980s the School of Fashion was doing well under its new leadership, but changes were afoot. Jocelyn Stevens had more than once offered Alan Couldridge the professorship, but the modest Couldridge had declined, considering this elevation unnecessary. Stevens was nurturing an ambition to save money for the College by amalgamating the two separate departments of Fashion and Textiles, and he had someone in mind to manage the change. Several years before, he had met John Miles, who had been running the vibrant school of textiles at Brighton School of Art for eight years when he applied in 1984 for a senior position at the RCA, under the colourful new Professor of Textiles, Bernard Nevill. One of Nevill's questions to Miles was 'what birth sign are you?' On hearing the reply, Nevill histrionically declared that he could not possibly work with a Cancerian; and that, if an unorthodox reason for rejection, seemed to be that. As an indirect result of the interview, however, Miles secured a position as design director at Courtaulds; he stayed there until he was headhunted by Next over two years later and decided to move. It was a dream job at first, until the company's fortunes altered, it relocated to Bradford, and its mastermind George Davies resigned. John Miles decided to take redundancy and set up his own design studio with two of his

1989 collections by James Dalton, Sue Chowles and Judith Bremner

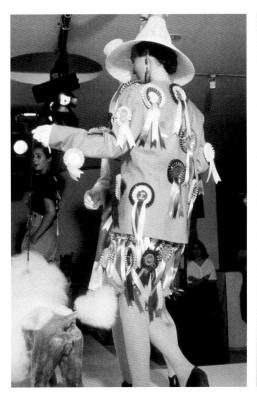
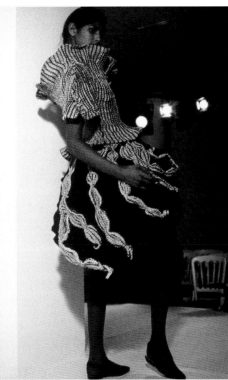
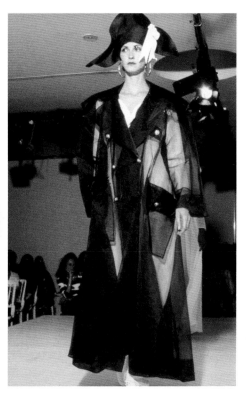

colleagues. Jocelyn Stevens, always remembering the 'star sign' interview, heard that Miles was free, telephoned him and asked him to take on Textiles – 'without Bernard Nevill'. By whatever strange and possibly underhand means this was arranged, Nevill resigned in autumn term 1988, John Miles took over in January as Professor of Textiles, and Stevens was able to fulfil his ambition. So Miles became Head of the School of Textiles and Fashion, with James Park managing Textiles and Couldridge and his team continuing to run the Fashion School.

Miles, an RCA textiles graduate himself, instantly made changes within the department. As Course Director, he set about creating stand-alone courses within each school. Fashion was divided into womenswear (which included millinery), menswear and knitwear, each with its own course leader, and textiles into four courses, again with a course leader directing each one. Alan Couldridge was deputy course director of Fashion, heading up its three courses. Womenswear was the largest course, with Couldridge as course leader and Sheilagh Brown as tutor; tailoring graduate Charlie Allen was asked by Couldridge to resuscitate the menswear option, leading it as a separate course. John Miles recruited Sarah Dallas as course leader for knitwear, a position in which Sarah felt very fortunate – she

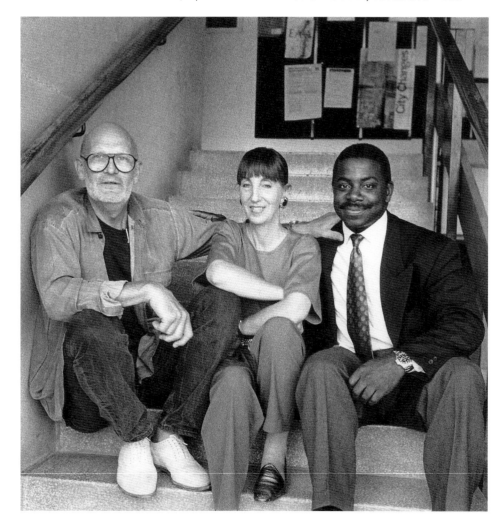

Staff group 1990: Alan Couldridge, Valerie Couldridge and Charlie Allen on the back staircase

'loved going in to teach'[2] and truly enjoyed her job. Within these new headings fashion continued much as it had done before Miles's arrival. The Project Studio system continued to operate with the IWS brief now including menswear, and even a gruelling day-trip to Albini's HQ in Italy did nothing to dim the students' enthusiasm. Other projects were with Woodhouse (menswear again), Viyella with French brand Daniel Hechter, and upmarket coat producer Mansfield Cache d'Or. Two first-year students, Ghislaine Gemmett and Gloria Bellini, won the French

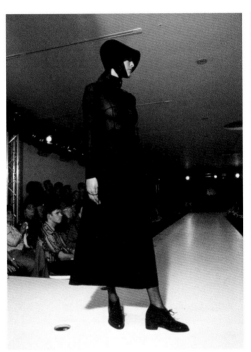
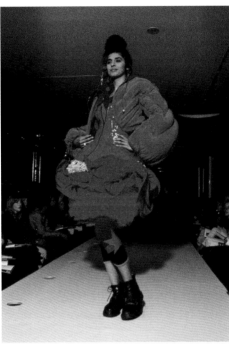
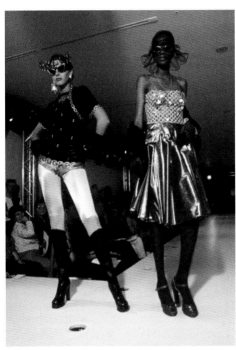
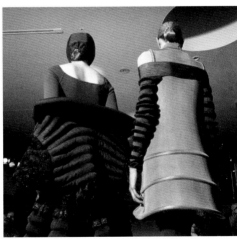

Top: designs by Andrew Fionda, Clare Lawrence and Harvey Bertram-Brown (all 1990). Bottom: designs by Carolyn Randolphi, Gary Harvey and John Ray (all 1991)

Comité Colbert design award, and scholarships were also awarded by ex-student Sara Sturgeon, now running her own company, and by Dunhill. The list of jobs was divided between Britain and overseas – Betty Jackson, Margaret Howell, Roland Klein, Reebok and Ghost; and MaxMara, Iceberg and Escada.

It seemed that the new regime was working with little change in the running of the Fashion Department (as it was now renamed), apart from Sheilagh Brown's exit in 1990 to helm the new womenswear design studio at Marks and Spencer where Brian Godbold, also an RCA alumnus, was creative director. To replace her, Henrietta Goodden was headhunted from her post as senior tutor in fashion at Kingston Polytechnic. Margaret Manley, formerly administrator for the fashion school at Harrow, was brought in to organise the office and to be particularly involved in the show. Generous sponsorship from Laura Ashley, whose design team was now headed up by Valerie Couldridge, was secure for the next three years, the deal being the production and catwalk presentation of a special womenswear collection which was largely produced over the summer when studio space and technicians were more available. Other projects were with Chiara Boni for the IWS; Windsmoor, Viyella, and a knitwear collection for French Connection. Challenging and more unusual, the second-year students worked on a secret brief from the Ministry of Defence, designing new uniforms for the Women's Royal Army Corps with hats by Philip Treacy and Philippa Eyland.

The menswear course, unique in Britain with its Master's degree, supported by the tailoring skills of Allen and Pallaris, grew fast and gained status, attracting attention in Europe and particularly in Italy. The director of Gruppo GFT, the manufacturing

IWS project with Italian fashion house Chiara Boni, 1991

giant, was so impressed that he invited Charlie Allen and John Miles to Turin to discuss an exciting proposal. He had noticed that the Royal College of Organists, whose flamboyantly-decorated Victorian building was adjacent to the College opposite the Albert Hall, was for sale. GFT had the idea that it could be bought and adapted to house an RCA school for menswear design, educating designers who could then work on a complete product from start to finish, using Italian fabrics with production overseen by a team of technicians – almost a mini Savile Row in its concept under one roof. Tragically, this dream was to be obliterated with the philanthropic director's death in a motor crash just as talks were starting.

Since Madge Garland's days, the Department had continued to bring in a stream of distinguished speakers related to the fashion world – designers, journalists, photographers, retail experts. The *coup* was a lecture by Jean-Paul Gaultier, at the height of his *enfant terrible* popularity, facilitated by the department's humanities tutor Susannah Handley, and was arguably the biggest draw of any lecture the College had ever presented. Gaultier led a new wave of French designers who underlined the demise of *haute couture* in Paris, and the world's proudest fashion city was keenly feeling the dethronement of its former leaders. The rise of independent French labels such as Gaultier, Thierry Mugler and Claude Montana triggered a change in the industry's respected but démodé older houses. In the late 80s the giant LVMH group, aware of this, gave a shot of life by bringing new young designers (often British, *mon dieu!*) to such distinguished names as Dior, Céline and Givenchy; PPR followed up a little later with its purchase of Yves St-Laurent, who remarked unhappily that 'couture will not survive the decade', not for lack of skills but lack of clients. By the early 90s several of Britain's brightest designers were heading up Paris houses: great for the nation's design talent, but not for its industry. UK retailers, deprived of home-grown product, were now buying their stock from French, Italian, German and American labels. London, though still seen as the most creative fashion capital, again suffered through lack of financial support, and the further recession of the early 90s meant the closure of several more businesses. The surviving British designers, who included Betty Jackson, Caroline Charles, Nicole Farhi and Jasper Conran, were choosing to manufacture abroad (mainly in Italy) although they would have preferred to stay closer to home, and the Fashion School was unintentionally assisting this move with its sponsorship from European companies. Sadly, these years saw the closing stages of depressing decline in the British garment industry, with factories reluctant to invest in modern machinery causing the high street giants to take their considerable business elsewhere, mainly the Far East. Established British names Aquascutum and Daks/Simpson had new Japanese owners, Harvey Nichols was bought by a Hong Kong business, and Harrods by the Al-Fayed family. Even Europe's largest textile manufacturer, Courtaulds, closed most of its British factories and went abroad. The results of all this were that between 1981 and the end of the 90s job numbers in British fashion and textiles halved, and imports of cheap clothing trebled.[3]

In 1991, in order to enhance London's fashion reputation, the British Fashion Council tried to encourage high-profile designers such as Jasper Conran, Katharine Hamnett

and John Galliano to ally with industry. Hamnett's work had already challenged unethical manufacturing methods, and a newly eco-conscious mindset began to push other designers to reconsider their output. Big names like Nicole Farhi, Bruce Oldfield and Vivienne Westwood began to produce 'diffusion' and other lines to support their main collections and Sir Ralph Halpern, chair of the BFC, was optimistic, calling it '…the start of a new decade of British style'. In the cities, the club culture of the 80s had reversed the perception of fashion inspiration, and the edgy, sporty style of the streets – particularly London's – was now what everyone wanted. These changes chimed very accurately with John Miles's aspirations for the School of Textiles and Fashion. Seeing how graduates from other schools, particularly St Martin's, were making their own names instead of being lured abroad to work, he was determined that a new culture of 'individuality as the key to the future'[4] should be the mission of his School. As an offshoot of this, his strong view that the two disciplines had a natural interdependency led to his encouragement of working partnerships within the department, and thus began a series of projects where textiles and fashion students would work together. Many of these brought spirited and inventive results and, often, relationships between textiles and fashion students which would continue into the final collections and sometimes beyond.

In 1991 Jocelyn Stevens stood down as Rector, to be replaced by Professor Anthony Jones. The fashion students got jobs, mainly abroad, at Falke, Escada, Pennyblack, Yohji Yamamoto, and Next. Karl Lagerfeld saw Philip Treacy's degree collection and whisked him off to Paris. It seemed that with Jones's arrival the College might be entering a less turbulent era, and the School continued to reinvent itself with ever more high-profile projects. Furthering the royal connections, Kensington Palace asked the textiles and fashion students to design a collection of nine special presentation

New uniforms for the Women's Royal Army Corps, 1990

1992 project with Viyella and Mulberry – British looks for Gypsy, Motoring, and Huntin', Shootin' and Fishin'

gowns for its lavish exhibition 'Court Couture 92'. Britannia Airways followed up the MoD's uniform project with a brief for a new corporate style, and Viyella joined with Mulberry for a womenswear collection. The students were excited that the IWS partner was the illustrious Giorgio Armani, whose effortlessly relaxed tailoring summed up the current post-1980s reaction to overstructured exaggeration.

Miles makes his mark

None of these distinguished sponsors, however, could be said to have much to do with the rise of a democratic style from the street, and John Miles felt strongly that there should be more diversity in the projects set to Fashion students. This may have triggered him to reconsider the department's structure, and to make some radical changes. Several staff contracts were up for renewal, and here was a chance to introduce some new blood. Tony Jones's first Annual Report, at the end of 1992, states that 'Alan Couldridge, Deputy Course Director for Fashion; Charlie Allen, acting Course Leader for Menswear; Gary Edwards, Tutor in Fashion Womenswear – all leave the Textile and Fashion Courses this year'. For Couldridge, who had dedicated so many years to the School, it was the most devastating blow. Although he and Valerie had a thriving consultancy business with high-profile British and international clients, the College and the fashion courses were his greatest passion. Jocelyn Stevens, after the event, ruefully admitted to him that he himself had been against the decision but had agreed, before his departure, to give Miles a free hand in making his own decisions. Charlie Allen, 'so brilliant, enthusiastic, passionate'[5] felt he had hardly started his new menswear course, already gaining such recognition after only three years. To replace them, Miles brought in Frances Mossman, a former colleague from Next, as deputy course director and course leader for womenswear,

Student collections 1992 – Kait Bolongaro's graphic bondage, Afua Praba's tribal menswear and Susan Wallace's sophisticated androgyny

Womenswear studio, 1993 – the original space (see chapter 6) now divided into two with a wall of wardrobes

and RCA graduate Anthony Hendley, already a visiting tutor, as course leader for menswear. The new external examiner was Caryn Franklin, design-educated fashion journalist and TV presenter of Jeff Banks's hugely popular 'BBC Clothes Show'. Anne Tyrrell continued as visiting Senior Tutor, the 'heart of the department';[6] eager students would queue up to see her, soaking up her advice and hoping she would help them with her many useful contacts. If any of them specially needed technical help Anne would send them across the corridor from her office at the back of the

1993 collections, ranging from the ultra-wearable to the purely experimental. Top: Kit Warren and Clare Waight, bottom: Brian Kirkby

building to Usha and Isabel's room for expert assistance. Graduating students from this 'crossover' year included a very strong knitwear group, an accolade to Sarah Dallas's teaching, amongst them Clare Waight (now Keller) who was to make a steady and impressive trajectory towards her current position as design director for Givenchy; and Orla Kiely, concentrating on a childrenswear collection, whose much-copied style became a global phenomenon. The main office, Joanne's elegant parquet-floored domain which had become Alan Couldridge's much less formal open-plan studio, was divided into separate spaces, the professor's office still in view of the Albert Memorial on the eastern corner nearest the main staircase, with smaller glass-walled niches shared by senior tutors along each side.

Paradoxically, the following academic year brought yet more glamorous alliances, most of which had been arranged before the staff changes. Karl Lagerfeld returned to the department to set a womenswear project, which culminated in an internship and award for Anna Mason (Lagerfeld suggested she should 'make Fendi trendy'). The IWS brief, now organised by visiting tutor Heather Holford with Anne Tyrrell attending fittings and critiques, was set by MaxMara; the knitwear students worked with Missoni, and both Swarovski Crystal and Champagne Mercier, who sponsored the Fashion Gala, made sure there was plenty of sparkle glamming up the School. To back this up, the flamboyant Milanese designer Gianni Versace was the year's main visiting speaker. In an exceptionally strong cohort of students Halifax boy Christopher Bailey, whose study had been supported by the Bill Gibb award as a result of winning the Graduate Fashion week scholarship, graduated from womenswear. His infectious charm and courtesy did much to support his natural understanding of luxurious textile quality and desirable silhouette. Bailey's first job was with Donna Karan before he moved to Gucci and later, by then a fashion legend in the making, was headhunted by Burberry where he endorsed and updated the company's product to such a successful degree that he was rapidly elevated to the post of Creative Director and eventually, in an unprecedented move at a remarkably young age, to Chief Executive Officer. These developments did not go unnoticed by the big names from the summits of European luxury and, in a bid to secure the skills of young and adventurous British designers, John Galliano was snapped up by LVMH while Alexander McQueen and Stella McCartney's businesses were both bought by Kering, the new incarnation of the PPR group. The influence of British names (most of them from St Martin's at that point) on French fashion, whether Paris approved or not, was becoming more and more evident. Meanwhile the Italian industry continued its interest in the College, and the womenswear students were thrilled to visit the Milan studios of the great Romeo Gigli to be briefed for the 1995 wool project.

Christopher Bailey's graduating show, 1994

Global interest was all very well, but the exodus of design talent to well-paid jobs elsewhere continued to hinder the British fashion industry. In the early-90s face of political adversity (the Gulf War, IRA bomb attacks in London and serious financial recession) the LDC and the BFC struggled to support the London Designer Show in a smart specially-designed venue at Chelsea Barracks. It was a relative success in spite of a lack of overseas buyers, but over the next few years it was to falter again. However, encouragement was to arrive. In autumn 1993 Philip Treacy was invited to put on a show, complete with all his supermodel friends, in London Fashion Week and, alongside a 'New Generation' show sponsored by Harvey Nichols, this caused a sensation. The British Fashion Council provided funding for a tent outside the Natural History Museum, and international buyers and press flocked to this as well as being shuttled to many other eccentric and far-flung venues, getting a taste of

1994 collections, top: Andrew Heather's puritan opulence, Flora MacLean's constructivist plastic. Bottom: Laura Watson's romantic beachcomber and a vertiginous hat by Jo Gordon

the diversity of London's shows. Students of St Martin's filmed a fashion week party at the Embargo Club, with champagne provided by M&S, and created a video demanding more government help from the Department of Trade and Industry. All this activity caused a turning point but, even though the BFC was doing its best, the designers continued to complain about the lack of official finance and support.

Meanwhile, John Miles was continuing to nurture the maverick style for which London was suddenly enjoying a renaissance. He was a risk-taker and, although fees were increasing, the department had never had so many students; in addition to highly qualified and talented applicants from undergraduate backgrounds, places were given to noticeable candidates from non-BA courses as well as to a welcome and growing influx of European Union students, many of them from Germany where design training was highly technical but with limited creative input. The method of teaching, partly due to larger intake numbers, had moved away somewhat from the informal and practical studio system which had worked so well for so long, and become more tutorial-based with staff arranging individual meetings with students in an office environment. Fashion students needed to arrive not simply with a sketchbook or portfolio, but also with all the studio paraphernalia – mannequin, toiles, half-made garments, scissors, tape-measure and pins.

The Show leaves College

John Miles also had another agenda. He felt that the College was insular and should look outwards. He had long believed that the acclaimed annual fashion show should move out of the College's galleries and be part of the international circuit – perhaps, even, to be held in Paris. So, to a mixed reaction from staff, a series of new venues was found, beginning with the baroque grandeur of the Banqueting House in Whitehall Palace. The logistics may have been challenging but the students were awestruck, the setting was breathtaking, and with Vivienne Westwood the first guest of honour, a touch of fashion anarchy was added to the proceedings. The following year, at Whitehall again, Princess Margaret graced the College once more with her presence, wearing a pink Dior coat and fascinating the students who gathered, dressed up for the occasion, in an exotic, expectant queue to meet her.

The shows had always been expensive, and in spite of continuing sponsorship from Next, through the 90s they became more and more difficult to finance. Sponsors were generous but money was scarce, and although the price paid for a Gala table ran into the thousands, it was difficult for the department to cover costs. The redoubtable Margaret Manley was tireless in her diplomatic efforts to encourage interest in the Gala as well as dealing with invitations to all the other shows leading up to it. Every graduating student showed a total of eight outfits which meant that a minimum of twenty-four models was required, and each year there were up to an almost impossible nine shows in three days, a pricy proposition even with the special rates offered by the agencies. During the decade, with the cult of individuality encouraged by John Miles, it became popular for students to use friends as models which helped costs somewhat, but with the venue, the logistics

and the show direction all eating into the budget, things got very tough. It was necessary to find committed sponsors, whether their product was fashion-related or not, and when the School had no choice but to tie up with a soap-powder manufacturer and, more bizarrely, a petfood giant, the Rector and senior management made it clear that, although they were unable to offer no extra funding for this expensive commitment, the College disapproved. Following Whitehall, shows were at various central London venues including Camden's famous Roundhouse in 1996, supported that year by no fewer than eight sponsors and including student Julien Macdonald's graduating knitwear collection. The previous year Karl Lagerfeld had presented him with the annual award, and Macdonald had come to the attention of Isabella Blow. During the final show, the cramped dressing-room at the Roundhouse was already pandemonium when Blow swept in with an entourage of young American models. Shamelessly pushing the staff and backstage crew out of the way, she proceeded to direct the dressing of her models in Macdonald's collection and sent them on as an unplanned finale, thus giving Macdonald a flagrant moment of unscripted glory and leaving behind the scenes a melée of furious students, tearful RCA models, and a powerless team of outraged dressers and helpers.

 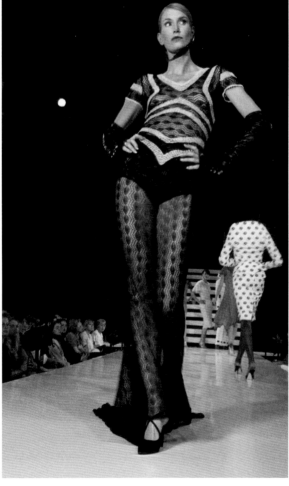

Knit dresses from Julien Macdonald's collection, 1996

Julien Macdonald followed up his entrée into the public eye by winning the now annual New Generation section, sponsored first by M&S and then Topshop, at London Fashion Week. The BFC's fortunes had gradually improved with generous funding from Procter & Gamble (themselves a soap-powder empire), owners of Vidal Sassoon; and on a different level Graduate Fashion Week, arranged by Jeff Banks and Vanessa Denza with Smirnoff as sponsor, allowed fashion colleges nationwide to show under one roof. Britain's somewhat neglected provincial courses, many of them excellent and often staffed by RCA graduates, were suddenly in the spotlight and encouraging suitable students to continue their training by applying, if they could afford it, for continuing higher-level study at London's MA courses.

Frayling puts the heart back

In the same academic year of the Roundhouse show the College celebrated the centenary of Queen Victoria's permission to use 'Royal' as a prefix to its title, and it also welcomed a new Rector. Christopher Frayling, already Professor of Cultural History, succeeded Anthony Jones after the latter's short-lived term in office. Frayling, passionate about the RCA and its history, realised like his predecessor Robin Darwin that '... the College is about the future, but it is also about a very distinguished past'.[7] An eminent and popular historian with a clear understanding of art and design, Frayling's arrival was perfectly timed to manage the national Research Assessment Exercise, in which every British university was now constantly being assessed for the quality of its staff research output in order to secure its future funding. In schools of art and design there was a growing interest in student research too, and John Miles had long had a wish to develop a more theoretically-based element in his department. He took on a number of postgraduate students, gave them the support of a research supervisor based in both the RCA and Imperial College, and resuscitated a tradition which had not been highly evident in the department since Victor Herbert's 1960s experiments with moulded clothing. Research studies undertaken by MPhil students during this time included investigation into seamless clothing, the influence of fragrance in fashion, and new uses for developing technonogy in 'smart' textiles. For better or worse (there was certainly criticism from some academic quarters relating to the quality and depth of certain proposals) the numbers of research students in Textiles and in Fashion grew. Something must have worked because, as a result somewhat galling to the RCA, St Martin's found it was eventually able to set up a textiles research centre entirely staffed with MPhil and PhD graduates who had studied in John Miles's department.

In addition to the building of a research culture, Miles had been making other academic changes to the curriculum. He enjoyed setting up structures for the necessary RCA systems, which were becoming more rigorous in line with government requirements for staff accountability. One was the introduction of a termly work review for each student, a more formal version of the one-to-one tutorial system which worked so well. Students recorded their progress by keeping sketchbooks and making personal notes as well as often photographing each stage

Julie Rooke's 1993 'hairstyle' millinery, from design drawings through development stages to finished product

of a design's development. Each would present a portfolio of work-in-progress to the Professor, senior tutors and visiting professors (who by now had replaced the Official Visitors of previous years) in order for staff to get an overview of how everything was going. Miles's belief that 'students tell you everything in subtle ways'[8] helped him give personal feedback on individual progress, and any needs or gaps in teaching were assessed and addressed. Report forms were issued to every student. These reviews, along with regular presentations of work to project sponsors, helped give students the much-admired confidence and ability for which RCA graduates became known in the world outside.

Another element introduced under John Miles's leadership was the annual 'Work in Progress' exhibition. Staged after the first term, it was an opportunity for both first and second year students throughout the school of Fashion and Textiles to take over the College galleries and exhibit whatever aspect of their work was relevant at

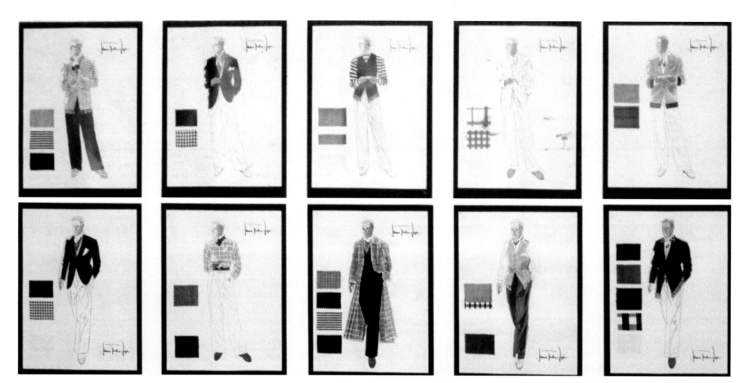

that stage in their development. Informal and lively, led and designed entirely by students, these shows were a chance to demonstrate what it was to be a student at the RCA. In one of the earlier examples, the fashion students actually set up a studio in the Henry Moore Galleries and continued to work while being on show to the public; generally, the shows were static but very lively installations, always well-attended by industry and relevant guests and doing much to create outside awareness of what the courses were doing.

The portfolios were obviously all-important both for internal reviews and, even more, for job applications. They needed to be kept up-to-date, particularly as potential employers could often turn up expecting to see work with little notice or none at all. The students' sketchbooks and notebooks, personal journals of thoughts and ideas, were and still are almost more crucial than presentation drawings, but an ability to observe and draw was still the traditional basis for a portfolio. With applicants coming into the school from diverse backgrounds, many had little experience of academic drawing, and it was rightly considered of enormous value in the College. The main drawing studio, just above the Fashion School, was a wonderful facility open to all students. Fashion tutors, particularly for knitwear where students had often come from textile backgrounds with little knowledge of the body and how to represent it, booked the studio and brought in specialist staff and models in order to study and record how clothes work on the body. Colin Barnes, Howard Tangye

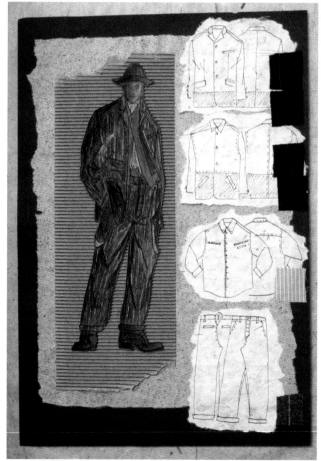

OPPOSITE Alternative ways of representing menswear by Tim Voegele (top) and Nitin Parmar (bottom), 1993

and, later, Julie Verhoeven were some of the artist-illustrators who came in as visiting drawing tutors and helped students find ways of best recording their ideas.

1996 was busy. The IWS collaboration celebrated its 10th year and brought the project back to Britain, to be briefed by Nicole Farhi. Sheilagh Brown was invited to be visiting professor for womenswear. The millinery option took on a new importance, accepting three students instead of the usual one or two, and a hat project with Kangol was opened to the whole of the first-year womenswear group. The young American designer Marc Jacobs, freshly-arrived creative director at Louis Vuitton in Paris, took on a whole group of recent RCA graduates in his design team. With the 1990s revival of many old-established luxury leather labels including Vuitton, Prada and Gucci and the introduction of their new fashion lines, there was a tremendous growth of interest in the manufacture of modern accessories, and remarkably few British courses where designers could be trained. John Miles recognised this omission and set out to correct it, creating links with the venerable Cordwainers' College in London's East End and setting up two new options within fashion, one for footwear, led by Sue Saunders, and the other for accessories (small leather goods) with Caroline Darke. As with millinery, the dearth of undergraduate courses in these disciplines meant that the applicants for the small number of places each year usually arrived via one of two routes: they were either from backgrounds in art and design, usually 3-D based such as product design or sculpture, or they were already working in their respective trades and wanted more tuition in the aesthetics of their particular specialism. This diversity of provenance made for an interestingly individual attitude to design and making, which was

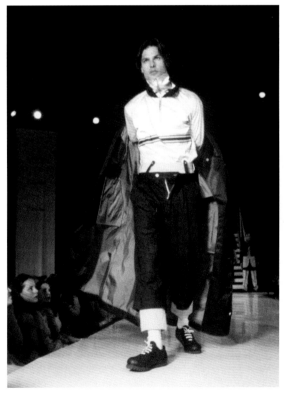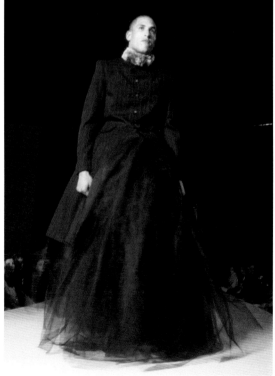

1996 collections – Amar Rai's streetwear and Karnit Aharoni's crinoline man

1996 collections – two
'bonnets' by Scott Wilson

supported by the rigorous practical course set up with expert technical tutors at Cordwainers'. The RCA students were fascinated to learn about such traditional leather-based crafts as saddlery as well as about the many processes involved in making shoes and luggage, and the techniques they experienced did much to inform and affect the way in which they developed their designs.

Caryn Franklin's term as external assessor was followed up by the choice of a second fashion journalist, Iain R Webb. Press interest in what the RCA students were doing was growing again, after a quiet period in which St Martin's (where Webb had been a student before heading up the British version of *Elle* magazine) always seemed to be in the limelight. The journalists were particularly interested in the knitwear and menswear students (perhaps, with the majority of British fashion schools specialising in womenswear, the RCA's course appeared less newsworthy). The foundations in men's tailoring laid down by Charlie Allen in the early 1990s had taken root. The IWS brief for the autumn term of 1996 was set by distinguished Italian menswear company Ermenegildo Zegna, and in addition to this there were projects sponsored by Savile Row tailors Gieves & Hawkes and luxury-goods label Dunhill. For womenswear a project came from the formidable Donna Karan, whose late-night RCA recruitment sessions had become a slightly scary annual event. A different approach was encouraged by IFF (International Flavours and Fragrances) whose 'noses', creators of many designer-name perfumes, introduced a new type of project to the final-year students: each one was asked to create the concept for a scent representing his or her final collection, an opportunity to do a bit of lateral thinking and to produce something different with which to enhance the portfolios.

IFF themselves continued to set this project annually for many years, awarding bursaries for winning students and providing generous and essential funding for the fashion shows.

A surprise departure

At the end of this academic year, John Miles felt that the department had consolidated and was on the cusp of 'a real high'.[9] After some early changes (when Frances Mossman decided to leave, Henrietta Goodden had taken over as course leader for womenswear, later being upgraded to senior tutor; Georgina Godley became first-year tutor and John Walford was contracted to produce the annual show) he was happy with the staff team, the breadth of projects and the diversity amongst the students. He had achieved his ambition to have teams of designers working across various textile and fashion disciplines, with several successful partnerships in the making, and he had taken the show, if not to Paris, out of its comfort zone and into the public eye. The early-nineties ventures into deconstructed clothing had moved on, and students were creating noticeable collections, a stimulating mix of laid-back modernism balanced by colourful eclecticism, much of it displaying all kinds of textile techniques. He had opened up new courses and consolidated research degrees. So when John Miles resigned, towards the end of the summer term, it was a surprise. Throughout his tenure Miles had never been shy in speaking his mind, particularly in the official boards and professorial meetings he had to attend, and senior management may have been aware that he was unhappy with prospective ideas for a restructure of the School. He loved the College but found it difficult to accept some of its systems, and he had been offered a contract with the huge European fibre producer DMC as director of their French and German design teams. Whatever the reason for going he felt unable to continue.

A moment of panic followed this abrupt departure. James Park, the much-loved deputy course director who had long been Miles's mainstay in Textiles, was immediately put in temporary charge of the School, with senior tutors responsible overall for their respective courses. It was near the end of term and most of the year's practical work was completed; after Convocation the next big task would be the organisation of the following academic year and, unexpectedly but crucially, the search for a suitable professor of fashion who would lead the department towards a new millennium. During his time as professor the mercurial John Miles, the first to oversee disciplines of both fashion and textiles, had by his own admission learned much about the differences between the study of the two. He had long understood the needs of a textile designer, but in his words fashion was something else: 'the most complex subject', a relentlessly immersive world in which students would have to devote themselves to 'a career not a job'; a choice of vocation, changing all the time, which requires such passionate commitment that it can take over completely, so encompassing that, providing you are strong enough to take it on '… you have to **live** it'.

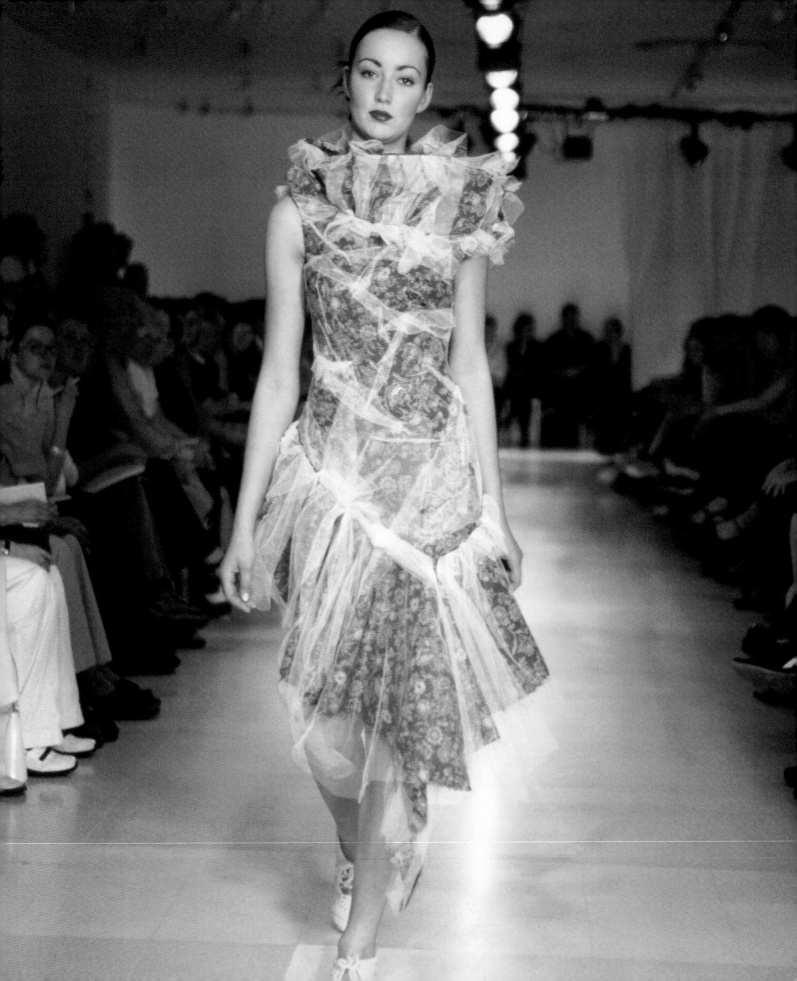

Chapter 11

A Blow for St Martin's

Wendy Dagworthy (right) with model at her first show, Playboy Club, 1978

Dress from Jonathan Kyle Farmer's collection, 2000. 'Repurposed from my grandmother's favourite chair, with hand-appliqué tulle'

In the year following the departure of John Miles there was a strange feeling of limbo within the Fashion Department – not really unsettling, but with an expectant frisson of 'what's next?' Rector Christopher Frayling understood the vital importance of the subject within the College and was determined to find a leader with the calibre to resuscitate the School and restore its reputation. Meanwhile, James Park as Head of School encouraged the leaders of the menswear, womenswear and knitwear courses to continue as they wished and, in an atmosphere of calm anticipation, Fashion continued to operate efficiently in the absence of an overall director, the staff and students working as normal while wondering what might be in store for the School's future.

In the autumn term of 1997 when, although there had been a strong group of applicants for the post, it seemed that no-one entirely suitable was available or inclined to take up the challenge of becoming professor, someone had a brainwave. The reputation of the fashion courses at St Martin's made it the only school considered a rival to the College (in fact, at that point, it was often judged superior in terms of creativity and style) – why not contemplate poaching the force behind its recent phenomenal success? The College's team of headhunters had already consulted Betty Jackson and also Wendy Dagworthy, who was running the remarkable three-year BA course from which such names as Galliano and McCartney had graduated, merely to ask if they could think of someone capable and charismatic enough to become the new professor. It was some time after this that Wendy answered a phone-call from David Hamilton, the College's pro-rector, asking her if she would herself consider applying for the job.

It was an agonising moment. Wendy was torn between her loyalty to the glittering course she had created, and the challenge of revitalising such a prestigious school as the RCA. In the end, the result was that the College's offer won – just. In what was considered by some 'a blow for the bohemian St Martin's and something of a coup for the stuffy RCA,'[1] the College was proud to welcome a vivacious, pragmatic, inspiring and of course enormously stylish new professor to the school of Fashion.

Wendy was born in Gravesend, Kent, in 1950. Her father was a Londoner and her mother from Kent, where they decided to settle after they got married. Wendy attended the local school in Gravesend and, from a young age, loved to help her father in his signwriting business, which he operated from the garage studio in their garden. One of his main clients was Truman's Brewery, and Wendy was always fascinated to watch her father add the pub's name to a painted signboard, working with gold leaf and the egg-tempera he created by draining the contents of an egg through a pinprick. The magical delicacy of this technique may well have inspired the love of craft and detail which became a recognisable feature of Wendy's later designs.

Always keen on needlework at school, Wendy enjoyed learning traditional handsewing techniques such as smocking and embroidery. When she reached the age of sixteen she enrolled on the foundation course at her local art college, Medway School of Art in Rochester, fifteen minutes away by train. Wendy describes the whole experience as 'brilliant – we did everything'. The first year provided an opportunity to study all areas of art and design (many art students used it to prepare a portfolio for the 'A'-level examination), and in the second, pre-diploma year students could specialise in a particular subject in preparation for a diploma course. Wendy chose to study on the dress course, which was taught by Beatrice Rhodes, the mother of the soon-to-be-famous Zandra who had completed her National Diploma in Art and Design at Medway before being awarded a scholarship to study textiles at the RCA.

Wendy aged 6 in 1956

Medway's story had started in 1853, when art classes were held in Chatham and Gillingham as part of a national movement, triggered by Prince Albert's Great Exhibition of 1851, to establish a template for the study of design. The classes moved to Rochester and by 1907 there was new accommodation with purpose-built studios. The school continued to expand until the 1950s, by which time it encompassed courses in architecture, fine art, commercial and industrial design, graphic design and 'women's crafts' (later to be known as 'dress'). There was a strong bias towards design for commerce, and it was at Medway that Wendy met a fellow-student called Jonathan Prew, always dressed in black, studying photography for advertising and later to become her husband. There was a lively after-hours scene and when there was a party the dress students, when not customising their own clothes, would often buy a cheap length of fabric and run up a new outfit to be worn the same evening.

In 1968 Wendy applied successfully for a place on the highly-regarded fashion course at Hornsey College of Art (later to become part of Middlesex University). In the tumultuous year of the devastating student riots in Paris, Hornsey was one of several British colleges severely affected by student unrest and the scale of the 6-week student sit-in meant that the school was effectively closed down. New students, including Wendy, had to wait until November to begin their courses, originally scheduled to start in September.

Wendy working on her final collection at Hornsey, wearing Mr. Freedom dungarees

Incidentally Robin Darwin, himself afflicted that summer by growing student discontent at his own RCA, made a generous offer to accommodate up to one hundred Hornsey students for six weeks while their local authority temporarily closed the school, 'in order that they can continue to work'.[2]

Wendy had found a room in a flat in Oakley Street, Chelsea, sharing with five other people, for which she paid £2 per week rent. Jonathan soon came to join her, having finished his vocational training at Medway, and when the fashion course finally started she found it interesting and great fun. The year group was small, 'about ten people', and in the final year several of them, including Anthony Hendley (later to head up RCA menswear), gained places at the College. Wendy chose not to apply for further study but, on graduating, immediately found a job. Prudence Glynn, the influential fashion editor of *The Times*, had seen Wendy's diploma show and introduced her to Monty White who was the boss of the Radley fashion label, which had a tie-up with Ossie Clark and Alice Pollock of Quorum and was therefore a desirable first job for a young designer straight out of art school. There were three designers and Wendy started as soon as she could leave Hornsey, at the end of the summer term of 1971.

Designer to the rock stars

Working in a commercial company, Wendy learned much which cannot be taught at college, about the processes involved in creating a fashion line. Everything, apart from production, was in-house – design room, sample room with cutters and machinists, fabric ordering and the sales department. Around Christmas of that year, one of Radley's salesmen left to set up his own label, Paul Jason, and offered Wendy a position as his designer. She had always made clothes for her friends, and while working in her new job began in her spare time to make stage outfits for up-and-coming band Roxy Music. Their solicitor, Robert Lee, was an old friend from Gravesend, and lived in a flat in Holland Park below Bryan Ferry's apartment. Wendy met Ferry and 'made him some clothes' with which he was obviously pleased, and he passed her name on to Roxy's lead guitarist Phil Manzanera, opening a period in which she became, to a certain extent, the band's bespoke designer. The dazzling image for their performances – Bryan Ferry's louche lounge-lizard look complemented by the rest of the band less formally styled in satin bomber jackets – was much due to Wendy's input. In terms of both sound and visuals, Roxy Music's art-school background gave them a sophisticated edge over the 'glam-rock' style of the early 70s, and it was fun designing for performers who really understood what they were ordering. The network spread, and soon Wendy was designing for the experimental rock band 10CC, as well as Roger Daltrey and Pete Townsend of The Who; Mick Jagger, Alison Moyet, and Kiki Dee all became clients, and later on Boy George was often seen in one of Wendy's black-and-white check coats. It was a special cultural moment in London where the club scene, music and fashion all began to influence one another, contributing to the success of young designers and, in a reprise of the 60s 'youthquake', creating a particularly British style and dynamic.

The brand gets going

A shift was also taking place in the world of independent retail. Up until the early 70s, much of London's fashion business was based on small boutiques paying low rent for ground-floor premises with a production room upstairs. Gradually the industry saw the opening of more expensive outlets selling labels other than their own. In 1972 a friend of Wendy's, wearing one of her jackets, went into Countdown (the King's Road boutique owned by RCA millinery graduate James Wedge and his partner, Pat Booth) and the owners immediately asked to see her. With a sewing-machine in her bedroom she began to make up commissions for Countdown, and this led to more orders from other shops. Wendy decided at that point to take the plunge and set up her own label and, when she had moved with Jon to a more spacious flat in West Kensington, the sewing machine acquired premises of its own in a separate design studio. The Wendy Dagworthy brand was born, and as it grew, the designer was able to take on more staff – first of all a freelance pattern cutter and one machinist, and eventually an assistant, Betty Jackson, who was working as a freelance illustrator and joined in 1973. Little by little the orders grew, and soon Wendy was able to employ outworker machinists, with her team delivering 'bundles' of cut pieces and returning to collect the finished product later in the week. The garments were then taken to another outworker for buttonholing, and pressed and finished, usually late in the evening, at home.

Jon Prew in Wendy Dagworthy dungarees

Wendy's design style was loose and comfortable, inspired by traditional workwear silhouettes: she had noted that London's established designers were better known for eveningwear rather than the daywear clothes which she sensibly viewed as much more important, and her love of practical fabrics along with a talent for mixing prints and patterns soon created a very recognisable product. However, the financial side of the enterprise was a challenge. A thousand-pound order from cutting-edge Kensington boutique Che Guevara was a thrill to receive, but how could the fabric be bought? Any number of business studies lectures at college cannot prepare a young designer realistically for the uncompromising world outside, and cash-flow was, to begin with, the main obstacle. Wendy's mother, now on her own (Wendy's father had, distressingly, died early in 1972) lent her a few hundred pounds to start her off. Robert Lee then introduced her to an accountant who helped her produce a business plan, and it is an accolade to Wendy's famous charm and integrity that on her request for a £600 loan her bank manager immediately offered her £800, quite possibly the first time he had helped a young female client in this way. So, despite a major recession, the business grew and by the end of 1974 had premises in Berwick Street in the heart of Soho, soon progressing to factory production as the orders grew and the label became more and more established. As well as sourcing British fabrics, Wendy visited the gigantic textile fair Interstoff in Frankfurt every season, selecting European and Indian cloths to complete the eclectic mix which was becoming her trade-mark. She loved the irregular, often flawed quality of the handwoven and printed Indian cottons, and made a first trip there to work with the producers, beginning a love-affair with the subcontinent that would continue indefinitely.

Autumn/Winter 1978, neutral wool with red accents

Before long the Wendy Dagworthy brand was invited to join Annette Worsley-Taylor's new London Designer Collections, the conglomerate of selected fashion names which showed twice yearly at venues such as the Ritz Hotel. Store buyers would make their selection for the following season, fabric previously sampled would be subsequently ordered in bulk, and factories commissioned to create the product. Wendy's wholesale business really got going in the mid-70s as the LDC's reputation grew and an influx of overseas buyers began arriving in London. She had asked the forceful Lynne Franks (later to be immortalised by Jennifer Saunders as Edina in the BBC's 'Absolutely Fabulous') to be her public relations officer, and held her first independent show in 1978 at the Playboy Club, fuelled by a breakfast of croissants and Bucks Fizz served cheekily to press and buyers by Playboy bunnies.

Triumph, then disaster

To deal with growing production, Wendy began to use manufacturers in Berwick Street and a tailor with a small factory unit. The first years were difficult, often hand-to-mouth, until 1983 when British and international sales increased. The collection

for spring-summer 1985 (striped linen and Liberty print with design references to traditional menswear) was a great success, selling to major stores throughout the US, and around 50 shops in Italy as well as Harvey Nichols, Harrods and Liberty in London. Impressive order numbers meant that new factories had to be found and Wendy's production moved up to larger manufacturers in Nottingham and further north. Success had arrived at last, even if it was to be short-lived. In late 1986 a triumphant 'trunk show', a series of special in-house presentations at major stores in New York, together with Betty Jackson (now with her own label), Jasper Conran, John Galliano and Katharine Hamnett, resulted in substantial press and TV appearances, and the irrepressible British designers were ready to conquer again, this time internationally. But almost immediately a bombshell fell when, in October 1987, the global stock-market crashed, instantly shedding enormous value in a very short time. The effects were disastrous. Just when it was all working so well, the enthusiastic buyers from the US and Italy were suddenly barred from travelling to collections in Europe. Cloth deliveries were delayed, orders cancelled, and retailers

found they had no budget to pay suppliers on receipt of a delivery. Particularly galling for Wendy, a new backer from the Channel Islands suddenly pulled out. Things got so bad that she and Jon had to remortgage their house, and she realised too late what a mistake it was not to have had a business manager for the brand.

On advice from her accountant Wendy Dagworthy sadly put her eponymous business into liquidation. Jon's photography business was doing well, their first son Augustus was one year old, and Wendy had certain other commitments but needed to find more lucrative work. At that point she was already acting as external examiner for one of the fashion courses at St Martin's, and when she heard from Peter Pilgrim, head of the fashion and textile school, that St Martin's needed a new leader for the three-year BA course she was interested. She interviewed successfully and, excited to be making a new start, arrived to begin her new job in January 1989. St Martin's, having developed enormously since the pioneering arrival of Muriel Pemberton, ran several much-admired courses and the team was strong, with Bobby Hillson running the masters' degree course and Lydia Kemeny in charge of the four-year option.

Wendy's 10-year reign over the St Martin's fashion school is legendary. She was the democratic, unthreatening yet wholly-focused director of a charismatic and experienced group of staff, and together they resuscitated a previously underperforming course to transform it into an extraordinary, globally-renowned British stable for fashion talent. Unlike the RCA where graduating students tended to be recruited by existing companies, St Martin's had a reputation for highly individual designers who set up their own businesses, and the names which emerged in Wendy's time as head are notable – Hussein Chalayan, Antonio Berardi, Giles Deacon, Clements Ribeiro and Stella McCartney amongst them. While nurturing all this exceptional talent, Wendy, not remotely missing running her own company, was in demand as a freelance consultant, notably for Liberty, Laura Ashley, and her own former assistant from all those years ago, Betty Jackson. With Jon, she also made sure that her family, now totalling four after the arrival of second son Somerset in 1990, had equal priority to her work. So when she received the portentous phone call from the RCA it caused her more than a little confusion.

Thoughts of the College must have crossed her mind when she heard that the post was vacant, but she was so enjoying the success of St Martin's that it had not occurred to her to move. She had been there ten years; she loved it and had built up a creative and harmonious team, the student triumphs continued and the course was going from strength to strength. The idea of a change, however interesting, was perplexing; nevertheless, in December 1997 she agreed to the interview, and was subsequently offered the job. For a while this made things even less clear in Wendy's mind: a tempting idea, but did she really want to leave what she had built up at St Martin's? She asked Betty Jackson, with her intimate knowledge of the College, to discuss the conundrum with her over dinner, in order to weigh up the pros and cons. It seems that the RCA option ticked more boxes; it would be difficult to improve on what Wendy had achieved at St Martin's, and here was a unique challenge to

Fashion drawing 1997 by Barbara Baum, Wendy's student at St Martin's who went on to the RCA

breathe new life into a proud but faded legend with a highly distinguished history. Wendy commented at the time that 'The name Royal should mean something and, at the moment, it doesn't'. The College had won a new professor. So, under her direction, a fresh era was about to start, one in which the Fashion School would regain the polished reputation which had become somewhat tarnished; a period which would often seem to recall the exhilarating spirit of the school's 1960s heyday, but repackaged with a shiny new image reflecting the global and cultural changes which were so much a catalyst for the ideas they generated.

Wendy was unable to leave St Martin's before the end of the academic year in summer 1998. Early in the spring of that year she undertook her first role as the prospective new professor – stage one in the recruitment of the next year's students, which was to assess the huge number of portfolio submissions to the school of Fashion. Each year would bring hundreds of applications, already sifted in Registry by academic qualifications, which would be whittled down to around a

Portrait of Wendy, Howard Tangye, 1998

hundred interviews for an average of forty places across womenswear, menswear, knitwear, millinery, footwear and accessories. The task of looking at so many portfolios was arduous, requiring physical resilience as well as mental application. Submissions varied enormously, and the staff team were expert in understanding the nuances of the applicants' work, depending on which undergraduate or similar course they were coming from. As well as accepting the obviously talented applicants for interview, Wendy's approach was to try 'some risky people, add a bit of madness' to the mix. For her first experience of the selection process, the College had outsourced temporary premises in a warehouse in Shepherd's Bush (coincidentally, just up the road from her home) – a huge, draughty loft which in an icy February was a chilly and unsympathetic introduction to her future career.

The Show comes home

For the staff, Wendy's appointment was a welcome shot of stability. The year without a head of Fashion had ticked over without too much difficulty, and some Gala funding was still in place, but there had been a certain lack of overall direction. Although projects had continued, many longstanding sponsors had broken their ties with the school during the previous few years and the current industrial links were mainly with large suppliers to the retail trade who, though they wanted creative results, were not entirely inspiring to students. Menswear in particular felt shaky when Anthony Hendley resigned, although Michael Fay was a professional and popular temporary replacement. Staff had liked the idea of reinstating the Show in the College's Henry Moore Gallery but this had been requisitioned well in advance for other purposes, so there was no choice but to stage it outside or not at all. The Porchester Hall in Bayswater was eventually secured as the venue but, in spite of some commendable collections, its rather down-at-heel atmosphere only added, in the view of sponsors and guests, to the school's current lacklustre appearance. So everyone was looking forward optimistically to the arrival of the new Professor in the autumn term.

When Wendy arrived she found, unsurprisingly, that there were certain issues needing attention. One was to find a new head immediately for the Menswear course, for which Wendy recruited Ike Rust, a graduate from the MA course at St Martin's ('a dream student, like blotting paper')[3] who had previously applied for a job on Wendy's course there before deciding on a position at the fashion school in San Francisco, where he had spent the previous few years. There was also a vacancy for a womenswear tutor, a contract which had been divided in John Miles's tenure between John Walford and Georgina Godley. Young designer Karen Boyd, also a lecturer of some experience, was interviewed and selected for this one-day-a-week post. Almost inevitably, as each regime is bound to have a different system, there were financial issues, and one surprise was finding that the fund for the annual travel scholarship set up years before in Janey Ironside's memory had mysteriously been redirected for other purposes. Wendy, always particularly respectful of the school's heritage, made sure this was reinstated and Virginia Ironside was delighted to resume the annual presentation of the award to an imaginative first year student.

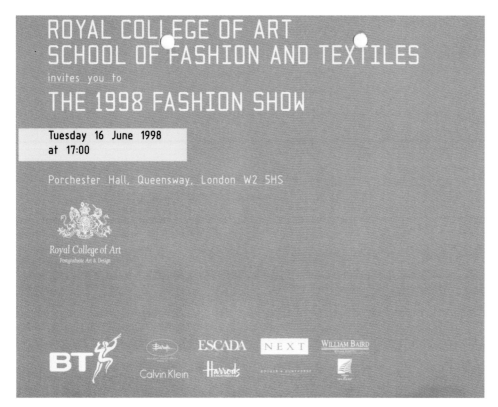

ROYAL COLLEGE OF ART
SCHOOL OF FASHION AND TEXTILES
invites you to
THE 1998 FASHION SHOW

Tuesday 16 June 1998
at 17:00

Porchester Hall, Queensway, London W2 5HS

Royal College of Art
Postgraduate Art & Design

BT ESCADA NEXT WILLIAM BAIRD
Calvin Klein Harrods

1998 RCA Fashion Show invitation, showing the importance of industrial sponsorship

Also unsurprisingly, Wendy found that fashion was 'a bit textile-based' when she arrived. John Miles had succeeded in his mission to get the two schools working together, often creating successful partnerships. Sometimes, though, this produced results which, however innovative and exciting, could end up less than professional-looking, but in other cases it worked well. Amongst the sponsors flooding back to support the course under its new professor was a joint fashion-textiles brief from Maureen Doherty, in which craft was one of the main issues. Her Belgravia shop 'Egg' sold beautifully-conceived independent clothing lines, Japanese-inspired and often hand-finished, and this aesthetic perfectly suited a craft-based project in collaboration with Tate Britain's 'Bloomsbury Group' exhibition. Alongside this, in addition to the stalwart sponsors who had continued their support, there were many notable new contacts queuing up to work with the school, and it was hard to choose which of their offers were best suited to the students. Project manager Heather Holford was almost overwhelmed by briefs from Harrods 'Way In', Daks/Simpson, Benetton, Puma, and the Saltwater label set up by knitwear graduate Laura Watson. The Woolmark project that year was with grand Italian house Mila Schon. IFF continued their lateral-thinking perfume project, the footwear students were thrilled to work on a project personally set and assessed by the great Manolo Blahnik, and the arrival of ace hatter Stephen Jones as a visiting tutor caused great excitement in the millinery studio.

For Wendy the College was 'a dream'. When she left St Martin's she had overseen the creation of over one hundred student collections, and the RCA's smaller groups, maximum thirty students, meant that much more time could be spent with each

1999 student designs: Matthew Millward's menswear, Maya Arazi's womenswear and Imken Donde's knitwear

1999 student designs: Adele Clarke's shoes

one. She also had the luxury of her own administrator, Margaret Manley, instead of sharing a willing but overstretched secretary with other senior staff. The fashion team was delighted to see that as soon as Wendy was settled in her new post she set out to reinstate the annual show in its original venue. The catwalk, more modest than before, once again wove its way through the Henry Moore Gallery to a rapturous welcome from College and industry, with producer Lesley Goring who would mastermind every show during Wendy's tenure. The Gala show for the year 1999–2000 commemorated 50 years of RCA fashion shows, and with the help of

staff and students IFF developed a special perfume named 'Madge'. The footwear and accessory students had their own static show, and that year's graduates secured jobs at the most illustrious of employers – Mila Schon, Sportmax, MaxMara, Alberta Ferretti, Ungaro, Armani, Valentino, and Calvin Klein. The interest shown in the students by these international names bore out the essence of the Rector's comment in *The Times* Higher Education Supplement, that 'Fashion's role is to stimulate the industry rather than to serve it'.

Outside the College, new arrivals to the industry were learning too. Perhaps as a result of the previous generation's problems in the 80s and early 90s, young designers made sure they knew how to deal with basic business and had a much greater understanding of the commercial world. To help them, the DTI and the BFC set up a 'designer fact file' full of practical guidance for independent companies. Some of the more adventurous chainstores took on established designers as consultants: collections by Philip Treacy, Jasper Conran, John Rocha and Betty Jackson were commissioned by Debenhams; Betty Jackson, along with Paul Smith and Sonja Nuttall, was also snapped up by M&S where Sheilagh Brown was in charge of the lively design team for womenswear. The British high street was once again at the top, and established outlets such as Topshop and Miss Selfridge with designers trained at British schools were now in healthy competition with the Swedish H&M group, and a new influx of Spanish stores, led by Zara, pulling in the spending power of very discerning young customers.

All this activity at the end of the 90s brought a resurgence of interest in individual London design companies who, without losing the mild, peculiarly British eccentricity admired by the buyers, were showing imaginative collections which were at the same time wearable and realistic. In February 98, legendary New York behemoth Saks Fifth Avenue was so impressed by the London designers that it gave

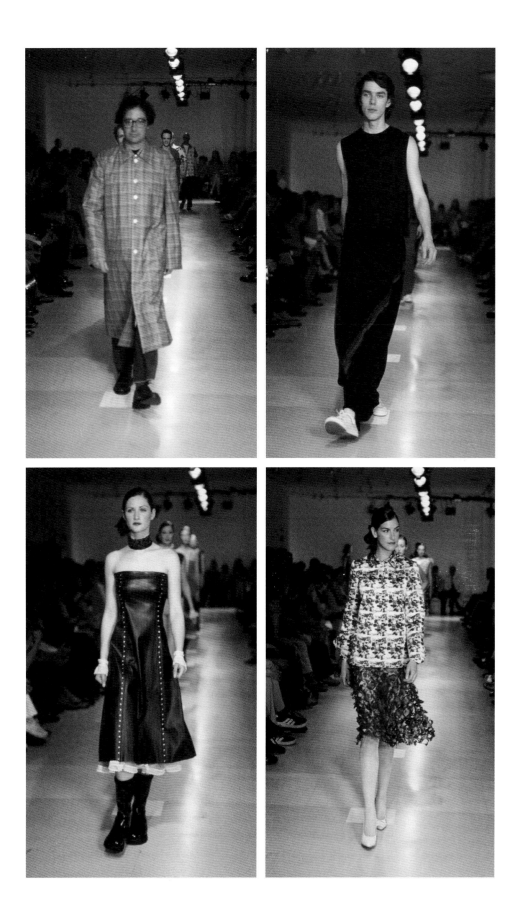

Millennial collections, 2000: menswear by
Kristof Hoeke and Michael McKenna,
womenswear by Nicola Berry and Jason
Masterton Copley

over all 32 of its windows to British fashion. It was partly thanks to enormous international admiration for the maverick skills of Galliano and McQueen that in September 1999 an edgy group of London designers including Hussein Chalayan, Nicole Farhi, Bella Freud, Tanya Sarne of Ghost, and Vivienne Westwood were invited to show in New York Fashion Week. International buyers began to appreciate the theatre of London shows and, in a reverse action, the city's design reputation abroad was filtering down to the level where all the creativity began – art school. From the moment Wendy arrived at the College, more and more of the Fashion School's applicants were from colleges in Europe and overseas. Her comment that 'London's individuality comes from its educational philosophies of UN-inhibiting students' appealed to many hopefuls from more formal educational backgrounds, and also from qualified young designers wishing to hone particular skills. European

Illustration for outfit 3 in Barbara Baum's collection, 2000

students paid the same fees as British ones, and to them the idea of living in cool multi-cultural London was hugely attractive. As many as 30% of students were now non-British, mainly from Europe but also, for much higher fees, from such faraway places as Israel and Japan. Finger-on-the-pulse *ID* magazine, summing up the influx of foreign students who would then hope to get international jobs, remarked that 'students are having to think more globally' both about their education and where it might take them afterwards.

The professor of Fashion, already in charge of such a sparkling group of courses, was about to take on more responsibility. Drawing a line under his impressively long career in Textiles at the College, James Park retired in summer 2000. New professor Clare Johnston replaced him, and Wendy Dagworthy became head of the School of Fashion and Textiles as well as director of the fashion courses. With the approach of a new millennium came different challenges, as the space-age fantasy of the year 2000 was about to become reality.

Chapter 12

Culture and Celebrity

The excitement of a new millennium brought with it a welcome feeling of stability in the British fashion industry. The positivity of the late 1990s, with its emphasis on individual British brands, gave fresh strength to the industry at every level. Triggered by the successes of sparky independent designers, reliable but uninspiring classic labels were forced to reinvent themselves; while on the high street, with its teams of British-trained designers, high fashion was available to everyone at very low prices. The designers were more often than not ex-students of Britain's 90-odd fashion courses producing around 3,000 graduates each year – an enormous number, hoping for jobs not just in design but in areas such as marketing, journalism and every other aspect of the fashion business.

The easy and culturally diverse atmosphere of London, along with the shining reputation of British higher education in design, encouraged more and more non-British students to apply to the College. Alongside this influx, Suzy Menkes wrote in the *Herald Tribune* in June 2000 that RCA fashion was 'regaining its lustre because Wendy Dagworthy joined … two years ago'. Wendy's appointment of younger part-time tutors, several of them previously staff or students from St Martin's, brought a fresh and challenging point of view and created a new RCA style which, contrary to some expectations, was very different to that of St Martin's. Far from trying to recreate what she had done in her previous appointment, Wendy's sensitivity and respect for the College's integrity resulted in the fashion students producing a special RCA brand of airy optimism, a sort of Millennial Modern for a new decade. To begin with, one of the new sponsors was the lively Japanese retail company United Arrows, whose director set up a project for men's and womenswear students which would continue annually for many years. Louis Vuitton also set a brief, and British sponsors included Katharine Hamnett promoting organic cotton, and an accessory project with Daks/Simpson, one of the classic British names enjoying a millennial revival. Manolo Blahnik's project became an inspiring annual event for footwear students, and millinery student Karen Scott was selected by the Ascot Authority to produce a Royal Ascot Collection, to be sold in selected small boutiques and at the racecourse itself. Jobs continued to come from both Britain and abroad – Burberry, Daks, French Connection, Balenciaga, Ferretti, Lagerfeld, Lanvin, Levi's and Nike.

In 2001, a restructure of the College's schools meant that Fashion and Textiles, one of the largest departments, remained a faculty in its own right while other schools amalgamated to create sizeable faculties within the university structure. As a result of this Wendy found her workload was becoming greater, owing to the increased

Wendy Dagworthy, with her signature armful of silver bangles

Menswear from Astrid Andersen's collection, 2010

Work review in the Professor's office, c.2000.
L–r: Sarah Dallas, Wendy, Betty Jackson,
student Bidyut Das, model Suna Barnes

number of meetings and boards she had to attend, but her first priority was her students. She saw them as much as she could, attending as many crits as possible and almost always chairing the twice-termly work reviews in her office. With emphasis on the individual, her advice was 'be yourself'; in answer to a question from one of the fashion journalists, she firmly stated 'We don't have an RCA look'. Work was never marked, but students always got verbal and written feedback. Wendy's belief was that it was important to learn from mistakes, and to look at design from a broad point of view: students should be able to appreciate all forms of clothing, whether historical, futuristic, ethnic, functional; the purpose of every garment type was essential to understanding design. While adjusting to advances in technology, one ought to be aware of primary sources. Students must always 'look at real things' to feed their ideas, so that even the most individual design is grounded in a practical understanding of the body and the environment.

Suk Han Lee, *Shadows in the Wardrobe*, 2001

Reflecting Janey Ironside's glorious reign, the journalists were never far away and the press couldn't get enough of the fashion students. With Betty Jackson back on board as visiting professor now that Wendy was in charge, there were ever-closer links with the London industry, and the second-year students were invited to show in London Fashion Week in both March and September. In the same year, 1997 graduates Roger Lee (womenswear) and Lesley Sealey (mixed media textiles), with their IE Uniform label, won the British Fashion Award for street style, and millinery student

Karen Hendriksen was named *Hat* magazine Designer of the Year. There were international events, and the School was invited to enter two fashion competitions in Trieste – Mittelmoda and the first ITS (International Talent Support) contest. The school's entrants proceeded to win major awards in both of these events regularly over the following years. Eventually Wendy was asked to be a judge at Mittelmoda which meant that the College was no longer able to enter, but the students continued to triumph at the annual ITS event.

Stars and the Show

It can be argued that starriness has been important to fashion ever since the arrival of the silent screen and the press that went with it. The public has always needed idols to worship, and the modern culture of celebrity has become uncontrollable with constant mass availability of news and images. From the mid-1980s (the decade in which the word 'design' was so often mistranslated) a new cult arose – that of the designer as celebrity alongside his or her socialite or showbiz clients. This was a trend largely created by mass media – many designers, continuing to work much as they always had, were surprised to find themselves centre stage along with their products. In some cases, with the growth of the red-carpet industry and its attention-seeking dresses, this engendered a certain amount of bling and dubious taste. The danger was that exhibitionism and publicity would take over from the appreciation of skill and aesthetics, and that a new arrogance regarding the trade would affect the nuts and bolts of the fashion industry.

In the early years of the decade the RCA fashion shows began to reflect this trend, albeit never forgetting the *raison d'etre* of the Fashion School and its ties with the industry. The lists of guests of honour for the annual Fashion Galas became ever more newsworthy. Although the show was a mammoth undertaking, with regular

Graduate collections 2002 – Georg Meyer-Weil's sinister birdman, Tibor Rohaly's elegant menswear, dark drama by Christian Aadnevik

organizational meetings beginning in the autumn term, Wendy loved every aspect and looked forward to selecting the guest-list. She and her team were immensely careful, however, that bling never took over from the school's innate style, however many current media stars were suggested by the students. The 2002 gala showed a vintage year of graduates, and the top tables (there had to be more than one) entertained veteran Italian designer Nino Cerruti, Philip Treacy, Julien Macdonald with soap star Martine McCutcheon, distinguished journalists Colin MacDowell and Iain R Webb, Alice Rawsthorn, director of the Design Museum and, invited at short notice by the Rector, the great Issey Miyake whose quote that RCA students are 'a nourishment to the world' would be remembered every year after that at Convocation. Over the following few years, special guests included Bryan Ferry, Suggs (of Madness), doyenne journalists Suzy Menkes and Hilary Alexander, Hamish Bowles of *Vogue* and an endless series of whichever big designer names were able to accept. Lord Snowdon was a regular – Provost of the College for many years and a passionate supporter of everything it stood for, his informal visits to the Fashion School would delight the students and staff, particularly the technicians with whom he would always stop and discuss what they were doing.

Erdem's Magic

A graduate who perfectly understood how to attract celebrity (and those less famous too) emerged in 2003. Erdem Moralioglu is a brilliant example of a modern RCA designer. With Turkish and English parents, he arrived at the College from Ryerson University in Toronto, having produced his undergraduate collection using textiles designed by Celia Birtwell in the years before she resurfaced as a cult designer. In some ways much like Christopher Bailey, as a student Erdem had

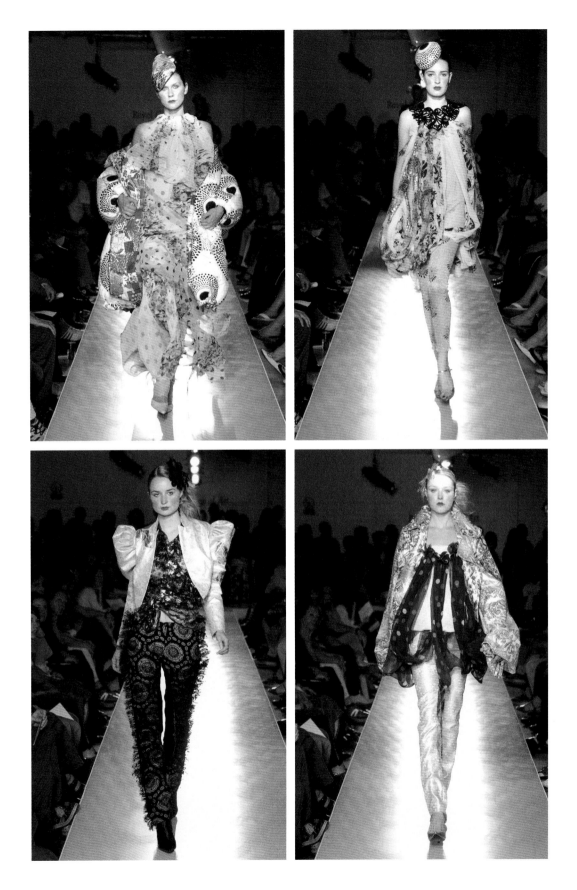

Erdem Moralioglu's final collection 2003, showing his eclectic talent with textiles

endless charm and enthusiasm and a natural talent for creating unexpected fabric combinations, learning how to work with technicians to achieve his aims. On graduation he secured a high-profile job, following RCA alumnus Nathan Jenden to Diane von Furstenberg in New York; he later returned to England to win Colin MacDowell's Fashion Fringe award in 2005, requisitioning the Fashion School technicians in their summer vacation to help him make his winning collection . This aided him in setting up his own business and, in the words of *Elle*'s Rebecca Lowthorpe, his collections, edgily pretty, had 'a touch of the Ossies – because he didn't attend St Martin's, the most competitive and anti-pretty fashion school on the planet'. Erdem's reputation grew, and after winning just about every major British fashion award over the years, including several times British Designer of the Year, his client list is impressive: the Duchess of Cambridge, the Duchess of Sussex, Michelle Obama, Nicole Kidman, Keira Knightley, Gwyneth Paltrow, Kirsten Dunst, Sienna Miller, and many other A-listers. His success with red-carpet clients has been due not only to his sensitive understanding of textiles and the use of detailed craftsmanship, but also to his natural courtesy and his unselfconsciously boyish ability to charm everyone he meets.

After the 2003 show the *Independent* was gushingly complimentary. Its report, of a presentation that was 'seamlessly produced, polished, professional' with 'restraint, elegance and finish' makes the graduate work sound almost too tasteful. In fact, Erdem's work was more experimental than this implies, but overall the school was reaching such a sophisticated level that, to some, a little more madness would

Collections (below) by Tove Christensen 2005 and (opposite) by Karin Gustafsson 2006, both of whom went on to be design directors at COS

sometimes have seemed welcome. Perhaps the lack of this was due to the smaller numbers of British students and their supposedly eccentric point of view. The sizeable influx of Scandinavian students, along with the arrival of Finnish fashion technician Anja Huttünen, brought with it an essence of minimal Nordic modernism, but with their appreciation of flamboyant Marimekko-type textiles and a fresh sense of colour, they could never be termed as 'safe'. Several of them went on to head up new labels, including Tove Christensen who set up the design room at COS, under the wing of the Swedish H&M group. Karin Gustafsson eventually took her place as senior designer. Over the following few years regular and diverse projects with Bower Roebuck (tailoring), Manolo Blahnik, United Arrows, Miss Selfridge (the first of several RCA instore collections designed by Eudon Choi) and IFF coexisted with a Swarovski Crystal project, in collaboration with the Costume Society and RCA jewellery students, and a new relationship with the old-established Umbro label in which menswear students worked with scientists from Imperial College to produce new technical concepts for sportswear. The following year Umbro included vehicle-design students in a project to rethink the training-shoe. This continued over several years, later including womenswear students and always producing a brief requiring the students to leave their comfort zones and think in new ways. In 2006, student Aitor Throup produced a brilliant conceptual response which impressed Umbro so much they offered him a job, and this culminated in the commission to design the 2009 England football strip, in collaboration with Charlie Allen and inspired by England's winning kit for the historic and unforgettable 1966 World Cup triumph.

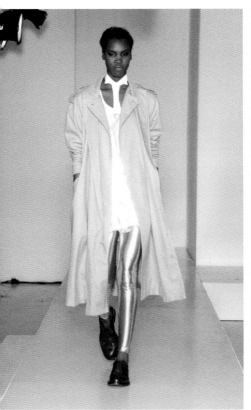
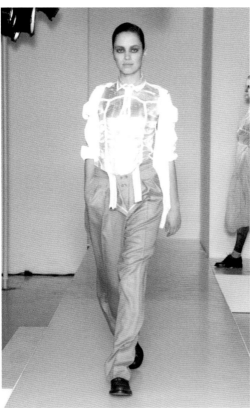
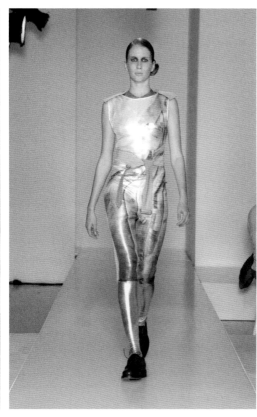

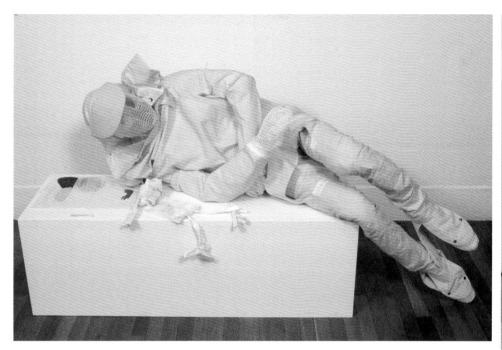

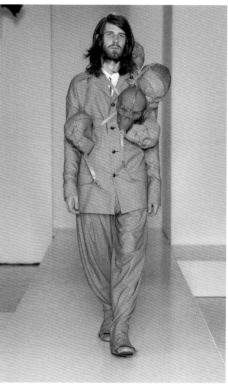

Static display and live model by Aitor Throup, 2007

The 'over-tasteful' reputation, if it had existed, was soon forgotten with the mid-decade arrival of a new extrovert spirit. Some of this may have been due to the diverse disciplines from which new students were emerging and it was interesting that two noticeable millinery students both came from hairdressing backgrounds. Justin Smith, already creating stage costume for the singer Bjork, won the iD Styling award and the Maria Luisa award for his extraordinary circus freak-show complete with professional performers, and Soren Bach Larsen used fur dyed with neon hair-colouring techniques to create spectacular 'hairdo' hats. The footwear and accessory courses were going from strength to strength, and students arrived from courses in sculpture, painting and engineering, all of which resulted in interesting influences on

The footwear/accessories studio

LEFT Foreground: Nicholas Dunn's men's shoe collection, background: women's footwear by Jane Brown, both 2001

RIGHT Modern luggage by Orlagh Dines, 2002

their fashion design. And those who had started at strong undergraduate fashion schools were also showing unusual points of view. Christopher Raeburn, ex-Middlesex, recycled army surplus, using its function and tough detail to create really wearable womenswear; Holly Fulton reconfigured the stylistic influences of her Glasgow background into overscaled embellishment for her feminine shapes, giant-sized but never gaudy. In the summer of 2007 the school's original spirit was once more acknowledged by a slew of awards in the ITS#6 competition in Trieste.

There were distinguished visitors to the school. After several attempts, the elusive Alber Elbaz of Lanvin was finally pinned down to give a masterclass to awestruck second-year womenswear students, and the menswear group had individual tutorials with a master-tailor before an intensive week at Italy's illustrious Brioni brand. John Galliano set a menswear brief, and Alexander McQueen gave a talk to the menswear students which was gatecrashed by just about every other department in the College. Karen Boyd, wishing to return to full-time designing, was replaced by cult artist/illustrator Julie Verhoeven as womenswear tutor. In addition to her responsibilities for the first year students, Julie's drawing classes were hugely popular and often attended by students from other disciplines. She herself then became so busy that eventually her place was taken by designer Tristan Webber, who had been a visiting tutor in the school for some time and who would eventually take over Henrietta Goodden's position when she stepped down as Senior Tutor. Graduate Flora Maclean took over the reins of the accessories courses. And there were regular after-hours visiting speakers too – popular informal sessions with young practitioners from fashion-related areas such as journalism, photographic styling, and show production as well as design in all its end-uses.

The government's funding of every university continued to be directly related to the amount of research output generated by its staff. Wendy's view was that fashion is

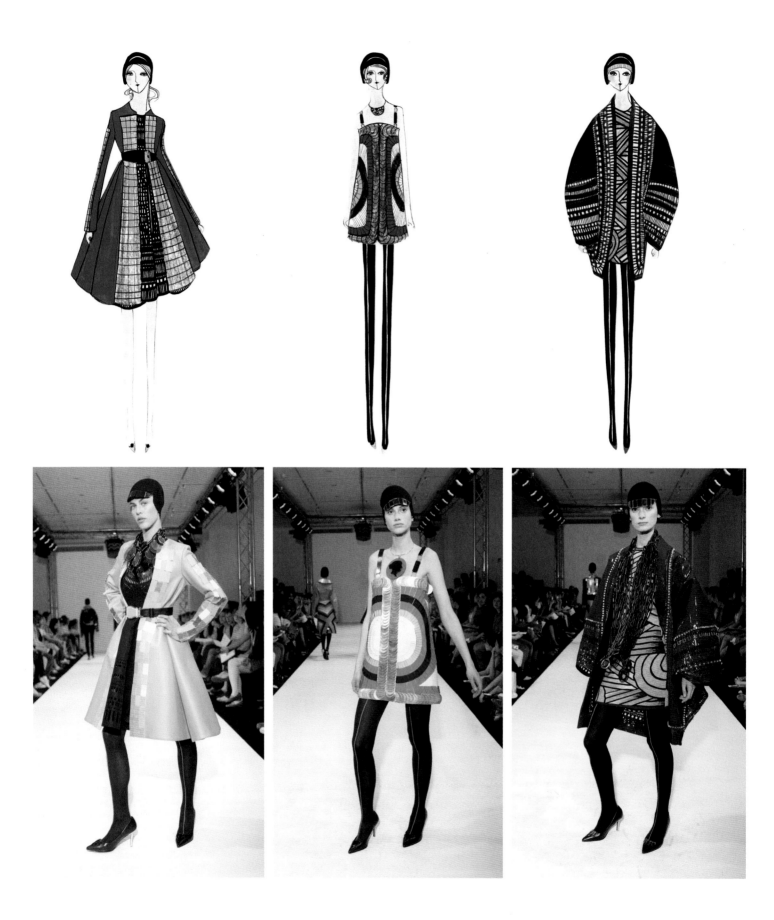

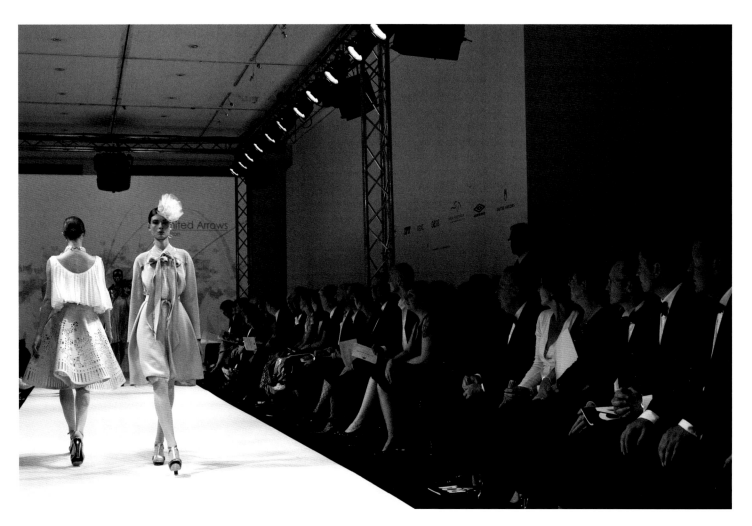

Fashion Gala 2007, with the first-year United Arrows project on catwalk

OPPOSITE Drawings and collection pieces by Holly Fulton, showing the transition from design to product, 2007

'a difficult field in research – if there is an idea, develop it, but there are limitations'.[1] She felt that students should not be forced into PhD study, that it should only be undertaken if there was a genuine idea. It was a different matter for the staff: every contracted tutor was expected to develop and then disseminate a research project. Some of them, Julie Verhoeven for example, were naturally involved in exhibitions and shows, meaning that they automatically qualified for the official Research Assessment Exercise. Others delivered academic papers at international conferences or authored books related to their research study. Wendy was asked to collaborate in the production of a book close to her heart, about 'the Forgotten Generation, London fashion 1968–89' – her memories of being part of this group, forgotten or not, were very clear; this was later published as *Style City* by Robert O'Byrne.[2] Links between the fashion school and the V&A remained very close, and in 2008 Wendy was also asked to co-curate, with her senior tutors, an exhibition in the museum's fashion galleries. 'Future Fashion Now' took examples of final-year students' MA collections, and showed the pathway of development from first concept to finished garment, by way of source material, sketchbooks, patterns and toiles, and including equipment and accessories necessary for the final look. This presentation, naturally interesting to many museum visitors, was obviously popular

with students and instructive in that it gave prospective applicants a clear idea of what might be required of them at Masters level. British design was continuing to be sought-after worldwide; international industry admired the 'feet on the ground' attitude of even the most experimental of designers, and although new MA courses had been approved and opened at a number of colleges, the flood of applications to the RCA still grew. Many of the more recent fashion courses were restricted in length, and although this made the RCA's two year commitment by far the most expensive, those who thought they could afford it considered this extended time an encouragement. Almost every British and European student found that it was necessary to have a part-time job in order to cover the fees, and as long as development was not hindered by this, staff would work around any attendance issues. The timetable allowed a certain amount of flexibility as long as essential lectures and appointments were honoured. Wendy's point of view was that a Master's degree was increasingly important, as undergraduate study was not enough to prepare students for the competitive world outside, and this was endorsed by the consistently high application to the RCA fashion courses.

Although Wendy's workload was impressive, she never lost the ability to balance academic commitments with the essential, more social aspects of College life. She adored the Senior Common Room, frequently using it for lunch, and reviving a spirit that had flagged somewhat over recent years. She and members of the fashion staff would be there as often as possible and, while not lingering well into the afternoon as former generations had done in less committed times, they would enjoy lunch at the long table formerly known as 'the painters' table' since Robin Darwin's time. To some, the regulars at the rebranded 'fashion table' were (in some ways like Darwin and his crowd) seen as an intimidating black-clad retinue, once or twice even described as 'snooty', but appearances were deceptive and Wendy's sociable charm soon dispelled this mistaken image. VIP guests and visiting staff alike were impressed by the informality of the rather splendid surroundings, dining with RCA-designed tableware amongst works by Freud, Hockney, Paolozzi and Ravilious.

Wendy's appreciation of the common room was so obvious that she was soon asked to take over the chair of the SCR Committee. She accepted with pleasure and, with her love of food and cooking, this was a perfect appointment. She and Jon had a passion for entertaining at home as well as eating out, and they would go miles to find a new farmer's market or a supplier of something special. So being involved in the running of the College's staff dining room seemed almost like an additional perk in her already very busy life, and the annual tastings of the wine committee (essential) which went with it were, though serious occasions, great fun. The College kitchens even ran, for several years, the considerable undertaking of catering for the Fashion Gala evenings. The revival of the 'RCA Cookery Book', the last version of which had been published in Joanne Brogden's time, was something Wendy organised almost as soon as she took over, its workmanlike spiral binding holding together recipes gathered from staff of all departments alongside witty illustrations by members of the school of Communication Art and Design.

Another annual event important to Wendy was entertaining the school's current external examiners. After a long, intense session on the first day of the final examinations, she would invite the examiners and staff to her home in Shepherd's Bush, where she and Jon would, seemingly effortlessly, prepare an informal dinner for a dozen or more people. These late-May evenings would often start with chilled wine under a huge parasol in the garden, Madge the cat elusively darting about the flowerbeds and a teenage son or two sometimes making an appearance. It was difficult to remember that these blissful evenings were business entertainment and especially to be aware that tomorrow was a working day, that a group of nervous students was working all night to finish final presentations and that an early start would be essential.

Endless accolades

2008 was a splendid year for British fashion achievement. It was as if the government and the Palace had suddenly become aware of the importance of the fashion industry to the national economy. The previous year Brian Godbold, fashion graduate, former director of design at Marks and Spencer and chair of the BFC, had been honoured with an OBE for 'services to fashion design'. This was followed by an MBE for Anne Tyrrell, and a CBE for Betty Jackson – great opportunities for much celebration in the Senior Common Room. An era was about to end with the retirement (to focus on writing and broadcasting) of Sir Christopher Frayling, whose long service as tutor, professor and finally Rector, endorsing his passion for the College's past and its future, had made him such a popular choice. His place was taken by Dr Paul Thompson, whose introductory statement about the Fashion School in his first Annual Report was that 'The design ethos is a powerful combination of creative expression, technical excellence, and high professional standards ... questioning the boundaries of menswear and womenswear'. The courses were certainly still making the news, with no less than eight recent graduates selected to show in London Fashion Week, backing a new and continuing RCA trend of successful own-label companies. The accolades continued the following year with Erdem, Holly Fulton and Christopher Raeburn all winning major awards at Fashion Week, and the newly-involved Buckingham Palace inviting the school to exhibit in a major show, '500 Key Figures from the Clothing Industry'. Many of the prestigious job openings that year were offered by RCA graduates returning to recruit, amongst them positions at Givenchy, Chloe, Nina Ricci, Louis Vuitton, Balenciaga, Cerruti, Gucci, Versace, Aquascutum, Burberry, COS, Topman, Umbro, Adidas, and Nike. Christopher Frayling's pronouncement that 'at the head of almost every international company is an RCA designer' had never been truer.

Each incoming principal likes to rethink the organisation of the institution he or she has entered. By August 2011, a new RCA academic structure was in place, comprising six schools, each to be led by a Dean. Fashion and textiles were part of the School of Material, the other component courses being the applied art subjects of ceramics and glass, and metalwork and jewellery. Wendy, thinking that being in charge would be preferable to taking orders, applied successfully for the post of Dean of the

School of Material. In her usual practical way she took the considerable extra commitment in her stride, supported by the ultra-capable Hilary Laurence (her softly anarchic humour much loved by every student and tutor) as her PA. It was difficult for Wendy to juggle her time – three days for fashion and two days for the Dean's activities allowed little thinking space. The new Rector saw things from a necessarily more corporate point of view than Frayling's; higher target student numbers required new layers of senior management, creating an unfamiliarly bureaucratic system for a college which had always been admired for the pragmatic, hands-on character of the way in which it operated. All six deans were on the senior management team with endless meetings and even a training course on 'How to manage people', mocked by a number of the attendees who felt they had been successfully doing just that for years. They were encouraged to become full time deans, an idea which appalled Wendy – the thought of never being with the students, and of someone else heading up fashion, didn't appeal in the slightest. It was often difficult to work with other professors, each of whom had a personal agenda and occasionally a combative or opposing point of view.

An OBE and the Olympics

In 2011 Wendy was at last honoured for her long-lasting commitment to education and the industry with an OBE from the Prince of Wales at Buckingham Palace. Early the same year, the organising committee for the 2012 London Olympic Games requested that the fashion students should create uniforms for resident Games staff, to be worn at award ceremonies on the podium which would itself be designed by students from the school of Industrial Design Engineering. The uniform brief was detailed, requiring two different looks for escorts to take winning athletes and medal presenters to the podium (both of these categories female) and for flower bearers (male). Trine Hav Christensen was selected for her 'Grecian punk' aesthetic for the womenswear, while Tom Crisp's angular designs sharpened up the look for the male flower-carriers. Hats were to be designed by graduate Zara Gorman, and the RCA name was fully endorsed with the choice of ex-students Edward Barber and Jay Osgerby for the design of the Olympic torch, and Thomas Heatherwick for the extraordinary cauldron, so magically emblematic in the opening and closing ceremonies.

Although the students were used to designing to industrial briefs, a uniform was a new challenge with many more restrictions. Function as well as a strong identity was all-important, and much was learned during the project. The final outfits were to be produced by the corporate-clothing division of Next, and visits to their factories near Leicester were an instructive experience. Although students had been allowed to suggest certain fabrics, the final products were made in a practical synthetic woven, in the rather vivid 'royal purple' chosen by the committee. The students and staff were involved at all stages of design, but the results were inevitably watered-down by the time they appeared, and the look (so carefully specified by the students) somewhat spoiled by the addition of black shoes for all, wedge-heeled and frumpy for the female escorts. Imogen Fox's comment in *The*

Guardian, 2 June 2012, was 'two parts airline uniform, one part trendy Japanese businessman'. In spite of a slightly disappointing end-result, it was a huge honour to have been selected, a great exercise in cross-departmental collaboration, and a boost for the CVs of all involved. It was also a useful introduction to the design of corporate clothing and the fact that corporations are by their nature made up of numerous staff whose various opinions can, if allowed to, cloud a concept and take it some way apart from its origins.

The Olympic year saw the appearance of helpful new initiatives for young designers. Under the chairmanship of Sir Stuart Rose, chief executive of M&S, the British Fashion Council had continued its support of the talent emerging from Britain's design schools, which in many cases led to the start-up of independent design labels. The London Development Agency, working with Hilary Riva, backed a generous funding package to support both individual designers and the international profile of London Fashion Week. Fashion was said to have the biggest growth potential in the City's specialist sector, making a direct contribution to the economy of London by bringing in extra revenue through tourism and retail, and the BFC understood that much of this depended on a continuing supply of exciting new talent. With the leadership of Caroline Rush and Simon Ward, the BFC began to run numerous programmes for fledgling designers: a number of special scholarships for Masters study; a Colleges Council which, amongst other support, offered paid internship in collaboration with MaxMara; Fashion Forward, providing designers with business advice and financial help; and a funding package to support at least one new or existing venture per year. In 2012 three out of the four BFC scholarships went to RCA fashion students, and the following year another two were successful. The growth of menswear as part of London Fashion Week highlighted graduates Lou Dalton, Katie Eary and Astrid Andersen. These accomplishments no doubt brought fresh commercial interest in the school, and there were many new sponsors including ASOS, Burton, Adidas, Esprit and Monsoon, the latter two highlighting ecological and ethical issues in their project briefings. Ralph Lauren and Abercrombie & Fitch brought revived interest from the US trade, and in 2013 RCA students once more swept the board in Trieste at the ITS#12 awards. Graduate Eudon Choi summed up the sought-after RCA individuality in saying 'You are encouraged to develop your own voice … this is not the case elsewhere', a reference to the influence of major brands over some European schools.[3] Support from business is desirable, but can inevitably affect results. This reiterated Betty Jackson's statement thirty years before that, because nobody was dictating to them, London designers had the uninhibited experimental edge so important to individual creativity.

Wendy was busy with other commitments too. Her natural ability to oversee and manage a very complicated structure illustrated the willing dedication of her staff, something which was only possible if harmony and respect existed within it. It says much about the apparent lightness with which Wendy wore her responsibility (hiding, of course, passionate dedication to her job) that everyone loved working for her. As well as taking on the Dean's considerable workload she was asked by the V&A

Astrid Andersen's saccharine streetwear, 2010

to curate an exhibition called 'Club to Catwalk – London Fashion in the 80s'. In many ways spinning off from her previous research for 'Style City', it explored the decade which, if fairly tough for many designers, had been so formative in drawing attention to the peculiarly British attitude to fashion during that time. Wendy was the perfect example of a designer who had set up in the 70s and been a founder-member of the club culture, a lot of it generated at St Martin's even before she worked there, which had been all-important in fusing music, graphics and fashion in a way unique to Britain, and to London in particular. Working with writer Sonnet Stanfill, she masterminded a show beginning with the anarchy of the decade's punk origins and ending with the observation by Vivienne Westwood (who, arguably, had started it all) that there was, by the close of the 80s, disappointingly little difference between 'street fashion and the fashion of the establishment'.[4] The private view of the show was spectacular, with many of the protagonists of the 80s' London scene turning up in their original designs, nostalgically and enthusiastically recreating the mood albeit after a gap of thirty years.

In 2010, the law governing university tuition fees and student loans had changed, leaving graduates worldwide, particularly in Britain and Europe, with mountains of debt to pay off. The interest in British design schools from overseas students (usually financed by private means) who paid substantially higher fees than their European counterparts did in part support the courses, but by 2014 fashion students were graduating with debts of £30,000 not including the costs of producing their final collections. Strangely enough, this was roughly the amount paid by each overseas student for a year's study – an encouragement to think that there must be a way around the huge problem, but it wasn't that simple. Although each college had a quota for overseas student numbers, at the RCA they were still always accepted on merit and not simply for financial gain. Larger numbers of foreign students, although creating exciting cultural diversity, meant different and sometimes trickier dynamics in every department – the issues of English as a foreign language (students had to pass an examination in order to fully qualify), methods of teaching, dealing with ever-larger groups. Wendy was to comment that 'The RCA is unique because there are no huge cohorts – everyone is an individual. We look for a dynamic within a group, a mix of people and personalities. My way of teaching is . . . to encourage them in a strong and honest way'.[5] Things had to change, but at that time the College never gave up its sought-after method of one-to-one teaching, even if this meant cutting the time allowed to each student; it was increasingly difficult, particularly as design subjects are by their nature practical and much is learned by demonstration and experiment. Many colleges were resorting to digital methods and group learning, but as Suzy Menkes pointed out, it is impossible to teach the discipline by these means – in fashion, touch and feel are as important as the final look of a garment. She was adamant that students more than ever needed award systems, bursaries and jobs from big players to pay off their debilitating debts.

In the Fashion School, the 'studio' system set up all those years ago by Alan Couldridge was easily the best way to manage growing student numbers. Projects,

RIGHT Setting up an exhibition in the Gulbenkian gallery

BELOW Work in progress in the Fashion studios, 2013

financed by eager sponsors, were split between several groups of students, with Heather Holford admittedly finding it increasingly difficult to juggle a growing number of design briefs from different sources, all of them wanting exposure in the fashion show. The task was more complex than it had been in earlier days because larger numbers of the students needed to take on part-time jobs in order to fund their courses, and were consequently not available every day. The organisation of sponsor visits and crits was complicated, but budgets were structured to allow for visiting tutors who could assist in the management as well as take on the teaching of these projects.

By this time Wendy had been at the College for almost sixteen years, substantially longer than she had spent at St Martin's. Things had changed enormously,

particularly from an administrative point of view. She was running two senior jobs, each of them with its own huge demands, in a 5-day week. The RCA system, in line with nationwide government educational developments, had inevitably become much more bureaucratic and a lot less fun, and though Wendy had a clear understanding of the reasons for this she began to feel it was time to think about her future. It seemed that the way in which the new system operated was to have layers of management personnel above the departmental teaching staff, something which appeared alien to a handful of the professors whose reason for being at the College was their 'hands-on' attitude to teaching. But every era has its characteristics, and this was the corporate path education was taking.

Wendy says farewell

Wendy decided to retire in the summer of 2014. Without exception, everyone was sad to see her go. She had resuscitated the School of Fashion and given it her own vibrant spirit, putting a royal pride back into its name once more; somehow she had united the aesthetics of the three indomitable women who had preceded her, taking the initiative style of Madge Garland, the modernity of Janey Ironside and the international savvy of Joanne Brogden to create a global-British brand for the RCA. Over the years the Fashion School had steadily worked to fulfil its original brief, to breathe new life into the British fashion industry, and had far exceeded it; Wendy's arrival had set it on an optimistic yet realistic journey into a future of diversity. Amongst a broad range of achievements in the summer she retired, graduate Christopher Bailey became CEO of Burberry; milliner Justin Smith styled Angelina Jolie for the film 'Maleficent', and the top three ITS awards were won by two RCA womenswear students. The exhibition 'Sixteen' staged in the Gulbenkian Gallery to celebrate Wendy's time at the College was a tribute to the whole of her fashion career. It also showed sixteen pieces, one for every year of her RCA career, willingly loaned by admiring graduate star designers for her farewell celebration.

As a team leader Wendy was unique – her dedication to the students didn't detract from her loyalty to her family, and the balance of the two, difficult though it may sometimes have been, certainly contributed to her perception as a leader. Her son Augustus, in a *Sunday Times* interview, voiced the mild criticism that 'she's just a bit too humble',[6] but this was just one more example of Wendy's endearing lack of ego, an all-too-rare trait in fashion luminaries. Superlatives can sound gushing, but no-one would disagree that Wendy's qualities of honesty, fairness, huge charm and above all fun made her the perfect professor of fashion. After her last Gala show, journalist Melanie Rickey pointed out her uniqueness: '… Wendy has been heading up the RCA MA for 16 years, and there are not many Wendys about the place'.

That statement was all too true. The only rival fashion course to the RCA's was still Wendy's previous professional home, St Martin's. The devastating news of the sudden death of Louise Wilson, the formidable course director of the MA course at St Martin's, shook the fashion world just weeks before Wendy's retirement. Louise had been in charge for sixteen years, exactly the timespan of Wendy's RCA tenure,

Wendy's farewell exhibition, *Sixteen*, in 2014

and in her straight-talking way had similarly nurtured extraordinary talent, influencing the international view of British fashion from luxury level to high street. Suddenly, not just one but both of the world's most-respected centres for fashion education would be looking for new leaders. Suzy Menkes, always a clairvoyant step ahead in fashion prediction, wrote that '... the writing was already on the wall'. It was truly the end of an ultra-creative era, one that would be impossible to replicate in a future so controlled by government restrictions and financial issues.

In spite of her dedication to the College, Wendy was relieved to retire. Although she had the experience and ability to handle two major posts at once, it was exhausting (so much so that after she left, the workload was reconfigured as two separate units – posts for Head of Fashion and a full-time dean). It says much for her resolution and diplomacy that for three years she had been able to manage both, but it was too much. What she really enjoyed was contact with the students and, with her commitments, this became more and more rare. The new managerial structure of the College was bureaucratic, a pointer to a very different future for the school, ostensibly led by finance rather than fashion skills. Necessary developments dictated new systems although actually, in a span of 66 years, there had been remarkably little change in the methods, academic and technical, of teaching fashion design at the RCA. Wendy's quote for a *Vogue* interview, during her last few months as professor, reiterated advice often given to students – 'Be yourself. Don't follow others or be blinded by any of it ... you need to be prepared for hard work ... Keep your feet on the ground and remember, fashion isn't everything'. The last three words, the clear acknowledgement that there is a world outside waiting to enhance every design experience, sum up the secret of Wendy Dagworthy's charismatic leadership of the Fashion School at the Royal College of Art.

Notes

Chapter 1

1 Alison Settle, Journal of the Royal Society of Arts, vol. 118, London 1970
2 Elizabeth Wilson and Lou Taylor, *Through the Looking-Glass – a history of dress from 1860 to the present day*, BBC Books, London 1989
3 Christine Boydell, *Horrockses Fashions – Off-the-Peg style in the 40s and 50s*, V&A Publishing, London 2010
4 *Drapers' Record Centenary Supplement*, International Thompson Publishing London 1987
5 Eric Newby, *Something Wholesale*, William Collins Sons & Co, 1962
6 Christopher Breward and Claire Wilcox, *The Ambassador Magazine*, V&A Publishing, London 2012
7 Elizabeth Griffiths, November 2017
8 Bobby Hillson to author, August 2016
9 Henrietta Goodden, *Robin Darwin – visionary educator and painter*, Unicorn Press Ltd, London 2015
10 Henrietta Goodden, *Robin Darwin – visionary educator and painter*, Unicorn Press Ltd London 2015
11 Madge Garland in *Twenty-Five Years*, School of Fashion Design, Royal College of Art, 1974
12 Elizabeth Ewing, *A History of 20th Century Fashion*, Batsford, London 1974/2005
13 The American financial initiative to aid Western Europe after WW2

Chapter 2

1 Henrietta Goodden, *Robin Darwin*, Unicorn Press Ltd, London 2015
2 Henrietta Goodden, *Camouflage and Art*, Unicorn Press Ltd, London 2007
3 Royal College of Art, Janey Ironside's staff file, letter to Prudence Glynn, August 1971
4 Royal College of Art, Madge Garland RCA/MG/2012/1.3
5 Royal College of Art, Madge Garland RCA/MG/2012/1.3
6 Lisa Cohen, *All We Know*, Farrar, Strauss and Giroux, New York 2012
7 Royal College of Art, Madge Garland RCA/MG/2012/1.3
8 Royal College of Art, Madge Garland RCA/MG/2012/1.3
9 Brighton Design Archive, CoID Papers
10 Brighton Design Archive, CoID Papers

Chapter 3

1 Prudence Glynn, *50 Years On*, The Times 1972
2 Janey Ironside, *Janey*, Michael Joseph Ltd, London 1973
3 Janey Ironside, *Janey*, Michael Joseph Ltd, London 1973
4 Janey Ironside, *Janey*, Michael Joseph Ltd, London 1973
5 *Twenty-Five Years*, School of Fashion Design, Royal College of Art, 1974
6 *A New School for Fashion Design*, Harper's Bazaar, 1949
7 *The Sunday Times*, 15 June 1950
8 Ed. Robin Darwin, *The Anatomy of Design*, Royal College of Art, London 1951
9 Lady Helen Hamlyn to author, June 2015
10 Ed. Robin Darwin, *The Anatomy of Design*, Royal College of Art, London 1951
11 Lady Helen Hamlyn to author, June 2015
12 *A New School for Fashion Design*, Harper's Bazaar, 1949
13 *A New School for Fashion Design*, Harper's Bazaar, 1949
14 Janey Ironside, *Janey*, Michael Joseph Ltd, London 1973
15 Lady Helen Hamlyn to author, June 2015
16 Pat Albeck to author, April 2015
17 Royal College of Art, Madge Garland MG1 1/2/2
18 Royal College of Art, Madge Garland MG5
19 Private letter to Lady Darwin

Chapter 4

1 Letter to Prudence Glynn August 1971, RCA, staff file of Mrs J Ironside
2 Janey Ironside, *Janey*, Michael Joseph, London 1973
3 Janey Ironside, *Janey*, Michael Joseph, London 1973
4 Janey Ironside, *Janey*, Michael Joseph, London 1973
5 Henrietta Goodden, *Camouflage and Art*, Unicorn Press Ltd, London 2007
6 Virginia Ironside, *Janey and Me*, Harper Perennial, London 2004

Chapter 5

1 Royal College of Art, staff file of Professor Mrs J Ironside
2 Janey Ironside, *Janey*, Michael Joseph, London 1973
3 Virginia Ironside, *Janey and Me*, Fourth Estate, London 2003
4 Virginia Ironside, *Janey and Me*, Fourth Estate, London 2003
5 RCA, staff file of Professor Mrs J Ironside
6 RCA, staff file of Professor Mrs J Ironside
7 Elizabeth Ewing, *A History of 20th Century Fashion*, Batsford, London 1974/2005
8 Elizabeth Ewing, *A History of 20th Century Fashion*, Batsford, London 1974/2005
9 Virginia Ironside, *Janey and Me*, Fourth Estate, London 2003
10 Janey Ironside, *Janey*, Michael Joseph, London 1973

Chapter 6

1 Iain R Webb, *Foale and Tuffin – the Sixties. A decade in Fashion*, ACC Editions, Woodbridge 2009
2 Sheilagh Brown to author, August 2015
3 Ed. Lady Henrietta Rous, *The Ossie Clark Diaries*, Bloomsbury Publishing plc, London 1998
4 Iain R Webb, *Foale and Tuffin – the Sixties. A decade in Fashion*, ACC Editions, Woodbridge 2009
5 Diana Vreeland's term for the London phenomenon
6 Royal College of Art, staff file of Mrs J Ironside
7 Sylvia Ayton to author, August 2016
8 Iain R Webb, *Foale and Tuffin*, ACC Editions, Woodbridge 2009
9 Ernestine Carter, *The Sunday Times*, 28 April 1968
10 Paul Babb to author, November 2015
11 Henrietta Goodden, *Robin Darwin – visionary educator and painter*, Unicorn Press Ltd, London 2015
12 Valerie Couldridge to author, June 2018
13 Janey Ironside, *Janey*, Michael Joseph, London 1973
14 Janey Ironside, *Janey*, Michael Joseph, London 1973

Chapter 7

1 Virginia Ironside, *Janey and Me – growing up with my mother*, Harper Perennial, London 2004
2 Virginia Ironside, *Janey and Me - growing up with my mother*, Harper Perennial, London 2004
3 Henrietta Goodden, *Robin Darwin*, Unicorn Press Ltd, London 2015
4 Royal College of Art Archive, *An Insult*, RCA Student Union, 1968
5 Royal College of Art, Dr. Leonard Selby, staff file of Mrs J Ironside
6 Graham Wren and Tom Bowker to author, June 2015
7 *The Sunday Times*, 28 April 1968
8 Royal College of Art, staff file of Mrs J Ironside

Chapter 8

1 Tom Bowker to author, June 2015
2 Ernestine Carter, *The Sunday Times*, April 1968
3 Joy Law to author, April 2015
4 Paul Babb to author, November 2015
5 Graham Wren and Tom Bowker to author, April 2015
6 Joy Law to author, April 2015
7 Royal College of Art, staff file of Mrs J Ironside
8 Ernestine Carter, *The Sunday Times*, April 1968
9 Ernestine Carter, *The Sunday Times*, April 1968
10 Robert O'Byrne, *Style City: How London became a Fashion Capital*, Frances Lincoln, London 2009
11 Prudence Glynn, *The Times*, September 1967
12 Graham Wren and Tom Bowker to author, April 2015
13 Robert O'Byrne, *Style City: how London became a Fashion Capital*, Frances Lincoln, London 2009
14 Joy Law to author, April 2015
15 Graham Wren and Tom Bowker to author, April 2015
16 Christopher Frayling, *Art and Design: 100 Years at the Royal College of Art*, Collins & Brown, London 1999
17 Charlie Allen to author, April 2018

Chapter 9

1 Christopher Frayling, *The Royal College of Art*, Barrie and Jenkins, London 1987
2 Christopher Frayling, *The Royal College of Art*, Barrie and Jenkins, London 1987
3 Betty Jackson to author, November 2016
4 Ed. Sonnet Stanfill, *From Club to Catwalk*, V&A Publishing, 2013
5 Betty Jackson to author, November 2016
6 Robert O'Byrne, *Style City – how London became a Fashion Capital*, Frances Lincoln, London 2009
7 Ed. Sonnet Stanfill, *From Club to Catwalk*, V&A Publishing, 2013
8 Ed. Sonnet Stanfill, *From Club to Catwalk*, V&A Publishing, 2013
9 Betty Jackson, November 2016
10 Tom Bowker to author, June 2015
11 Ed. Sonnet Stanfill, *From Club to Catwalk*, V&A Publishing, 2013
12 *Drapers' Record Centenary Supplement*, International Thompson Publishing, London 1987
13 *The Times*, June 1988
14 Christopher Frayling, *Art and Design – 100 years at the Royal College of Art*, Collins & Brown, London 1999
15 Valerie Couldridge to author, June 2018
16 Betty Jackson, November 2016
17 Colin McDowell, 'Material Differences at the RCA', *The Perfect Place to Grow*, Royal College of Art, London 2012
18 Joy Law to author, April 2015
19 *The Sunday Times*, July 1984
20 Betty Jackson, November 2016
21 Valerie Couldridge to author, June 2018

Chapter 10

1 Christopher Frayling, *Art and Design*, Collins & Brown Ltd/Richard Dennis Publications, 1999
2 Sarah Dallas to author, May 2018
3 Robert O'Byrne, *Style City – how London became a Fashion Capital*, Frances Lincoln, London 2009
4 Christopher Frayling, *Art and Design*, Collins and Brown Ltd/Richard Dennis Publications, 1999
5 Betty Jackson to author, November 2017
6 Usha Doshi to author, November 2016
7 Henrietta Goodden, *Robin Darwin, Visionary Educator and Painter*, Unicorn Press Ltd, London 2015
8 John Miles to author, January 2018
9 John Miles to author, January 2018

Chapter 11

1 Ann Treneman, *Independent*, March 1988
2 Henrietta Goodden, *Robin Darwin, Visionary Educator and Painter*, Unicorn Press Ltd, London 2015
3 Bobby Hillson to author, August 2016

Chapter 12

1 Wendy Dagworthy to author, April 2017
2 Robert O'Byrne, *Style City: how London became a Fashion Capital*, Frances Lincoln, London 2009
3 Eudon Choi, *The Times*, June 2012
4 Sonnet Stanfill, *From Club to Catwalk*, V&A Publishing, London 2013
5 Wendy Dagworthy, *Another Magazine*, June 2014
6 Augustus Prew, *The Sunday Times*, August 2013

Glossary

Acrilan brand name for a synthetic fabric made from acrylic resin, produced by Monsanto and popular in the 1960s

Batwing sleeve loose long sleeve with a very deep armhole

Britain Can Make It major 1946 exhibition, mounted in order to resuscitate British post-war industry and to introduce affordable design to the British people

Chilprufe a 20th century British manufacturer of wool/cotton underwear

Comité Colbert a French association 'to promote the concept of luxury', with membership of 81 luxury brands

Empire line a high-waisted dress silhouette, inspired by women's clothing after the French revolution

Faggotting a form of openwork embroidery, producing rows of tiny perforations and originally used to attach one piece of fabric to another

Gored a pattern cutting term meaning 'flared' or growing wider

Guinea pre-decimal coinage, twenty-one shillings

Hambleden Committee a government committee set up in 1936, to look into advanced art education in London

Horrockses large cotton-textile and garment producer originally based in Preston, Lancashire

ICI Fibres Imperial Chemical Industries, one of its many divisions producing synthetic fibre used for textiles

Liberty print printed cotton dress fabric designs, often floral, produced by Liberty of London since the mid-19th century

Lurex brand name for a synthetic metallic thread, used to make textiles with sparkling surfaces

Lycra brand name for Du Pont's highly elastic synthetic yarn, used for ultra-stretchy textiles

Madam shop a boutique selling smart fashionable ladieswear

Madras cotton multi-coloured woven checked cotton originally from Madras (Chenai) in India

Moiré silk or synthetic fabric treated to have a watermarked ripple effect

Multiples large stores with a number of branches

New Look Christian Dior's groundbreaking post-war silhouette launched in 1947, its exaggerated femininity a reaction against wartime austerity

Sekers, Miki Sir Nicholas Sekers, British-based Hungarian industrialist who founded a large textile business in the Lake District

Separates informal garments worn together, a look which marked a progression from the formal dresses of the 1940s and 50s

Set-in sleeve a sleeve structured to neatly accommodate the shoulder, used mainly in tailoring

Shot taffeta lightweight silk or synthetic fabric, with warp and weft in contrasting colours

Summerson Council a division of the National Council for Diplomas in Art and Design, chaired by Sir John Summerson in the 1960s

Toile original French translation 'canvas', in fashion terms a calico prototype for a garment

Vendeuse French translation for 'saleswoman'

Viyella brand name for a soft woven textile made by William Hollins, 55% wool and 45% cotton, used mainly for shirts and nightwear

Abbreviations

AFD Associated Fashion Designers

BFC British Fashion Council

CEC Clothing Export Council

CBE Commander of the most excellent Order of the British Empire

CoID the Council of Industrial Design

DTI Department of Trade and Industry

FIT the Fashion Institute of Technology, part of the State University of New York

IncSoc the Incorporated Society of London Fashion Designers

IRA Irish Republican Army

LDC London Designer Collections

NUS National Union of Students

OBE Officer of the most excellent Order of the British Empire

V&A the Victoria and Albert Museum, London

Picture Credits

Every effort has been made to trace copyright holders and secure permissions for reproduction of all images. Images are reproduced by kind permission of private collections with the exception of the following:

Title page portraits, top to bottom: Wendy – Jonathan Prew; Janey – John French; Joanne – unknown photographer; Madge – unknown photographer.

Royal College of Art Archive (photographers unknown unless named): 10, 12, 17, 34, 36, 39 (reproduced under Open Government Licence), 43, 44, 45 (John Gay), 49, 50, 53, 55, 66, 68, 74, 75, 78, 79, 82, 84, 85 (Bryan Wharton), 92, 93 lower, 96, 99, 100, 104, 105, 107–111, 113, 114, 116 left, 116 right (Murray Irving at John French), 118, 124–127, 130–138, 140, 141, 142, 146–156, 162–169, 171–188, 198–201, 202 right, 204, 206 upper, 207–213, 214 lower, 215, 219, 221, 240

Madge Garland Papers, Royal College of Art Archive, Special Collections (photographers unknown): 24, 26, 28, 30, 38

Royal College of Art Collection: 81

Bridget Bishop Photography © bridgetbishop.co.uk.co.uk: 73, 87 right, 88, 89, 94, 95

Design Council Archive, University of Brighton Design Archives: 32

Desmond O'Neill Features: 103

The Estate of Fred Dubery and Joanne Brogden: 119, 122, 128, 139, 161 right

The Estate of Paul Tanqueray, National Portrait Gallery: 33

Shutterstock/Vyntage Visuals: 20

Sothebys © The Cecil Beaton Archive: 27

Victoria and Albert Museum © Elsbeth Juda Archive: 22

Images supplied by courtesy of the following: Sylvia Ayton: 87 left, 101; Dr Kevin Almond: 158; Barbara Baum: 196, 202 left; Valerie Couldridge: 93 upper, 129 (Tim Mara), 144, 145, 170; Wendy Dagworthy: 189 (Jonathan Prew), 190, 192, 193 (Jonathan Prew), 194, 223 (Jonathan Prew); Holly Fulton: 214 upper; Liz Griffiths: 15, 16; Virginia Ironside: 56 (Michael Wickham), 58-63, 71, 80, 86 (John French); Marian Kamlish: 48; the late Joy Law: 161 left; Suk Han Lee: 206 lower; Howard Tangye: 197; Anne Walls, the Gerald McCann Archive: 102

Bibliography

J Anderson Black and Madge Garland, *A History of Fashion*, Orbis UK, 1975

Christine Boydell, *Horrockses Fashions: off-the-peg style in the 40s and 50s*, V&A Publishing, London 2010

Christopher Breward and Clare Wilcox, *The Ambassador Magazine: promoting post-war British textiles and fashion*, V&A Publishing, London 2012

Joanne Brogden, *Fashion Design*, Studio Vista, London 1971

Lisa Cohen, *All we Know: Three Lives*, Farrar, Strauss and Giroux, New York 2012

Elizabeth Ewing, *A history of 20th Century Fashion*, Batsford, London 1974/2005

Christopher Frayling, *Art and Design, 100 years at the Royal College of Art*, Collins & Brown, London 1999

Christopher Frayling, *The Royal College of Art, One Hundred and Fifty years of Art and Design*, Barrie & Jenkins, London 1987

Madge Garland, *Fashion – a picture guide to its creators and creations*, Penguin, Harmondsworth 1962

Madge Garland, *The Changing Face of Beauty*, Weidenfeld & Nicholson, London 1957

Madge Garland, *The Changing Form of Fashion*, J M Dent, London 1970

Madge Garland, *The Indecisive Decade*, Macdonald & Co, London 1968

Madge Garland, *The Small Garden in the City*, Architectural Press, London 1973

Henrietta Goodden, *Camouflage and Art: Design for Deception in World War 2*, Unicorn Press Ltd, London 2007

Henrietta Goodden, *Robin Darwin: Visionary Educator and Painter*, Unicorn Press Ltd, London 2015

Janey Ironside, *Fashion as a Career*, Museum Press Ltd, London 1962

Janey Ironside, *Janey*, Michael Joseph, London 1973

Virginia Ironside, *Janey and Me, growing up with my mother*, Fourth Estate, London 2003

Angela McRobbie, *British Fashion Design*, Routledge, London 1998

Eric Newby, *Something Wholesale, My life and times in the Rag Trade*, William Collins Sons & Co, 1962

Robert O'Byrne, *Style City: how London became a fashion capital*, Frances Lincoln, London 2009

Helen Reynolds, *'Couture or Trade' – an early pictorial record of the London College of Fashion*, Phillimore & Co Ltd, Chichester 1997

John Russell Taylor, *Muriel Pemberton: Art and Fashion*, Chris Beetles Ltd, London 1993

Scottish Arts council with the support of the V&A Museum, *Fashion 1900–1939*, Idea Books, London 1975

Graham David Smith, *Celebration*, Mainstream Publishing, Edinburgh 1996

Iain R Webb, *Foale and Tuffin, The Sixties. A Decade in Fashion*, ACC Editions, Woodbridge 2009

Elizabeth Wilson and Lou Taylor, *Through the Looking-Glass: a history of dress from 1860 to the present day*, BBC Books, London 1989

Ed. Robin Darwin, *The Anatomy of Design*, Royal College of Art, London 1951

Ed. Christopher Frayling and Clare Catterall, *Design of the Times, Royal College of Art Centenary Catalogue*, Richard Dennis Publications/Royal College of Art

Ed. Octavia Reeve, *The Perfect Place to Grow, 175 Years of the Royal College of Art*, Royal College of Art, London 2012

Ed. Lady Henrietta Rous, *The Ossie Clark Diaries*, Bloomsbury Publishing plc, 1998

Ed. Sonnet Stanfill, *From Club to Catwalk*, V&A Publishing, London 2013

Journals

Another Magazine, June 2014

Drapers' Record Centenary Supplement, International Thompson Publishing, London 1987

The Evening Standard, June 1973 (Suzy Menkes)

Harper's Bazaar 1949, 'A New School for Fashion Design'

The Independent, Anne Treneman, March 1988

Journal of the Royal Society of Arts, vol. 118, 1970

The Sunday Times, June 1950, April 1968 (Ernestine Carter), July 1984 and August 2013

The Times, 1967 and 1972 (Prudence Glynn), June 1988 and June 2012

Acknowledgements

I would like to thank Sir Christopher Frayling for first suggesting the School of Fashion as a subject, and then agreeing to write the foreword. The Royal College of Art Archive became, for a while, a second home and without Neil Parkinson and his endless patience this book could not have come to life.

I am also grateful for the generosity and support of the following:

The British Library Sound Archive
The East Anglian Art Fund
London College of Fashion Library and Archive
The National Art Library
The Royal College of Art Library
The Royal Society of Arts
University of Brighton Design Archive

The people listed below have supplied invaluable memories, information, images and encouragement:

The late Pat Albeck, Charlie Allen, Kevin Almond, Sonia Ashmore, Sylvia Ayton, Paul Babb, Barbara Baum, Durrell Bishop, Tom Bowker, Ian Collins, Valerie Couldridge, Wendy Dagworthy, Sarah Dallas, Vanessa Denza, Usha Doshi, Holly Fulton, Elizabeth Griffiths, Uli Haas, Lady Helen Hamlyn, Bobby Hillson, Heather Holford, Sheilagh Hosker-Brown, Virginia Ironside, Betty Jackson, Cathy Johns, the late Joy Law, Suk Han Lee, Frances Loyen, Angela MacFarlane, Suzy Menkes, Marcia Mihotich, John Miles, Milo O'Sullivan, Caroline Riches, Graham Smith, Sara Sturgeon, David Thomas, Dr Paul Thompson, Danielle and Nicole Tinero, Tim Voegele-Browning, Graham Wren and, of course, the numerous RCA graduates whose work appears in the book.

Thanks to Nick and George Newton whose design skills so perfectly complement the text, and to Hugh Tempest-Radford my publisher at Unicorn Press, and Louise Campbell and her colleagues at Unicorn Publishing Group.

Index

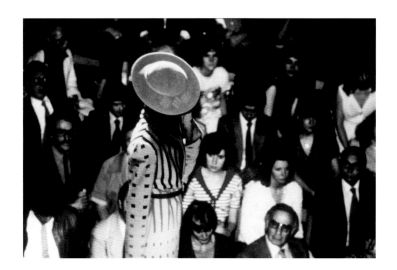

Julia Pines's collection, 1979